DEPARTMENT OF THE ENVIRONMENT

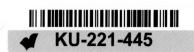
architecture

A handbook on commissioning

compiled and edited by

Deanna Petherbridge

from research conducted by the
Art & architecture research team:
Peter Fink, Lesley Green and Deanna Petherbridge
with contributions from:
Timothy Ostler, Peter Coles

LONDON: HER MAJESTY'S STATIONERY OFFICE

ISBN 0 11 751794 1

Acknowledgements
Research Project Steering Group

Chair: Patricia Tindale, Chief Architect, *Department of the Environment*

Rory Coonan – *Arts Council of Great Britain*
Professor Philip King – *Royal College of Art*
Stuart Lipton – *Stanhope Securities Ltd.*
Sandy Nairne – *Freelance curator and writer.*
Iain Reid – *Calouste Gulbenkian Foundation*
William Whitfield – *Architect*

Administration: Public Art Development Trust

Co-ordination: Hillary Bauer
 Ian Macdonald

Photo Research: Karen McCartney

Consultation: Henry Lydiate, Robert Coward

Cover Photograph:

Antony Gormley, *Places to Be*, detail, 1984, Lead, fibreglass & plaster, 3 figures 1.97, 180 & 1.90m high. Monkstone House, City Road, Peterborough.
Funded by Peterborough Development Corporation.
Photograph by courtesy of Peterborough Development Corporation.

Foreword

We take it for granted, in the enduring buildings of our architectural heritage, that art and architecture go hand in hand. Sculptures, tapestries, ironwork, stone and woodcarving, whether on a grand scale or in a simple setting, gladden the eye and raise the spirits.

Enrichment of this kind was stripped away in the stern functionalism of recent times and we are beginning to realise just how much we have lost and how unsatisfying and lack lustre buildings can become.

Style and image in architecture are now recognised as being as important as function – as indeed they are in other fields of design. Happily artists, craftsmen and architects are working together again to create beautiful environments in which people can enjoy living, working and taking their leisure.

But much more needs to be done and the purpose of this book is to encourage patrons and developers, artists, craftsmen and architects to incorporate works of art and craft as an integral part of new building and renovation schemes.

We commend it to you.

WILLIAM WALDEGRAVE
Minister of State for
Housing and Planning

RICHARD LUCE
Minister of State for the Arts

Contents

GUIDELINES

SECTION 4
Appendices

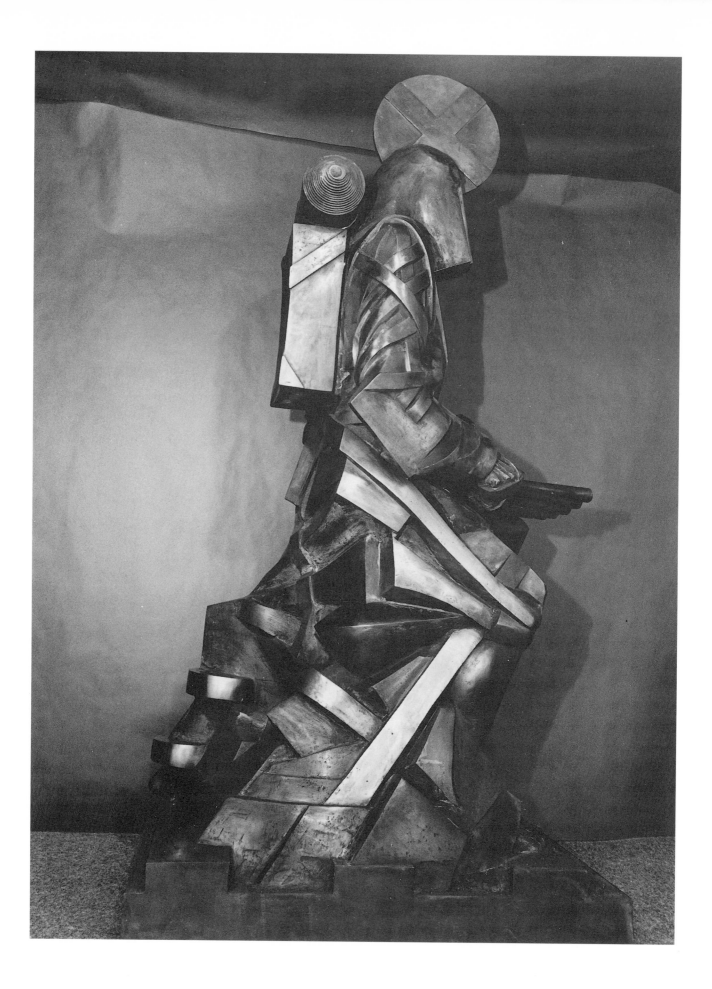

SECTION 1

1 Introduction

How to use the book

The aim of this book is to act as a source of ideas and a practical guide for potential patrons interested in commissioning art and craft works for new and refurbished buildings. It is for the use of individual clients and developers, architects, interior designers and planners, artists and arts bodies, local authorities and development corporations, and sets out to establish guidelines for successful collaborations. The book is the result of a research programme commissioned by the Department of the Environment and the Calouste Gulbenkian Foundation from the Art & Architecture Research Team, and is a response to the growing need for information in the field.

The book is divided into four sections. In the introductory section, the aims and uses of the book are set out and the wider notion of collaboration between artists, architects and craftspeople is placed within a historical context. In the second section, examples of recent commissions in Britain are described by individual members of the research team, followed by photographic surveys of a wide variety of examples of art and craft which have been incorporated into the built environment. The case studies have not only been selected on merit, but in order to illustrate a wide range of single and multiple commissions, drawn from both the public and the private sector and related to a variety of new and refurbished sites. The approach to the case studies has in some cases been critical in order to give a clear picture of the pitfalls occasionally encountered in first-time commissioning and draw out the lessons for other would-be patrons. Two case studies from abroad exemplify successful long-term commissioning programmes, which might well be an inspiration for similar schemes in this country.

The third section contains practical information on how to commission art and craft, and is based on information extrapolated from interviews and questionnaires. Four model commission situations are set out step by step, and in two cases there are diagrammatic flow-charts for easy reference. The stages itemised in this section are cross-referenced to the detailed chapters which follow dealing with budgets, legal contracts, maintenance, consultation procedures, fund raising and so on. The final section contains appendices, including a list of useful names and addresses and recommendations based on the findings of the Team.

It should be noted that this book relates to the commissioning of works of art *and* craft, and that the terms artist and art work are not used in an exclusive sense, but intended to embrace craft and craftspeople whenever used.

The New Collaboration

The coming together of artists and architects has always marked a period of creative vitality in Western cultural history. Such collaboration was central to the Italian Renaissance and left its marks on the fabric of cities as richly as it endowed palaces and churches. In our own country, artists and architects came together with great exuberance during late Victorian times under the influence of William Morris and again in the 1930s under the influence of Modernism; now, through the ferment of ideas and plurality of aesthetics which mark Post-Modernism, artists and architects have embarked on a new dialogue.

The new collaboration is all the more healthy for not being style-bound. The very fact of artistic pluralism in the 1980s is a positive one, as it means that collaboration comes about for all sorts of reasons – social, financial and aesthetic – but not out of subservience to a monolithic style. There is not one 'right' way of doing things, so that every commission has the chance of being a valid and fruitful experience.

Central Issues

Central to the new collaboration are the issues of materials, social relevance, humanism of scale and the rediscovery of ornament.

Just as in the early twentieth century artists and architects were stirred by the purity and inexpressiveness of synthetic materials, the present decade is marked by a return to new ways of using traditional materials. The architects of 'Romantic Pragmatism' are building in tactile brick and wood, with reference to vernacular traditions; while sculptors are increasingly abandoning the resins and synthetic materials of indoor installation for the more robust traditional materials of stone and metal-casting; and painters are returning to oil paint as a more expressive medium for the new figuration. The new attitude to materials is also a humanistic and democratic one. Artists are just as interested in wresting expression, humour and commentary from the throw-away materials of industrial society, as responding to the pristine materials of 'high tech.' Architects, having discovered the sculptural qualities of pipes and ducts no longer hide service viscera behind discreet panels but gleefully put them on display.

The question of social relevance is paramount: low-rise building, sympathetic materials, human scale, consultation and community involvement, are the constituents of much contemporary architecture. The same is true for artists, who are seeking ways to relate to an audience outside of the gallery and contribute to society with their skills. An artist who recently completed a large public commission

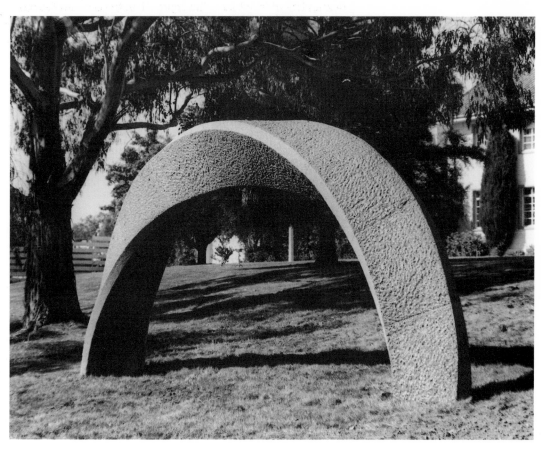

John Maine, *Arch stones,* 1982-4; nine independent, self-supporting stones of South Australian black granite, 2.74 x 5.49m, British High Commission, Canberra, Australia. Commissioned and funded by Government Art Collection with assistance from Monier Granite Ltd.
Photograph: John Maine

3

Sue King and James Robison, *Ceramic mural* 1983, 2.46 x 1.82 x 0.20m, Salters Row Shopping Centre, Pontefract. Architects: Turner, Lansdown Holt (Manchester). Commissioned by Standard Life Pension Funds Ltd
Photograph: James Robison

commented. 'It is going to be so difficult returning to my studio. Working to a public commission gave me such a sense of purpose and relevance: it made sense of all those years of plugging away at my painting.'

Many artists and architects are referring again to the classical tradition in order to rediscover a language of figuration and embellishment. In architecture the language of neo-classical revival often remains denuded and stripped, lacking the full plasticity of ornamentation which sculptors and painters once traditionally provided. The time is therefore ripe for artists and craftspeople to collaborate with architects to provide enrichment, meaning and emphasis for an architectural programme.

The climate of support

Just as artists and architects are moving towards closer collaboration, so the climate of support is growing. In the public sector, Art in Public Places schemes have grown up in direct response to the need for information, funding and administration in the commissioning of art. Schemes have been set up by the Scottish, Welsh and Arts Council of Great Britain, and the Crafts Council, and are implemented at local level by the Regional Arts Associations. Government is concerned to stimulate architectural quality and to encourage the commissioning of art and craftworks as an integral part of design. It is the policy of the Property Services Agency to take a positive approach to the provision of Works of Art in its projects and to ensure that all suitable opportunities for their inclusion are fully considered. The DHSS is also pursuing a positive policy towards the therapeutic and social value of art in redeveloping and building new hospitals. At regional and local level, authorities are increasingly using art for the purposes of improving amenities. In 1983 The House of Commons Select Committee on Public and Private Funding of the Arts recommended that business companies, local authorities and government departments should allocate up to one percent of their building budgets for the purchase and commissioning of works of art by contemporary artists. 'Percent for art' provision of this nature has been adopted by some local authorities, including the London borough of Lewisham and South Glamorgan County Council [See Chapter 22]. Following the Art and Architecture conference at the Institute of Contemporary Arts in February 1982 (out of which grew the idea for this research) Art and Architecture groups have been set up across the country as forums for debate and meetings between the practitioners.

In the private sector, a growing number of developers budget for art in their buildings, knowing that the consequent improvement of the environment is directly linked to letting and sound commercial practices. A survey of 62 architectural practices in the private and public sector carried out in connection with this book [see Appendix II] established that 82% of the practices have commissioned art and crafts work, most of it recently, 45% within the last year. The survey also demonstrated that in 80% of the cases the clients were fully satisfied with the commissioning results and 96% of architectural practices would like to continue their involvement with artists and craftspeople.

Recommendations of the Art and Architecture Research Team

Although the number of art and craft commissions is on the increase and contacts between practitioners are growing, it has been the finding of the Art & Architecture Research Team that commissions tend to be predictable, conventional and bland. They see the need for patrons to take more risks, and commission more adventurously. In order to achieve this, patrons should give opportunities to artists of promise, not necessarily those who have worked in the field of commissions, and be prepared to fund them adequately. In this respect, the Team are conscious of the fact that patrons and architects experience difficulty in gathering information about artists and their work and they recommend that the relevant arts bodies and artist groups be more dynamic in their marketing strategies. Most Regional Arts Associations have registers of artists, or slide indexes but these need to be better promoted with architectural and design firms, to be kept up to date and organised for easier access. The system of a loan slide collection, such as that run by the Crafts Council, should be adopted by other bodies. Regular contacts between architects and artists should be maintained, and information about exhibitions and open studios disseminated to interested bodies. Access to information does not only depend on archives, but also on press and publicity. The Team believes that greater efforts should be made by all those involved in commissioning to encourage appropriate critical assessment by the specialist art and architectural press, and proper accreditation of artist, architect and commissioner when works are publicised.

The most important recommendation of the Art & Architecture Research Team is that commissions should be considered at an early stage of the design process and the cost of the commission should be an integral part of the budget. Many architects pay lip service to these notions but in practice either allow the initial idea to 'fade away during the development of the project' (as mentioned more than once in the survey quoted above) or decide very belatedly that a work of art should be grafted on to a building or interior space. It is essential that architect and client plan for commission(s) at the initial design stage, so that close collaboration can take place between designer and artist to make the work truly site-specific or integral with the architecture, and the cost can be part of the overall budget and not an optional extra. Consultation over the development of a commission needs to be mutual, with the architect as open to suggestions and modifications as the artist is to meeting the requirements of the brief.

Strong consideration should be given to using artists in a broader professional relationship with architectural teams, as special consultants or working within multi-disciplinary teams. This is the approach which is increasingly favoured in the United States and Europe [see Chapters 13 & 14] and it allows architects and planners access to the technical and imaginative skills in which artists have been specially trained.

On the general issue of codes of conduct, it has been the finding of the Team that commissioners are sometimes lax with regard to the organisation of contractual matters and that artists often complete a commission without having signed a contract. The Team recommends very strongly that commissions should not be entered into without proper contractual agreements between all the parties. Related matters on the conduct of competitions, payment to artists, maintenance contracts and so on are contained within the guidelines and are not the subject of separate recommendations.

With regard to education, funding, percentage legislation and planning and legal matters, more detailed recommendations are included in Appendix I, together with statements from the relevant government departments to which they are addressed.

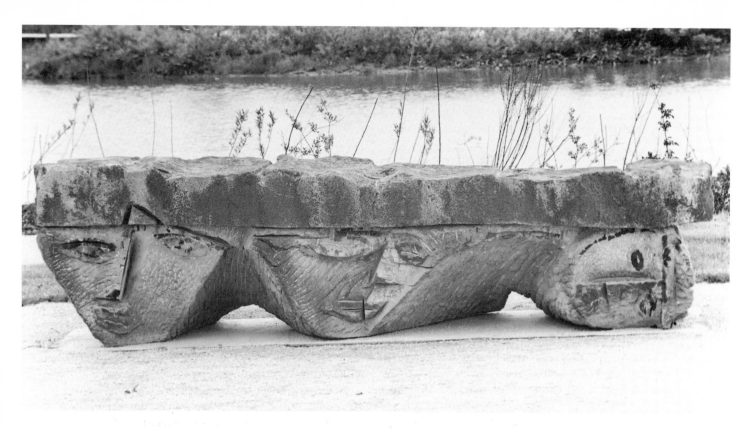

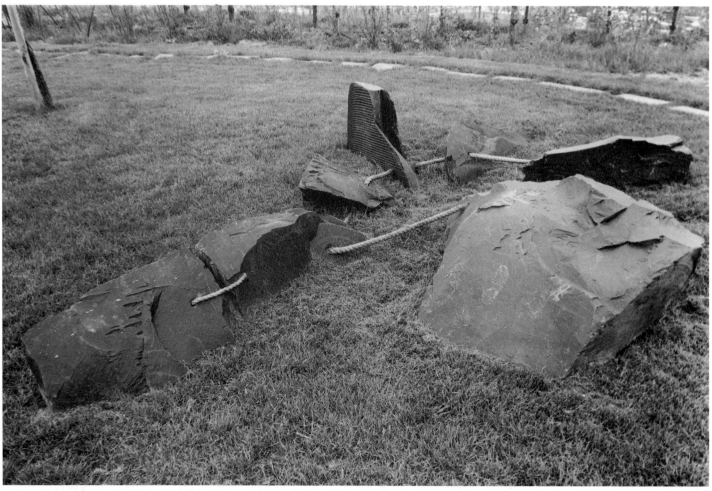

2 Historical perspective

1 The importance of relating art to industry is again the subject of vigorous debate within the Royal College of Art under rector Jocelyn Stevens.
2 Quoted in Peter Davey, *Arts and Crafts Architecture: The Search for Earthly Paradise*, The Architectural Press, London 1980, p.46.
3 Quoted in Ray Watkinson, *William Morris as Designer*, Reinhold Publishing Corporation, New York, 1967, p.72.

The relationship between architects and artists in this country has been a very particular one, mainly because the systems of education and professional institutes of both groups have always been totally independent. This differs from the European model, developed out of the French Beaux Arts system whereby architecture, painting and sculpture were traditionally associated.

Historically, art training in Britain was controlled by the Royal Academy until the foundation of the National Art Training School in 1837, later the Royal College of Art. The debate within art training has consistently been polarised around notions of training 'Fine Artists' through academic studies and studio systems or equipping young people to design for industry.[1] In contrast to this debate, the Architectural Association was set up in 1847 to train the young men articled to Victorian architects, and the first full-time course in architecture was established at Liverpool University in 1894 as the School of Architecture. The influence of the Ecole des Beaux Arts was reflected within both these schools at the turn of the century, with regard to systems of atelier training and the importance of drawing styles, but the teaching of art and architecture remained totally separate disciplines.

Attempts to bridge the gap between the professions, as much during the 19th as the 20th century have therefore centred around extrinsic issues. The predominant issue has been to regard decorative art or industrial design as the meeting ground for artists and architects, often related to an ideology of social relevance. Notions that art can only regain significance by becoming accessible to a wider audience, are as much a part of current debate in the 1980s as they were in the Arts and Crafts Movement, or at other times during the present century. Artists and architects have also been brought together by the predominance of a significant style, which, for example, united practitioners under the blanket of Cubism in the 1930s and Pop and Op Art in the 1960s.

The craftiest collaboration of all

Whatever the peg for the argument, each new manifesto or discussion between artists and architects has been based on a plea for closer collaboration between the professions. This was typified in the late 19th century, under the influence of Ruskin and Morris when a collaboration of art, architecture and design reached a richness and unity of purpose which is now being reconstituted as a possible model for the present. The architect founding members of the St George's Art Society, forerunner of the Art Workers' Guild, for example, decided to open up membership to artists and designers in order to challenge the narrowness and exclusiveness of the Royal Academy and the Royal Institute of British Architects. 'In France, Architects, Painters and Sculptors were trained together in one common school of the Arts . . . The architects of this generation must . . . knock at the door of Art until . . . admitted', replied Norman Shaw to a deputation of his pupils on this subject.[2] 'Any real Art-revival can only be on the lines of the unity of all the aesthetic arts' wrote W.R. Lethaby in his contribution to the committee's report.[3]

Bruce McLean, *Bridgehead/s,* 1983 Derbyshire limestone. Sited at The National Garden Festival, Stoke-on-Trent in 1986.
Photograph: Donald Pittman

Avtarjeet Dhanjal, *Along the Trail* 1986, Slate & rope, length approx. 14m, The National Garden Festival Stoke-on-Trent. Commissioned by the National Garden Festival with support from ACGB, organised by Vivien Lovell
Photograph: Donald Pittman

Recipes for achieving the new collaboration between the arts at this time read uncannily like statements of today. At the first congress in 1888 of the National Association for the Advancement of Art and its Application to Industry, William Emerson, a future President of the Royal Institute of British Architects appealed for architects and sculptors to 'work together in the first concept of designs, and . . . not desire to be independent of each other's view in the carrying out of works.' Henry Wilson, an

4 Both statements quoted in Susan Beattie, *The New Sculpture*, Yale University Press, New Haven and London, 1983, p.55 and pp.59-61.
5 The essay on Art & Socialism appears in Roger Fry, *Vision and Design* 1920, Pelican Edition, 1961 pp.57 & 69.
6 Wyndham Lewis, *The Caliph's Design. Architects. Where Is Your Vortex?* London 1919, p.7.

Arts & Crafts architect wrote: 'It is not enough to have panels to fill and friezes to flounder in; the sculptor ought to be in the very birth of the building and advise on the management of the mass and the distribution of light and shade.'[4]

Lethaby went on to found the Central School of Arts and Crafts in 1896 and his book *Architecture, Mysticism, and Myth* is of significance in that it provided a source-book of architectural symbols for decorative commissions, such as the Tree of Life motif used by Charles Harrison Townesend on the Bishopsgate Institute and the Whitechapel Art Gallery. While artist and critic Roger Fry was opposed to the Art Workers' Guild concepts out of which Lethaby developed, it is relevant that he too believed in the reformist significance of applied arts. 'Ultimately, of course, when art had been purified of its present unreality by a prolonged contact with the crafts, society would gain a new confidence in its collective artistic judgement, and might even boldly assume the responsibility which at present it knows it is unable to face', he wrote in *Art and Socialism*.[5] In the same essay he thundered: 'In Great Britain . . . we cannot get a postage stamp or a penny even respectably designed, much less a public monument. Indeed, the tradition that all public British art shall be crassly mediocre and inexpressive is so firmly rooted that it seems to have almost the prestige of constitutional precedent.' The Omega Workshop which he set up in 1913 was intended to supply a means of livelihood for painters and sculptors, who as well as anonymously designing applied arts from furniture to fabrics, also collaborated on mural schemes and interior projects.

Wyndham Lewis soon broke away from the Omega Workshops to set up the Rebel Art Centre and launch the Vorticist movement. In an angry pamphlet of 1919 he railed at architects for failing to collaborate with artists, whose pent up energies 'must be released and used in the general life of the community'. 'Why does not the Architect . . . why does not this strange absentee, this shadow, this Ghost of the great Trinity, Sculpture, Painting and Architect . . . why does he not cheer us up by Building a New Arena?'[6]

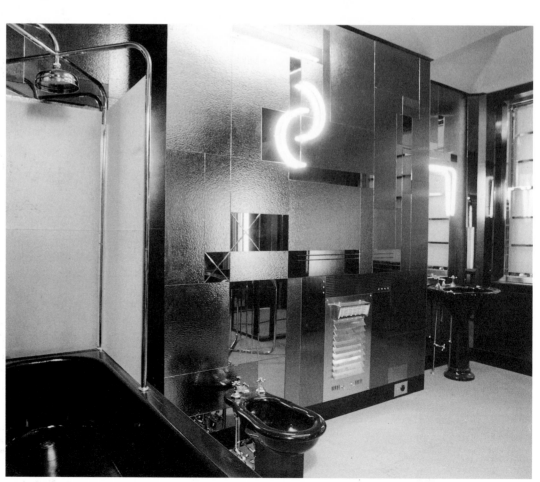

Paul Nash, Reconstruction of *Tilly Losch's Bathroom*, 1932, Commissioned by Edward James
Photograph: Michael Duffet, by courtesy of the Tate Gallery

Plate 3

Art for a new public

Dhruva Mistry, *Sitting Bull*, 1984.
Concrete and paint, Liverpool Garden
Festival, 1984, 2.44 x 3.35 x 2.90m.
Commissioned by Merseyside
Development Corporation and
Merseyside County Council with the
support of the Arts Council of Great
Britain
Photograph: John Mills by courtesy of
Merseyside Development Corporation

Sue Ridge, 1983, mural for
underground car park, Rome
headquarters of Jacarossi Agip,
eggshell paint, 2.4 x 50m.
Designers: DEGW Commissioned by
Jacarossi Agip
Photograph: by courtesy of Jacarossi Agip

Stephen Cox, *Palanzana* 1983-4, Peperino Stone, ht. 3.05m,
Liverpool Garden Festival 1984. Commissioned by
Merseyside Development Corporation and Merseyside
County Council with the support of the Arts Council of Great
Britain
Photograph: Stephen Cox

Plate 4

Art in the work place

Kenneth Martin, *Screw Mobile,* 1983, 6.10 x 7.62m, stainless steel, Victoria Plaza, Buckingham Palace Road, London. Architects: Elsom Pack Roberts & Partners. Commissioned by Greycoat Group plc
Photograph: Crispin Boyle Photography by courtesy of Greycoat Group plc

Guiseppe Lund, Gates 1984, forged steel with galvanised zinc finish, ht. 7.62m. Victoria Plaza, Buckingham Palace Road, London. Architects: Elsom Pack Roberts & Partners. Commissioned by Greycoats Group plc
Photograph: Richard Bryant by courtesy of Public Art Development Trust

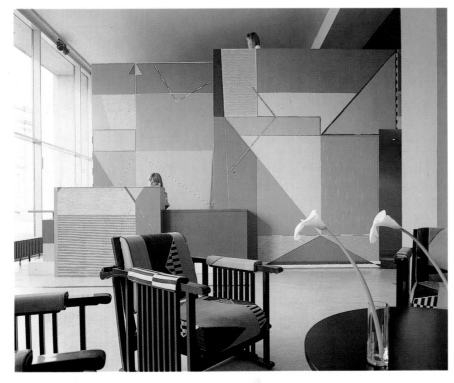

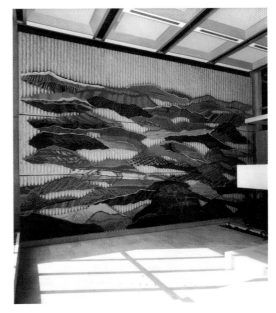

Sally Greaves Lord, 1984, ground floor reception at Research Recordings, Hawley Crescent, Camden, London. Architects: Pierre D'Avoine of Powell-Tuck, Connor, Drefelt & Davoine Partnership. Commissioned by Research Records.
Photograph: Richard Bryant

Samantha Ainsley, 1982-3, Tapestry, 5.18 x 9.14m. Main entrance hall, Head Office, Pitheavlis, Perth. Architects: James Parr & Partners
Photograph: by courtesy of James Parr & Partners

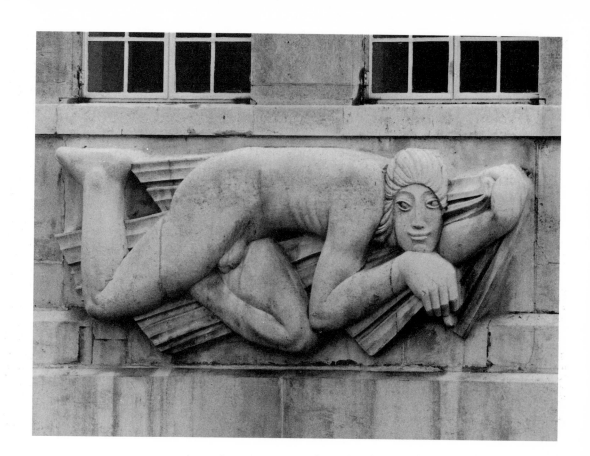

Eric Gill, *East Wind* 1928/9, Portland Stone 2.44m length, sited on west wing of Broadway House, London. Commissioned by The Underground Electric Railway Company
Photograph: by courtesy of London Regional Transport

Bauhaus and the new unity

British attempts to establish a dialogue between art and architecture have been consistently cross-fertilised from Europe. Gropius (who acknowledged his debt to the Arts & Crafts Movement) called for a unification of the arts within architecture in the 1919 Bauhaus Manifesto: 'The complete building is the final aim of the visual arts. Their noblest function was once the decoration of buildings. They were inseparable parts of the great art of building. Today they exist in isolation, from which they can be rescued only through the conscious, co-operative efforts of all craftsmen. Architects, painters and sculptors must recognise anew the composite character of a building as an entity. Only then will their work be imbued with the architectonic spirit which it has lost as 'salon art'.[7] The Bauhaus as such never actually took root in England, but Modernism won the day, eventually leading to the establishment of Industrial Art as an independent field appropriate to express Bauhaus concepts of 'cultural unity'. The 1930s were a period when artists and architects had the freedom and confidence to experiment with many forms of applied art and design in a way which the demarcation of professional fields has since precluded. Paul Nash's bathroom for Tilly Losch in 1932, Moholy-Nagy's shop window displays, Wells Coates' Ekco Wireless in Bakelite, designed in 1934 are just a few examples of this versatility. Apart from the exuberance of Art Deco cinemas and factories, enlivening the urban environment with colour and plaster excess, sculptures were also being commissioned in a more traditional manner.

A controversial series of architectural commissions in 1928-9 were the reliefs for Broadway House, the Head Offices of the Underground Railways (later London Transport). These commissions were as much the idea of the architect Charles Holden as a response to the progressive artistic patronage of Frank Pick, Chief Executive of London Passenger Transport Board, and Chairman of the Council for Art and Industry who employed artists and architects at all levels of design and advertising during the late 1920s and 30s. Holden who had commissioned Epstein years earlier for the sculptures for the BMA Headquarters in the Strand (later mutilated) also commissioned the experienced Eric Gill, and five young sculptors including Henry Moore to produce reliefs symbolising the four winds.

7 *Bauhaus*, Institute for Foreign Cultural Relations, Stuttgart 1975, p.13.

Le Corbusier and disunity

Art and design were exhibited together under the title of *Unit One* in 1934, as a strategy 'in the forward thrust of modernism.'[8]. Nevertheless the unconscious schism between artists and architects is already present in the peak document of 'international' modernism in Britain, *Circle* published in 1937, edited by J L Richards, Ben Nicholson, and Naum Gabo. Le Corbusier's contribution, The Quarrel with Realism: The Destiny of Painting, is so arrogant, and has so unquestioningly dominated architectural thinking about the visual arts for many generations, that it deserves to be summarised and quoted at some length.

He begins by asserting that the world is dominated by images. 'Is not therefore a great part of the tasks of painting accomplished? Thus, in this era of construction, it is architecture which concerns us most . . . I speak here of a certain quality in pictorial and plastic art which alone has the right to intervene in the great architectural symphony of the new era'

'Let me – as an architect – affirm this: architecture is an event in itself. It can exist quite independently. It has no need either of sculpture or of painting.'

'It has been customary . . . to assert that our houses require art and artists. Some would like to see a dining room decorated with a basket of fruit, painted, or carved on a beam. I think that a good leg of mutton on the table would supply this want better . . . The house requires a lot of other things more urgently.'

'Such an art [as collaboration with architecture] requires elevation of character and of temperament. Who is ready for this immediate task? Excuse me if I speak frankly . . . I love walls beautifully proportioned and I dread to see them given over to minds unprepared. For, if a wall is spoilt, if it is soiled, if the clear, sane language of the architecture is ruined by the introduction of inappropriate painting or sculpture, if the artist is unable to enter into its spirit or goes against its spirit, it is like so many crimes of deceit.'

In addition to 'architectural polychromy' Le Corbusier declares that art and architecture can only collaborate within the 'universality' of cubism. With regard to sculpture he warns: 'The architect can arrange his plans with the desire . . . of introducing the note of plastic lyricism . . . But there is always the danger of the dualism of two plastic arts out of tune with one another . . . restraint is necessary, special qualities of monumentalism and careful preparation.'[9]

Notions of genius

In this statement Le Corbusier firmly established the doctrine that the visual arts were not only subservient to architecture, but could only be tolerated subject to very strict controls. These notions were entirely in line with his view of the architect as a figure of genius capable of solving all the social ills of society. Le Corbusier's influence on British architectural training was immense during the 1940s, 50s, and 60s and is still strongly ingrained in an older generation of practising architects. The corollary to this attitude were the generations of artists with an equally strong belief in the sacrosant nature of their own practice, and refusal to compromise it in any collaborative exercise.

Rigid models

The two possibilities of using art mentioned by Le Corbusier, the geometric mural, formulated in relation to Leger and Ozenfant and the 'note of plastic lyricism' had already been prefigured in the Bauhaus. Although magnificient collaborative projects like the 1921 Sommerfeld House in Berlin by Walter Gropius and Adolf Meyer with Joost Schmidt and the Bauhaus workshops had fulfilled Bauhaus ideals, they were the exception. The model for placing sculpture in relation to architecture was defined by Mies van der Rohe in the German Pavilion for the World fair at Barcelona in 1929. In

8 Wrote Herbert Read in the catalogue to the first exhibition: '. . . the aims of the Unit are strategical; to form a point in the forward thrust of modernism in architecture, painting and sculpture, and to harden this point in the fires of criticism. *Unit One: Spirit of the 30s*, Catalogue, The Mayor Gallery, 1984.
9 *Circle: International Survey of Constructive Art*, Edited J L Richards, Ben Nicholson, N. Gabo. 1937 (Reprinted Faber & Faber 1971) pp.65-73. With contributions from Mondrian, Herbert Read, Lewis Mumford and others, the manifesto was intended to express the unity of the constructivist principle in the arts, and the dominance of the machine aesthetic.

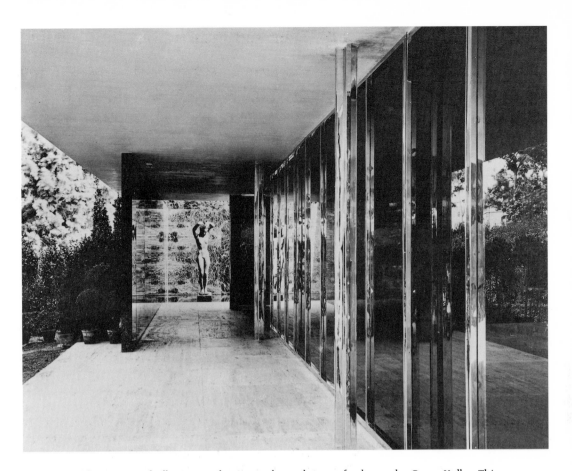

the courtyard were two shallow water basins and a sculpture of a dancer by Georg Kolbe. This concept of a small-scale figurative sculpture in relation to a pure disposition of geometric volumes has sustained itself in the architectural canons of international modernism to this day. Its descendants are the American plaza sculptures, where the human limbs have become geometricised in sympathy with the architecture, but the sculpture continues to work as an arabesque or counter-movement to the severity of the architectural backdrop. These two models are still unquestioned as the *sine qua non* of siting art works by many contemporary architects, however much they might have moved away from the International Style in their own design practice.

10 'Henry Moore, Jacob Epstein, Barbara Hepworth, Keith Vaughan, Victor Pasmore, Ben Nicholson, John Minton, Feliks Topolski, Frank Dobson, Graham Sutherland, John Piper, Reg Butler and some twenty other artists carved, modelled and painted in complete unison with the architects who ensured that walls were available for murals and plinths for sculpture.' Misha Black, Architecture, Art and Design in Union, in *A Tonic to the Nation: The Festival of Britain 1951*, Edited Mary Banham and Bevis Hillier, Thames and Hudson, 1975.
11 Nursery conceits pervaded from Emmet's Railway and the John Piper and Osbert Lancaster designs for the Grand Vista in Battersea Gardens, to the plaster casts out of Teniel's Alice in Wonderland in the Lion & Unicorn pavilion on the South Bank. It is interesting that at the recent Liverpool Garden Festival the chance to display site-specific art works was similarly overwhelmed by Luna Park whimsy.
12 Artist Richard Hamilton wrote (ten years after the festival): 'The Festival was an elegantly prepared platform from which to jump into a newly designed future – unfortunately the leap found us just where we were.'
13 Henry Moore: *Sculpture and Drawings since 1948*, Volume 2, Percy Lund, Humphries & Co Ltd, London 1955 pp.xii and xiv.

The Festival style

The Festival of Britain of 1951 was an attempt to move away from rigidly formulated models of collaboration and bring back artists into building again. Organised by architects, designers and engineers rather than administrators, there were two objectives according to Misha Black: 'The first was to demonstrate the quality of modern architecture and town planning; the second to show that painters and sculptors could work with architects, landscape architects and exhibition designers to produce an aesthetic unity . . . Practically every concourse was designed to contain a major work; each building was a sanctuary for important works of art.'[10] One of the most successful works was Victor Pasmore's ceramic mural outside the Regatta Restaurant designed by Jane Drew, and the Design Research Unit. Subsequently, Pasmore worked for a period of nearly twenty years as consultant to the architects of Peterlee New Town, and had a considerable influence on design and landscaping.

Unfortunately, the overall impression of the Festival was of whimsy,[11] and the commissioning of art in the great public building boom of the 50s and 60s was a return to narrower and more sober systems of collaboration.[12]

Victor Pasmore, *Sunny Blunts Pavilion,* 1968, Peterlee New Town
Photograph: by courtesy of Architectural Review

Landscape, fantasy and reality

In 1952 Henry Moore was commissioned by the architect Rosenhauer to design a functional screen for the Time-Life Building in Bond Street, and the work remains the most architecturally integrated of all Moore's commissions. The typical reclining figures or abstract bronzes which he has produced in great numbers for major international sites, under the auspices of the British Council, are normally detached from the architectural context. Herbert Read determined the aesthetic context of Moore's commissions in 1955 when he wrote: 'A great work of art . . . only yields its essence to an act of contemplation – an act that is impossible in a busy thoroughfare. It has some chance of recognition in a park or garden: but attention is best induced when it stands dramatically isolated in a landscape.' Moore had stated in 1951, 'I would rather have a piece of my sculpture put in a landscape, almost any landscape, than in, or on, the most beautiful building I know.'[13] Moore's landscape aesthetic has been very influential in Britain, not least in the Battersea Park open-air sculpture shows of 1948 and 1951 and the follow-up exhibitions. The tradition persists in the Sculpture Parks which have recently been established in Grizedale Forest, Yorkshire, Portland Bill and in Scotland and Wales.

Henry Moore, *Time Life Screen,* 1952, Maquette for Time-Life Building, Bond Street, London, bronze, 0.38m x 1.00m
Photograph: by courtesy of Henry Moore Foundation

In contrast to this, artists and architects engaged in an imaginative urban collaboration in the *This is Tomorrow* exhibition at the Whitechapel Art Gallery in 1956. Thirty-six artists and architects were divided into twelve teams and produced a riot of new ideas which proved to have a lasting effect on art and architectural theory if not on future practice. Richard Hamilton's collage *Just what is it that makes today's homes so different, so appealing,* became one of the founding icons of the Pop Art movement. The collaborative exercise also influenced the development of *Archigram,* a body of architects grouped around Peter Cook who were to emerge with fantasy ideas, exhibitions and publications in the next decade, including the notion of the *Plug in City.*

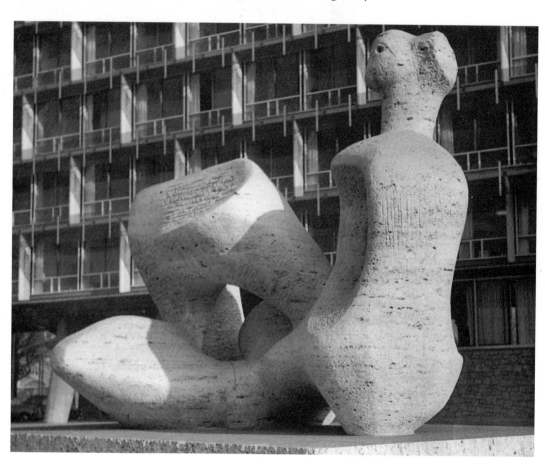

Henry Moore, *Reclining Figure 1957/8,* Travertine stone, 2.74 x 5.08m. Sited outside the UNESCO building, Paris.
Photograph: by courtesy of Henry Moore Foundation

14 Advice on commissioning came from the Art Panel of the Arts Council, (Nicholas Pevsner, William Coldstream and Henry Moore were on the panel in the early 1960s). Some of the artists commissioned at the time were Robyn Denny, Victor Pasmore, Francis Carr, Franta Belsky, Robert Clatworthy and Frank Dobson, and professional 'architectural' artists like Anthony Holloway and George Mitchell.

15 J M Richards, Patrons Sculpture and Buildings, in the *Design and Industries Association Yearbook*, 1962, pp.22-29. As this seems rather an obscure publication to launch the notion of the 'brooch on the wall' which had such wide currency, one must assume that Richards publicised the ideas elsewhere.

16 John Willet, *Art in a City*, Methuen, London, 1967. This developed from a report to the Bluecoat Society of Arts in 1965 and was commissioned with a grant from the Calouste Gulbenkian Foundation. Willet recommended five goals for improving the city, and the appointment of a Public Art Adviser 'to make a plan for the use of works of art in conjunction with any new schemes for building development, housing, street furniture and open spaces . . . Works . . . would as a rule best be FINANCED by adding up to 2 percent to building costs.' p.242.

Art for the Polys

Following the public interest aroused by the rebuilding of Coventry Cathedral and its commissioned art works, and later Liverpool Cathedral, the late 1950s and 1960s saw a proliferation of architectural and public commissions. These were mainly in relation to the new polytechnics and universities, the new towns like Peterlee and Harlow and Cumbernauld, and the massive public housing schemes of the building boom. By 1961, the London County Council had already commissioned 51 works, and 18 sites were ready for sculptures (sited in playgrounds, terraces, courtyards, entrances) or sculptural reliefs and mosaics.[14] 'Integrated architectural reliefs', became increasingly popular in response to stern strictures from critics like the redoubtable J M Richards about sculptures pinned to walls like 'costume jewelry'. The technical nature of steel and concrete skeletons makes it difficult for the sculptor to recapture immediacy . . . although . . . there are possibilities in the way of designs and patterns in relief imposed on wall surfaces through sculptural manipulation of the form-work.' However '. . . an admirable example . . . of using works of sculpture in relation to modern buildings [is] simply to place them in front, using the impersonal, repetitive rhythms of modern architecture to set off, with the maximum contrast, the free baroque forms of the sculpture.'[15]

John Willet followed the same orthodoxy when he wrote his report on Liverpool, *Art in a City* in 1967, but with a sharp eye for architectural self-deceptions. 'Too much of the "built-in" decoration on recent buildings – the Liverpool Building Centre is a characteristic example – is a humdrum regurgitation of modern art conventions which has no real identity of its own and could date disastrously as soon as the fashion supporting it has collapsed. Certainly the architect's assumed primacy in this field is subject to more qualifications than he normally admits.'[16]

The grey concrete reliefs, the 'brooches on the wall', and the dismally-sited bronzes of the period however, had a marked effect on artists, many of whom scornfully rejected the notion of working to

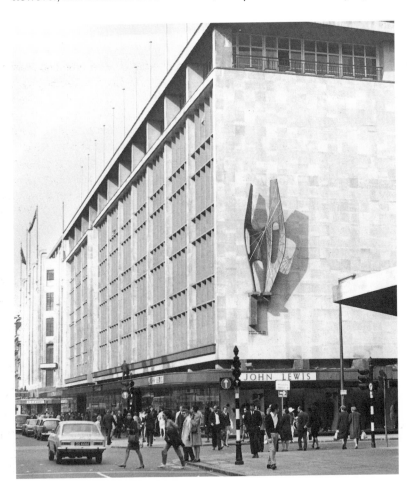

Barbara Hepworth, *Winged Figure 1962*, Aluminium, ht. 5.87m **Commissioned by John Lewis**
Photograph: by courtesy of John Lewis Partnership

Geoffrey Clarke, *The Spirit of Electricity 1958*, Cast bronze, ht. 24.4m Thorn House, London
Photograph: by courtesy of Thorn EMI

George Mitchell, *Marble Arch Subway,* Commissioned by London County Council
Photograph: by courtesy of the London Residuary Body and the Greater London Records office

17 An awareness of this contradiction was revealed by Richard Hamilton in an interview in 1966. Hamilton, who had been instrumental in establishing influential basic design courses at the Central school and later at Newcastle-upon-Tyne, said in relation to the School of Environmental Design at Ulm: 'What puzzles me . . . is that it was initiated by artists – Maldonado, Bill and others, who . . . came from the world of modern abstraction, and then the principle was adopted that fine art would have no place in their school of environmental design.' Richard Hamilton, *Collected Words 1953-1982*, Thames & Hudson, p.180.
18 David Thorpe, *Town Artist Report*, unpublished and undated report of the Scottish Arts Council.

commission. By a quirk of history, this was the period when basic design courses were being taught in British art schools. Based on systems developed at Ulm, these courses sought to bridge the gap between traditional fine art practices and design within the realm of abstraction and geometry. Similar courses were being taught at the architectural schools, but educational establishments persisted in their traditional isolation.[17]

Art in the City

John Willet's report on Liverpool contained clear recommendations for an arts policy for the city and the appointing of a public arts adviser. In 1968 David Harding took up a post at Glenrothes as the first Town Artist, not as a designer as Pasmore had been at Peterlee, but as a catalyst 'working with the townscape',[18] influencing planning and working closely with the architects' department. He was followed by a series of Town Artists working in Scottish New Towns like Livingstone and East Kilbride. A primary consideration of Town Artists was to establish close links with the community, and they assumed some of the methodology and concerns of the Community Art movement which was gaining credibility during this period. The International Mural movement, which had been sparked by the 1967 *Wall of Respect* in Chicago also found its adherents in Britain during the 1970s, ranging from the architectonic wall decorations of Tim Armstrong and Stan Bell in Glasgow, to the agitprop murals

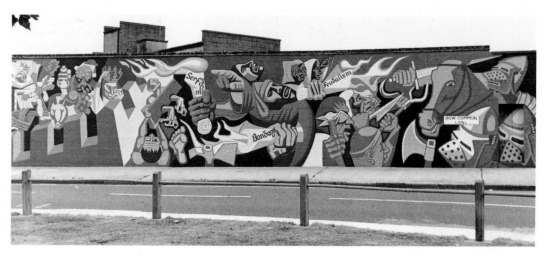

Ray Walker, Mick Jones, *Peasant's Revolt*, 1982, Mural, 3 x 9.75m , Bow Common, London, Commissioned by London Borough of Tower Hamlets. Funded by Tower Hamlets with support from GLA, GLC.
Photograph: David Hoffmann

of Brian Barnes and Ray Walker in London. The exhibition of photographs of murals, *Painting the Town* organised by Graham Cooper and Doug Sargent in the late 1970s toured for many years, and had a wide effect in popularising the movement.

In 1972 the Arnolfini in association with the Peter Stuyvesant Foundation organised the *City Sculpture Project* whereby a number of sculptors were commissioned to produce works for specific sites in different cities. Works were to be placed for a minimum period of six months, in the hope that they would be acquired by local authorities and permanently sited. In the event, not all the artists were able to rise to the challenge, some works were vandalised and very few found permanent homes. Nevertheless it was an ambitious project which had far-reaching consequences. It centred the debate on site-specificity, which had been given little emphasis within art-school training for decades, and, even more importantly, on the issues of the importance of robust materials for outdoor sites.[19]

In 1974, 1977 and 1980 the series of exhibitions entitled *Art Into Landscape* were mounted at the Serpentine Gallery in London in association with RIBA and the Landscape Institute. The first exhibition invited contributions from professionals and non-professionals to transform neglected sites across the country, while in the following projects, briefs of existing problem sites were offered for imaginative solutions. It was hoped that the local authorities selected would implement the best schemes but, like the Stuyvesant Project, the response was disappointing. The setting up of the Arts Council's Art in Public Places scheme in 1977 has proved far more successful in stimulating projects and attracting outside investment in public and architectural commissions.

Responses to the *Art into Landscape* briefs from artists and architects alike reflected a further strand which has enriched the recent public art dialogue. This has been the interest in site-specific landworks which developed in the United States in the late 1960s and 1970s in the work of Michael Heizer, Robert Smithson and Robert Morris amongst others. In their desire to move out of the galleries and make a more publicly accessible art, these artists have constructed large-scale and sometimes temporary structures in the landscape, working in an area somewhere between built form and sculpture. Their influence in this country has been two-fold; on the one hand, the archaizing aspects of their work, with references to neolithic structures and myth has found a welcome reception within the British predisposition for romantic primitivism. On the other hand it has provided a vocabulary for hard and soft landscape forms which can readily be adapted to urban situations, and has increased awareness of site-specificity and the 'quality of place'.

The growing need for a forum for debate between artists and architects resulted in the *Art and Architecture Conference* at the ICA in 1982. The prophets – and critics – of the New Collaboration assembled to try and establish a critical base for the movement. What emerged was a reflection of the complex issues surrounding the whole subject, and the impossibility of energising people around a simple notion in an age of sophisticated pluralism. The debate exists but the solutions are multifarious. As Lawrence Scully has put it, 'The feeling is of a new freedom but not of a new salvation.'[20]

19 Theo Crosby noted in a special issue of *Studio International* on the project: 'In the recent attempts to introduce sculptures into the surroundings of the Hayward Gallery, a large work in glass fibre by Francis Morland lasted a week, in spite of being propped nightly. Nicholas Munro's fibre-glass boats were linked together with chains, yet one was tossed overboard within a fortnight. Neville Boden's painted sculpture had to be wheeled back into the gallery nightly. The only work to stand the stress was Bernard Schottlander's large steel piece which required to be re-painted only twice in the six months it was outside the gallery. Experience with the first Stuyvesant pieces shows a similar experience.' Theo Crosby, A Kind of Urban Furniture, *Studio International*, July/August 1972. pp.45-47.
20 *Collaboration: Artists & Architects*, Edited Barbara Diamonstein, The Architectural League, Whitney Library of Design, New York 1981.

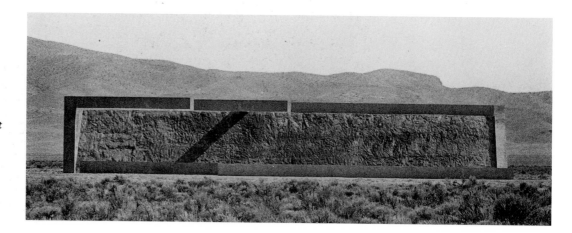

Grandiose earthworks like Michael Heizer's Complex One/City in Nevada have never been realised in Britain but have had an influence on more modest environmental pieces and sculptural earthworks

Michael Heizer, *Complex One/City*, 1972/6, Concrete, granite and earth, 33.52 x 42.67 x 2.74m, Near Hiko, Nevada, USA.

Photograph: Gianfranco Gorgoni

The City Sculpture Project

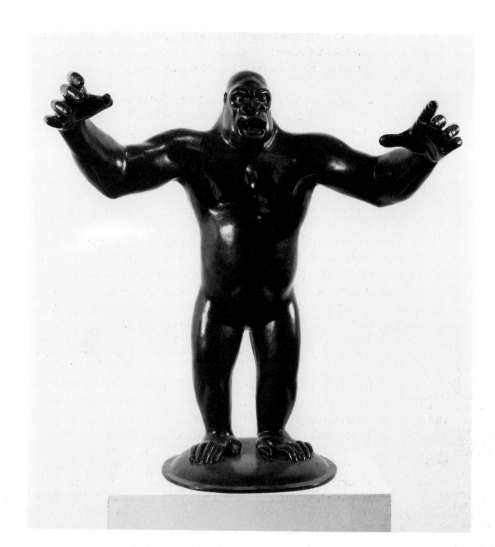

Nicholas Monro, *King Kong 1972*, Reinforced fibre glass, ht 5.5m. First sited Manzoni Gardens, Birmingham, Commissioned by and part of the Peter Stuyvesant Foundation City Sculpture Project, 1972
Photograph: by courtesy of Arnolfini Gallery, Bristol

Bernard Shottlander, *Sculpture 1972*, Paint on steel plate, 6 x 5 x 2m, first sited opposite the Crucible Theatre, Sheffield. Commissioned by and part of the Peter Stuyvesant Foundation City Sculpture Project, 1972
Photograph: by courtesy of Arnolfini Gallery, Bristol

SECTION 2
Art in architecture

Kevin Atherton took great care to make his peace sculpture Pond Reflection *vandal proof by firmly rooting it to the base. The reflection in the pond is cast bronze.*

Kevin Atherton, *Pond Reflection,* Life-size bronze, 1985, Elthorne Park, North London Commissioned by Islington Council with the support of GLAA, ACGB, & M J Cagney (Civil Engineering) Ltd.
Photograph: Sue Ormerod, by courtesy of the Public Art Development Trust

3 Refurbishment of Unilever House, London

Peter Coles

This scheme demonstrates how contemporary works of art and craft can enliven a 'period' reconstruction of a listed building in a vigorous but historicist manner. Most of the commissions were carried out to the architect's designs, but independent pieces were also commissioned and the building houses an important collection of contemporary art.

Background

1 Quotations from Theo Crosby come variously from: Theo Crosby, *Unilever House: Towards a New Ornament*, Pentagram Papers No 9 1984 and Theo Crosby, Untitled manuscript, February 1984.

Unilever House, headquarters of the giant multinational, situated near Blackfriars Bridge, London, was designed in the 1920's by J. Lomax Simpson with Sir John Burnett, Tait and Lorne. It shows the influence of the Modern Movement and Art Deco style and is in Portland Stone, with a tall rusticated base, fourteen Ionic columns, and a blank eighth floor attic. The original building incorporated sculptures by Sir William Reid Dick, who also made the keystones with their low relief heads.

In the 1970's a project to demolish and erect a new building was abandoned and it was decided to build a new wing to the north (designed by Fitzroy Robinson and Partners), to re-orient the entrance to the north east and to re–service the building completely.

In the refurbishment contract, Theo Crosby of Pentagram Design Ltd proposed 'to accept and restore the original elements of ornament and decoration wherever possible, to understand and extend this language and also to enrich it with the work of modern artists and craftsmen.'[1]

Exterior commissions

Because Unilever House is a Grade II listed building, proposals affecting the exterior and the entrance hall required Listed Building Consent and were referred to the GLC Historic Buildings Committee, the City of London Corporation, and the City Architect. Part of

Main entrance hall of *Unilever House*, Blackfriars, London. On the left is the decorated glass wall by Diane Radford and Lindsay Ball. The timber relief on the right by Benin artist, Chief Emokpae, is a gift to Unilever from United African International
Photograph: by courtesy of Pentagram

the refurbishment programme involved conversion of the attic to a directors' suite, thereby considerably changing the appearance of the building. The solution finally accepted by the GLC involved extending the windows of the lower floors upwards, using the same proportions and bronze spandrel panels, and setting a sculpture above each column to emphasise the verticality of the facade.

External Sculpture

Sculptor Nicholas Monro was commissioned to produce seven maquettes which were to be repeated to produce 14 sculptures, each 4.5 metres high. In the end only three models were completed, representing English, Nigerian and Japanese girls. Alternate spaces were filled in by adaptations of the existing stone vases that decorate the top of the building. The figures were made of glass reinforced plastic on stainless steel armatures, by Edwin Russell and David Gillespie Associates from Monro's designs, and were installed in one day.

In order to focus attention on the new main entrance in the north front, an arched opening was cut to receive the bronze gates from the south entrance. Bernard Sindall was commissioned to produce a 'festive' gilt sculpture which was placed in the arch,

Nicholas Monro, Cornice sculptures, *English, Nigerian and Japanese girls.* Glass-reinforced plastic on steel armature. Ht 4m.
Photograph: by courtesy of Pentagram

and was intended to follow the formal style of the sculpture from the original building. The work is cast in bronze-coloured resin and gilded, and represents Ceres with the horn of plenty, framed in a floral wreath; it celebrates the image of Unilever as an 'all-provider'. A bronze and gilt name and sunburst was placed in the pediment, after a sculptural group was refused planning permission, although Theo Crosby feels this entrance 'lacks authority and style'. Listed Building consent was also refused by the GLC for the proposed iron work screen intended to mask the entrance in the south facade. Instead, the scale of the main entrance arch, now part of a dining room was reduced by the introduction of an iron screen made by Richard Quinnell to Theo Crosby's designs.

Interior

The full exuberance of Theo Crosby's scheme is to be found in the interior, where the craftwork has been integrated on an impressive scale. Most of the decorative work is to be found in the entrance hall, the various restaurants and conference rooms, and the lifts. The main entrance hall positively seethes with decorative glass, travertine marble and plaster, augmented by a collection of art and craft gifts from Unilever subsidiaries around the world. The giddy scale of ornament makes it sometimes hard to focus on any element. Many of the contemporary designs have origins in patterns found in the original decorations, or are based loosely on a trellis theme, which Theo Crosby felt would 'provide a play of space, of something beyond the immediate surface'. Elsewhere, accent is provided by art works from a collection assembled by the Contemporary Art Society.

Art and craft commissions

Many of the ornamental details appearing throughout the building – plasterwork, floors, woodwork, and light fittings were carried out by specialist contractors working from Theo Crosby's designs. The materials are generally those of the original building and existing fittings were re-used wherever possible.

In addition a number of artists and craftspeople worked on specific commissions. Diane Radford and Lindsay Ball made the etched glass screens with complex trellis motifs in the waiting area, lifts, conference area concourse, and the eighth floor. Bernard Sindall completed several items around the building – particularly a relief for the vault of the visitors restaurant, the reliefs on the east lifts, the Unilever Jubilee and Commemorative medals. Artists Gillian Wise and John Dugger were each commissioned to produce set pieces for the conference foyer.

Gifts from Unilever subsidiaries

The lavishness of the interior owes much to sponsored commissions and gifts from Unilever world-wide subsidiaries. In some cases, commissions

were guided by the architect, such as the stained
glass for the east entrance windows, a gift of the
German company. Similarly, Ronald Tolman was
commissioned to make a sculpture for a space
prepared in the main entrance, a gift from the Dutch
company. A carved timber relief by Chief Erhabor
Emokpae of Benin dominates the entrance lobby,
depicting Lord Leverhulme's African travels and
enterprises (with a gentle jibe at the colonial image if
one looks closely).

The conference area is one of the well-used parts of
the building and has become the main receptacle for
company gifts. Each room has a regional character:
the cinema is lined with Nigerian cloth, there is a
Scandinavian wood relief in another room, the foyer
uses the trellis motif, with the columns cased in
decorative glass and the walls covered with stained
oak and a traditional indigo batik cloth produced by
Unilever in Holland. Scattered throughout the
building is a collection of ethnic textiles, partly
selected by Theo Crosby.

Fine art collection

With an initial budget of about £25,000 per annum,
the Contemporary Art Society was asked to purchase
art works by young British artists, both to
complement the decorative scheme and to extend it
into parts of the building not affected by the
refurbishment. The CAS purchaser, Lady Beaumont,
had a free hand to purchase works up to a limit of
£1,000 each (£600 in the first year), above which she
needed the approval of two directors. Her purchases
were reviewed every three months by an art
committee which included Theo Crosby and Director
Cob Stenham.

This collection was built up over three to four years
and is still being added to, even though CAS is no
longer involved. There is an eclectic mix of British art,
Unilever memorabilia, 19th century river-views and
textiles, making a total of over 250 items. Some of the
art has proved controversial; in other cases, despite a
policy of change, works have been permanently
appropriated for their offices by staff and directors.

Recently an outside expert has been commissioned
to re-hang the collection. This procedure may be
adopted on an annual basis and is facilitated by the
'art store', a special room for works not on
permanent show, like the growing collection of staff
photographs.

Selection procedures

Decisions relating to art and craft work (including
what might be termed 'artisan' execution of some of
Theo Crosby's designs) were made by him in close
consultation with Unilever's client management
team, headed by the chief architect and project
controller. Theo Crosby chose craftspeople with
whom he had previously worked: 'Every architect has
to have a team of people he is used to working with.
This is positively beneficial, otherwise you are
constantly working from scratch, initiating people
into the intricacies of working to contract.' The artist
commissions were similarly made on the basis of the
architect's suggestions, with approval from the client
management team, following a visit to the artist's
studio to assess their work. Once the site had been
identified and an artist engaged, the work had to be
closely co-ordinated with the various contractors.

**Judy Clark, Decorated column, Main
staff dining room.**
Photograph: by courtesy of Pentagram

Contracts and finance

Artists and craftspeople were employed directly by
the client. In the case of Nicholas Monro, a contract
was drawn up, but all the other commissions were
confirmed by letters of instruction with a note of the
agreed fee.

The total budget for refurbishment was £25 millions.
With regard to the interior design budget, established
three years before Pentagram were involved, the
entrance hall cost more than anticipated, but the
architects claim to have completed within budget.

Nicholas Monro was paid a fee of £10,000 to produce
the 7 maquettes for the parapet sculptures and a
further £15,000 and free studio space for making the
life-sized models (which were never completed). All
material and installation costs were borne by the
clients.

The art collection was started with an initial budget of
£50,000 made available to the CAS. This was not part
of the refurbishment contract. Currently between
£10,000 and £20,000 is allocated for new purchases
every year.

Comments

In this project, it is sometimes difficult to know who is
the artist and who is the architect. Pentagram's
approach was autocratic (as least compared with
competitions and committee decisions made in other
art and architecture projects) with Theo Crosby
directly engaging craftspeople and artists. In the case
of the cornice statues, by Nicholas Monro, the
departure of the final product from the original
proposals was a disappointment to the architect.

It proved difficult to negotiate the radical re-analysis
of the entire building through the various planning
committees, and two major projects were refused
permission. (For example, the proposal to build a
spire in the centre of the facade to house an air
conditioning plant was refused on the advice of the
Surveyor of St Paul's on the grounds that it would
obstruct the view from Waterloo Bridge)
Commitment to the architectural spirit of the existing
building, however, was a positive factor when the
proposals went before the GLC Historic Buildings
Committee.

The project continues the tradition of art and crafts
involvement of the 1930's and Theo Crosby suggests
that 'This kind of complex interior can be made
today, by much the same process and people as in
the past and it is financially viable. It is a question of
will.'

4 Craft commissions at Oriel House, London

Timothy Ostler

This development is distinguished by a varied but consistent series of craft commissions, integrated into the design from an early stage by the architects who work regularly with artists and craftspeople.

Background

Oriel House, at 16 Connaught Place, London W1, is a good example of the way that successfully integrated works of craft can give an air of quality to an entire development. The property agents and managers for the scheme, Chestertons, believe that, 'The most important thing in letting a building . . . is the first impression'. The impression here, thanks to external ironwork by Jim Horrobin, and Terence Clark and incised lettering by David Kindersley, is one of solidity and attention to detail, reinforced on entering the foyer where there are further craft works. Believing that signs of care such as these increase the prospect of attracting a high rent, the agents have featured the craft works in the building prominently in their marketing.

Whitfield Partners, architects for the scheme, are among those architectural practices who most

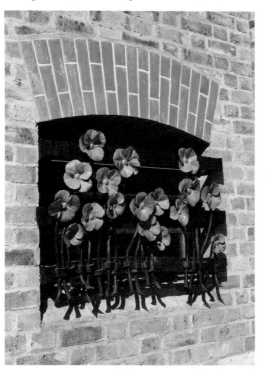

Terry Clark, *Poppy Grille*, 1983, mild steel 0.69 x 1.02m, Oriel House, London. Architects: Whitfield Partners. Commissioned and funded by Church Commissioners.
Photograph: Nicholas Mackenzie, by courtesy of Whitfield Partners

regularly commission art and craft work in their buildings, mostly for corporate or governmental clients. They feel strongly that art increases the prestige and lettability of an office scheme. But they also point out that site-specific work costs the same as buying original work, with the advantage of an integrated architectural approach.

It would appear, that crafts are perhaps more readily integrated into the building process than fine art. However, says David Lyle, partner in charge of the project, 'I think it's actually more difficult for architects to commission or consider commissioning craftsmen rather than artists because to a certain extent a painting, or sculpture, is identifiably different. But a work of craft – a railing, or carpet, or table, is materially part of the building and part of that bit that the architect wants to hold on to for himself.'

The craft programme

Following the decision to incorporate art and craft works, the craftspeople were brought in at detail design stage. For instance, the main access to the building unavoidably takes the visitor past the service yard, necessitating screening of high quality to avoid spoiling the first impression. Horrobin's work on the screen came about because a plan to adapt an existing classical screen turned out to be too expensive. He was known by the architect from a previous collaborative project. Terry Clark, the blacksmith, responsible for the entrance portcullis, a 'red poppy' window railing visible through Jim Horrobin's screen, and light baskets inside the portico, was introduced to the architect by Jim Horrobin.

It had been suggested that there should be a clock appropriate for a 'Building of the Nineties' in the foyer, using holographic or laser projections. However, this idea proved technically too ambitious. Following initial attempts by David Lyle and project architect David Walsh to design the clock themselves, they followed up suggestions from the Crafts Council and eventually commissioned Michael Stevenson. The clock was designed as an integral part of the foyer scheme, with an exposed movement based on Big Ben's, by horologists Keith Harding and Cliff Burnett. The movement drives three contrasting clock faces.

The wall hanging in the stairwell, on a theme of *Four*

Seasons in the Brecon Beacons, serves as a subtle means of guiding visitors towards and up the stairs, and was carried out by Penny Roberts and Julia Crallan.

Other independent designers and makers who were involved were David Kindersley (who lettered the Oriel House nameplate and incised the street name on a string course), Banks and Miles (who were responsible for signing within the building) Gordon Russell Ltd., (responsible for furniture in the foyer, including a deceptively simple reception desk) and Ray Adnett who designed and made the ceiling light fittings.

Funding and contractual matters

The total cost of art and craft work was just under one per cent of the building costs.

Because Jim Horrobin's metalwork was integral with the building, the client was insistent that he be employed as a nominated sub-contractor within the terms of the building contract. This ensured that it was the contractor who was responsible to the client for his work. The JCT80 contract used, however, is notorious for the mounds of paperwork it produces. Because of this and the onerous public liability insurance requirements, Jim Horrobin asked for a £600 premium on top of the figure he would have been paid for a direct order. The £3,000,000 public liability insurance figure was also reduced to £500,000. Terry Clark was also employed as a sub-contractor. With the exception of Gordon Russell Ltd., the other craftspeople were treated as 'artists and tradesmen' under the contract, being employed directly by the client who was therefore responsible to the contractor for any possible disruption. This was not a problem as most of the work was independent of the fabric of the building, and in the case of Penny Roberts and Julia Crallan was installed virtually the day before handover.

All craftspeople were paid in stages. Penny Roberts and Julia Crallan were not paid separately for the model they produced, but it was understood that an *ex gratia* payment would have been made if the design had not been accepted.

Artist/contractor liaison

Because of delays in the building programme, Jim Horrobin's ironwork, ready on schedule, had to be stored at a friend's workshop for about eight weeks. The special arrangements with regard to damages payable in the event of delay therefore became irrelevant. Co-ordination between Horrobin and the contractor was particularly important, because the fixings for the railings had been detailed in such a way that the contractor had to carry out work on the fixings after they had been installed by Horrobin, but before he could commence on the railings proper. Although this did not lead to delay, it was a matter which could have been better rationalised. Painting and grouting the railings was the responsibility of Jim Horrobin, with two assistants.

Installation and Maintenance

Completion of the building took place in June 1984. Comments Jim Horrobin received during installation of the screen tended to focus on the prison-like appearance of the combination of brick and steel grating, but once the grilles were in position, responses proved more favourable. The screen design as built was the fourth option presented to the client, who preferred it to an all-metal alternative.

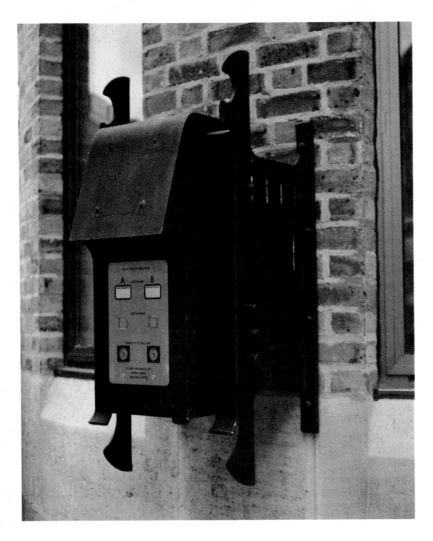

Jim Horrobin, Railings, *Lift Call Point* 1983, painted mild steel, Oriel House, London. Architects: Whitfield Partners. Commissioned and funded by Church Commissioners.
Photograph: by courtesy of Whitfield Partners

It was partly the client's concern about maintenance that prompted the rejection of a proposed *trompe l'oeuil* mural. Because maintenance was to be the responsibility of the tenants, it was considered that any feature requiring a high level of maintenance might affect the building's lettability. In assessing the applicability of craft work, the client therefore considered this factor more important even than cost, although in the event no potential tenants have expressed concern about possible maintenance problems. Entering fully into the spirit of this concern, Whitfield Partners specified a micaceous finish to Jim Horrobin's railings which was developed as a coating for North Sea oil rigs – and is also extremely attractive.

Funding Independence

Surprisingly for a practice so experienced in the field, Whitfield Partners have never sought outside funds for art or craft works. This is partly because they have been fortunate in the policies of their clients but equally due to an attitude towards art and craft as a potential resource right from the start of the project.

Although the facilities of the Crafts Council were drawn on during some of the selection process, no outside funds were called upon for the craft work which was carried out, and this in turn ensured that there were no delays in commissioning caused by discussions between architect and funding bodies.

Comments

Oriel House is a prime example of ornamental craft reinforcing the architectural effect, as opposed to artistic set-pieces serving as a foil.

The architects were impressed by the professionalism of the craftspeople whom they commissioned. David Lyle has said: 'I find it's always the commercial sub-contractors and contractors who are the ones to lapse, not the artists: so there's no argument against using artists on the grounds of professionalism.'

From the point of view of the property agents, their policy is wherever possible to concentrate responsibility in the main contractor, and they would in future try to ensure that all artists are sub-contractors. However, they acknowledge that there are real organisational incompatibilities involved when small-time operators such as craftspeople enter into a conventional nominated sub-contract with a very large contractor.

5 The Easterhouse Mosaic

Peter Fink

The colourful Easterhouse community mosaic in a dilapidated site in a Glasgow housing estate has served as a focus for an environmental improvement scheme.

Background

Easterhouse is a large post-war housing development built on the Eastern edge of Glasgow, with a population of approximately 50,000. After twenty-five years of existence, the area has few shops, negligible local industry, six pubs, no all-day nursery, no cinema or restaurant. This grim picture is currently compounded by a high level of unemployment and a lack of job opportunities.

Against this background, the Easterhouse Festival Society was formed by local residents in 1978 to make Easterhouse more attractive socially and environmentally. Its main aim, to quote from its founding document, was to 'allow the community to celebrate its own life; provide a platform for local talents; help the community focus on solutions to its own problems; and help further a change of image of the area.'

The EFS has now developed into a broadly based community organisation involved with a variety of art, drama, sport and employment creation projects. It has also established the Easterhouse Community Business Partnership in conjunction with Scottish Business in the Community which involves other community groups. One of the examples of their initiatives has been an environmental improvement scheme in the Lochend area of Easterhouse.

The site

In 1980, a painter Alan Kane was brought in by the EFS to run a Youth Opportunities Programme mural scheme employing young people. The Lochend site was selected for this purpose, as it included a crumbling brick wall, 240 ft long in staggered sections, enclosing a derelict site at the rear of a row of rundown shops with old people's accommodation above. On one side of the sea of broken concrete was the windowless Casbash Public House; on the other a ruined prefab, once a surgery, verging on a scruffy woodland. The shops, barricaded behind rarely-raised metal shutters faced two large denominational secondary schools across the road.

The first stage

As vandalism was a very real threat, the artist proposed that the mural be made in the durable medium of mosaic, and that the site should be floodlit at night. The necessary community involvement was brought about by producing the mosaic panels in an empty classroom in one of the neighbouring schools, so as to involve the local children.

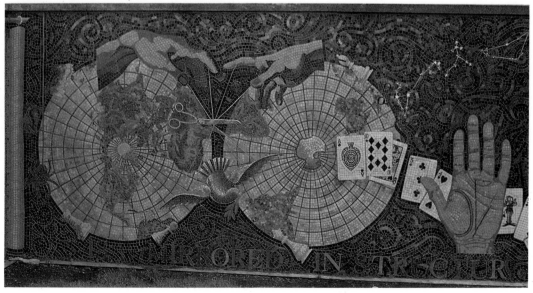

Easterhouse, detail of mosaic, 1984 total area 140sq.m.
Photograph: by courtesy of Easterhouse Festival Society

45 ft of mosaic were completed during the first year of the project, using mostly basic techniques of uncut mosaic tiles. The theme of the panels was nature, expressed through images of butterflies, ladybirds, trees and plants; the simplicity of the forms reflected the difficulties of the young people in scaling up preparatory drawings and their lack of manual skills.

Once the panels were made, and local reaction was felt to be positive the EFS decided to set up a MSC Programme to continue the mosaic project. They also saw the possibility of extending the project into a broader environmental improvement plan, and distributed a leaflet to households in the area and held a number of well-attended public meetings.

The mural

The five artists responsible for the final design and creation of the work were William Hamilton, Allan Kane, Brian Kelly, Tommy Lydon and George Massey. The original theme of nature was expanded to include foliage, and a pond with birds and insects, executed in cut mosaic. In following panels, the early, more tranquil mood gives way to a whirl of leaves and plants in an autumn landscape punctuated by two monuments, a tower and a sculpture, overlooked by a reclining figure representing Time. According to the ambitious programme of the mural, described in an illustrated leaflet, the tower signifies 'man's presence and his capacity to form nature' and the sculptures symbolises the 'evolutionary processes within nature' The East wall is completed by a separate panel portraying a seascape with boats, planes and a beach littered by various man made objects.

After completing the mural up to this point, a problem arose because the artists working on the project were not elegible for further training under the MSC scheme. At the same time the EFS and the local residents had jointly developed a blueprint for the broader plan of environmental improvements containing proposals for landscaping, street furniture, play areas, clearing the woodland, upgrading the pub and improving the shop fronts, and converting the old prefab into a community centre. As the completion of the mosaic seemed essential for the success of these proposals the EFS set about organising a further MSC scheme.

During the final phase Willie Hamilton was employed and the remaining four artists generously worked as voluntary helpers to complete the panels for the West wall. The theme of these panels is linked to a concept of a theatrical performance acted out by symbolic images related to social and political themes such as liberty, peace, alienation and ecology. The mural uses directly recognisable images such as the figure of liberty, a peace dove, a hand holding an unemployment benefit card, contrasted with more disparate images of snakes and ladders, masks, palmistry and tarot cards. The sharp sense of visual confrontation between the variously juxtaposed images provides an average viewer with a wide scope of possible interpretations. This part of the mosaic seems to be the most popular with school children.

The mosaic mural itself was completed in June 1984 and is one of the largest of its kind in the UK, covering approximately 1,500 square feet. It took three years to complete from inception to installation. The completed mosaic was unveiled in a day-long celebration on 21 June 1984, with entertainments and events for the local community provided by various local groups and school children.

Funding

The finance for the mosaic came mainly from the MSC, the Scottish Arts Council, the Scottish Development Agency and material donations from the Housing Department and local businesses. The total cost of the mosaic was £93,000 most of which represents wages, the remainder being for materials and landscaping.

The first year of the project was funded under a Youth Opportunity Programme[1], and ten school leavers worked with the artist. During the second year, four artists were employed full-time under a MSC scheme together with an artist funded by the Scottish Arts Council. In the final year, under an expanded MSC scheme, two artists were employed full-time and three part-time under a supervisor, together with seven full-time siteworkers. The four artists from the previous MSC scheme, donated their services free to the project and were paid expenses only.

The Continuing Programme

A newspaper article of 10 January 1985 in the Glasgow Evening Times reported that the burned-out prefab would soon be demolished to become the site for a children's play area, and noted that the nearby popular mosaic had escaped the vandalism seen in other parts of the area.

This is no doubt due to the genuine identification of the local people with the mosaic, fostered by the regular progress information through slide shows in pubs, community centres and schools, as well as by

1 This account is based on experience of the Youth Opportunities Programme which is no longer operated. For up to date information Local Jobs Centres or Careers Advice Centres should be approached.

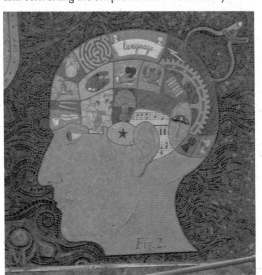

Easterhouse, detail, 1984
Photograph: by courtesy of Easterhouse Festival Society

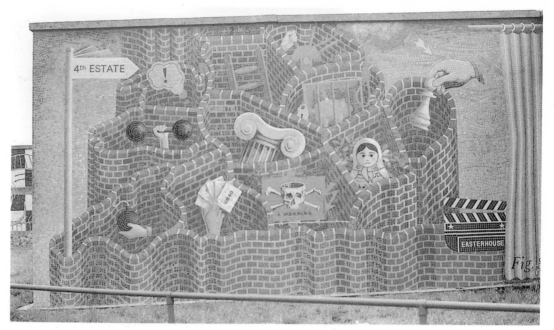

Easterhouse, detail of East Wall, 1984,
Photograph: by courtesy of Easterhouse Festival Society

the voluntary help given by many when the wall was being re-rendered.

Further spin-offs include upgrading the pub, planting the tidied woodlands, with the help of the Scottish Conservation Project, and a plan for upgrading the shops. The play area and associated landscaping will be carried out by Project 80, an MSC scheme, run by the Glasgow City Parks Department. Offers of free materials and planting have come from private business firms such as Barratt and Newcastle and Scottish Breweries.

Comments

The use of art projects as a catalyst for organic growth in environmental improvement and the raising of cultural and social expectations in a rundown inner city area is a well tried strategy in the USA. The philosophy behind these projects is concerned not only with the visible material achievements but also with the way the projects act as a constant reminder to the local community that their neighbourhood does not need to remain dull and drab, and that with vision and imagination things can change.

The success of these projects depends on the partnership principle under which the local community acts jointly with outside agencies. In order for the community to act effectively as an integrated social grouping and take advantage of the available state grants as well as attract independent funding, it needs to be energised by some social dynamic or focus of interests. Art projects can provide just the positive emotional framework for schemes of this sort.

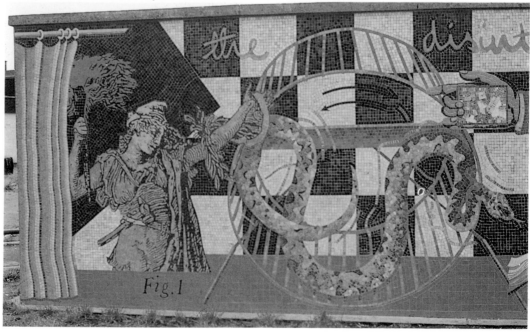

Easterhouse, detail, 1984
Photograph: by courtesy of Easterhouse Festival Society

6 The Mural Company at Hockley Canal Port

Timothy Ostler

This series of murals were carried out by a professional mural group in response to a community iniative and with community assistance. The murals have not been vandalised, and include a frieze designed to incorporate children's designs which can be re-used each season.

Background

The two dramatic murals painted on adjacent gable ends overlooking the Hockley Canal Port, Birmingham, dominate the large green space in front of them. The site was originally developed as a canal port during the Industrial Revolution. After its industrial use ceased in 1965, it lay derelict until the late sixties, when an adventure playground was laid out. 1980 saw a substantial government grant for the local charity set up by local businessmen to administer the scheme, and the port developed as a youth adventure centre with workshops, boats, a city farm and riding stables.

In January 1980, Chris Robinson, community worker and youth leader of the centre, approached the Mural Company which includes artists Steve Field, Paula Woof and Mark Renn, after seeing murals they had already completed in the Handsworth district. There are six gable ends facing the site which rear dramatically above the retaining walls. Robinson originally intended them all to be painted, involving children as part of a summer playscheme. Discussions with the artists revealed this plan to be

over-ambitious, as there was only time to complete one mural over the summer. Further, the idea of children working directly on a large gable end was too hazardous; (during execution, the artists had to remove their ladders and grease the uprights at the end of each day, to prevent children from climbing the scaffolding). It was agreed instead that children would participate in painting the low link-wall beneath the gables.

The prime aims of the project were to describe and celebrate the history of the site, to encourage the involvement of local people, particularly with historical research, to create a landmark, to inform and engage local children, and to attract funds for the community project as a whole.

Execution of first mural

In January the clients applied for funding from West Midlands Arts, and in March from Dulux ICI as part of the Dulux Community Award scheme, which operates by offering free paint to community organisations, which can be entered in a competition.

In May, West Midlands Arts awarded a grant of £750. Research into the history of the site then commenced, involving local residents and site workers. From the material gathered, the artists generated working sketches. A 1/12 scale painting was hung on site to facilitate critical contributions. An exhibition about the history of the area was put up in

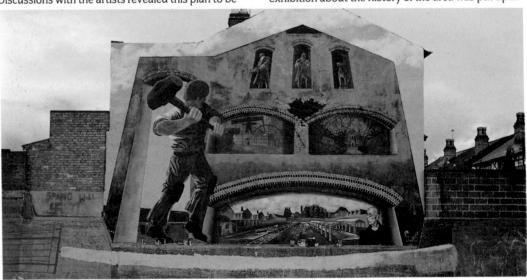

The Mural Company, 1981-2, mural depicting the past of Hockley Canal Port and its destruction. Commissioned by Cut Boat Folk Ltd. a charity set up by local businessmen to administer the Hockley Canal area.
Photograph: Timothy Ostler

the local library nearby, using material from the research period.

In July paint was received from Dulux, and in August work began. It was completed in October, and won first prize in Dulux's scheme. The opening celebration took place on 31 October. The mural depicts a gigantic man in the process of demolishing a grey Victorian brick structure with a sledgehammer. Set within three niches high up on the structure are statues of historic figures associated with the Industrial Revolution. Lower down, arches give on to views from local history: these include a church and factory, now demolished, which once stood nearby. The lowest and widest arch shows the Port in its heyday, along with a large portrait of a local personality who worked there at the time. The sky forms a bright frame to the sombre colours of the composition.

Execution of second mural

Thanks to the success of the first mural, it was agreed in February 1981 to paint a second on the adjacent gable. This time the artists made an application directly to the Arts Council for 50% of an £8,000 estimated total cost, a more realistic figure than the first mural. At the same time, a Manpower Services Commission scheme was organised to involve three other artists on art works around the site, and another application was made to Dulux for paint. In May the artists learned that their applications had been successful.

Compared with the first mural, which dealt with the site's past, the second mural was intended to be contemporary and forward-looking. The *rapport* that the artists felt had been achieved with the local residents by this time made the same degree of research unnecessary. In July work began, and the link wall was the first part to be completed. Execution of the main mural was seriously delayed because the weather was unusually wet. The administrative work arising out of the MSC scheme was considerable, but this scheme did produce some other interesting art works such as a banner for the hall of the Adventure Centre.

In June 1982 painting re-commenced, with help from local volunteers and students from the Polytechnic, Wolverhampton (where Field and Renn were then working part-time on a research fellowship into Mural Design).

The right-hand mural forms a direct tonal contrast to the earlier gable and is altogether a busier composition. Here the surround is the arm of a JCB excavator, dark against the brighter scene it contains. This time a large female figure lifts an overhanging tarpaulin like a theatre curtain to reveal an imaginary view of the Port, as it could be in the future. The space has been transformed into a recreation ground, and there is an impression of great activity. In the foreground a man with his shirt-tail hanging out chases a pig. In the background on the left a team of muralists are painting a gable-end. All

those represented are local children and site workers. The artists' growing familiarity with local personalities by this time allowed some engaging characteristic portraits.

Linking the walls is a frieze depicting a broken wall littered with fallen statuary, while the left-hand wall is flanked on its left side by a blueprint image of a canal barge, towed by a skeleton of a dray horse which is located on the other side of the mural.

Openings and publicity

The mural was finally completed at the end of September and another opening celebration held in October 1981.

The opening is an essential feature of any public work of art, when the artists seek to form a close relationship with those living and working around. At Hockley Port, the openings included barbecues, bonfires, fireworks, music, floodlights and a beer boat. The painting of the second mural was also the subject of a Central Television documentary.

The low cost of the project over two years was £6,450 including grants from West Midlands Arts and the Arts Council, and small sums from Lloyds Bank, the Birmingham Civic Trust and Cut Boat Folk Ltd. Paint donations from Dulux ICI were to the value of £1,400.

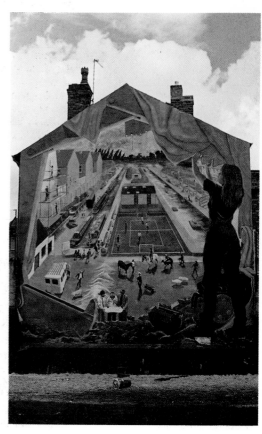

The Mural Company, 1981-2, mural depicting the past of Hockley Canal Port and its destruction. Commissioned by Cut Boat Folk Ltd. a charity set up by local businessmen to administer the Hockley Canal area.
Photograph: Timothy Ostler

Content and style

An attempt was made to avoid what was seen as a mistake in many other murals: namely, that of ignoring the range of colours already existing in the area. So, contrary to Chris Robinson's original wish to brighten up the site, the muralists felt that it would be more appropriate to reflect the colour of the older existing structures, built by London Midlands Railway and British Rail in red and blue brick. The palette for the mural therefore consisted of the colours of brick, concrete, slate, cloud and canal water.

This matter was also the subject of a conflict of opinion between the Mural Company and the designer responsible for an adjacent new sports hall and redecorating old stable buildings. Despite their protestations (Field had himself trained as an architect) some of the red and blue brick stables were painted white, and the sports hall designed in an ochre mix brick to tie in with the modern block of flats overlooking the Port from the North. The artists were disappointed therefore that their suggestions on aesthetic issues related to the development of the port had apparently been ignored. They did not want their terms of reference to be restricted to the creation of the mural.

The second mural was intended to read as a negative of the first. As before, it is dominated by a giant figure, here a woman. The male and female figures refer amongst other things to the City of Birmingham's Coat of Arms featuring industry and the art. In the murals their significance is transformed: 'Industrial Man' is destroying what his ancestors previously built, while 'Artistic Woman' is shown to be far more practical, and lifts the veil on a scene of creativity and industriousness. The colours of the right-hand wall, while bright, harmonize with the colours predominating on the site – dull blues, grass green and brick red.

The low retaining wall linking the murals is painted in a monochrome frieze to suggest the period between the abandonment of Hockley Port and its reconstruction. The other retaining wall is heavily varnished to allow successive groups of summer playscheme children to paint in the horse and boat outline with powder paints, which will weather over a short time to reveal the bones beneath. The boat blueprint utilised the skills of an unemployed technical draughtsman, who designed and painted it. The purple-blue of the background is intended to harmonise with the colour of the roof slates around the site.

The murals both relate well to the shape of the gables themselves. Renn feels that painting sky around the first mural was less successful than the use of the frame on the second, as it dictates a frontal view. The artists also have reservations about the way the scale in the second mural jumps from foreground giant to small background figures while in the first the male figure is not in the same perspective as the facade he demolishes. The mural works probably better in the context of the large space in front, by virtue of its dramatic and unfussy composition; the niche statues in particular, have a very attractive fluency. The second mural, meanwhile, while charming in detail, is less successful at long range.

Community art?

The Mural Company is now dissolved, and the artists are members of a larger new West Midlands Public Art Collective. They have never seen themselves primarily as community artists. They believe that any work on a public site has clear responsibilities to the community, but these form just a part, albeit a major one, of the range of disciplines involved in the creation of a large-scale mural.

Certain areas of the mural allowed for community participation in a direct way. One of the most active helpers has gone on to do other mural work, as have some of the students who helped. Two of them even found a small gable end at the entrance to the site and painted an entrance sign on it to advertise the location of the Port.

Comments

Mark Renn feels that it would have been preferable if funding had been available in a lump-sum, enabling the design of both walls together as a diptych, along with the development of the rest of the Port. It would also have allowed greater continuity and work over winter months. The MSC scheme was unexpectedly time-consuming and should have been independently administered. However, until the first mural had been painted, it was understandable that the project was not able to attract proper funding.

The murals have become a landmark and remain unmarked by graffitti. There is no doubt that they have increased the public profile of the Port considerably, and have attracted more interest, possibly even funds, to the site. Involving senior citizens in the research through the local library was also extremely successful as a means of bringing older residents into contact with local children.

Paradoxically, murals once intended as a means of 'brightening up' derelict sites, have now taken on some of their stigma. Renn drily quotes one resident of the West Smethwick estate, Sandwell: 'With all these murals this must be a run-down area'.

Plate 5

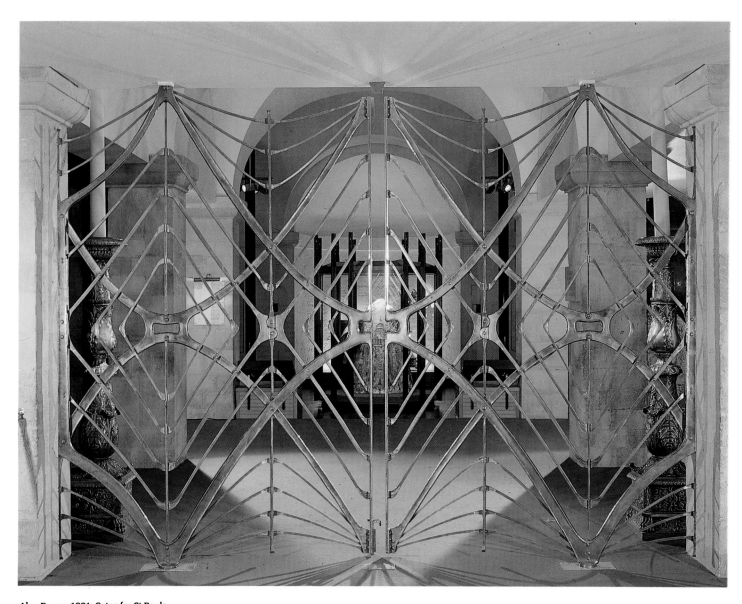

Alan Evans, 1981, Gates for St Pauls
Cathedral Treasury, mild steel plate
and bar with lacquered surface. 2.7 x
3.6m. Commissioned by Dean and
Chapter of St Paul's Cathedral with
assistance from Crafts Council
Photograph: George Wright, by courtesy of the
Crafts Council

Plate 6

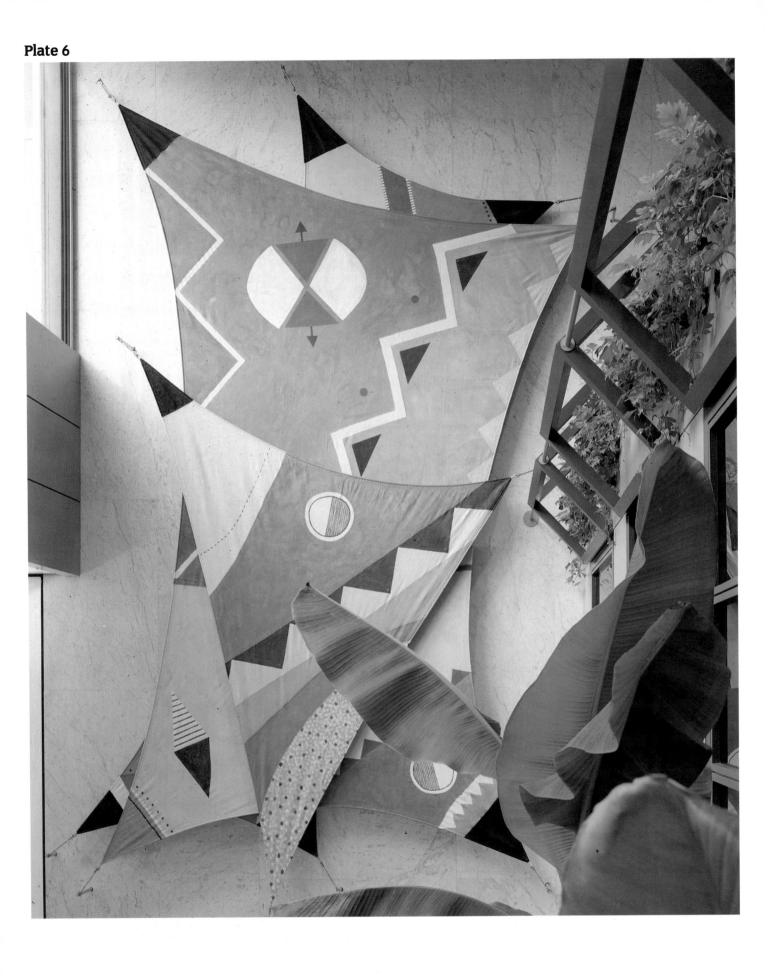

Plate 7

City Murals

Muralists Ken White and Ramsay Burt favour *trompe-l'oeil* in transforming dull gable ends or bland facades into architectural fantasies

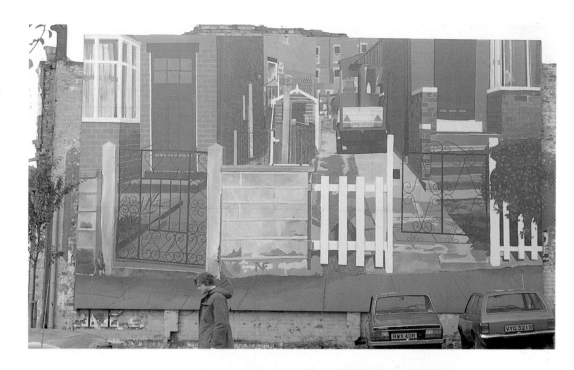

Ramsay Burt, Mural at Woodhouse Gates, Leeds 1979, 6.71 x 12.19m, eggshell gloss paint on plywood. Funded by ACGB.
Photograph: by courtesy of Yorkshire Mural Artists Group

Ken White, Covent Garden Mural, 1982 12.2 x 18.9m. Covent Garden, London. Commissioned by Clifton Nurseries.
Photograph: Heini Schneebeli

◀ Sue Ridge, 1984, three canvas sails for reception area, IBM, Chiswick. Acrylic on cotton duck with boat fixings, 4.80 x 3m. Designers: Michael Aukett Associates. Commissioned by IBM
Photograph: Richard Bryant, by courtesy of Michael Aukett Associates

Plate 8

Art in hospitals

Most art is commissioned by hospital trusts, endowment funds or leagues of friends but health authorities are increasingly coming to regard art not as an optional extra but of therapeutic importance. The DHSS has sponsored a number of publications encouraging the commissioning of art in hospitals.

Michael Ginsborg, 1981, staircase mural, entrance to St Charles' Hospital, West London. Commissiond by St Charles' Hospital. Funded by King Edward's Hospital Fund for London, GLAA.
Photograph: P Coles

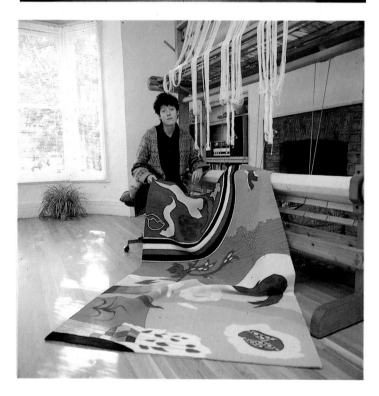

Hannah Collins, *Shelf/Situation/Shrine,* 1985, photographic print in light box, 1.52 x 1.07m, entrance, Colindale Hospital, London NW9. Commissioned by Barnet Health Authority. Funded by King Edward's Hospital Fund for London, GLAA and Barnet Health Authority.
Photograph: Hannah Collins

Marta Rogoyska, *Greenhouse II,* 1984, tapestry, 1.22 x 1.83m. Commissioned by Queen Mary's Hospital, Sidcup for the outpatients waiting area. Funded by Queen Mary's Hospital, King Edward's Hospital Fund for London, Crafts Council, GLAA, Councillor John Raggett, Mayor of Bexley 1983/4, Bexley Arts Council.
Photograph: Edward Woodman by courtesy of Public Art Development Trust

7 The Riverside Collaboration

Deanna Petherbridge

◀ Faye Carey, 1984, mural for St Stephen's Hospital, Fulham Road, London oil on canvas, 2.44 x 23.16m. Commissioned by Friends of St Stephens Hospital. Funded by King Edwards Hospital Fund for London, Calouste Gulbenkian Foundation, GLAA, Mercer's Company and Tom Bendhem.
Photograph: Richard Bryant, courtesy of Public Art Development Trust

◀ Bridget Riley, 1983, Royal Liverpool Hospital corridor. Commissioned and funded by Merseyside County Council, Royal Liverpool Hospital Endowment Fund with the support of ACGB.
Photograph: by courtesy of Juda Rowan Galery

1 Quotations in the text are from the following articles: Gareth Jones, Collaboration: A Dirty Word?, *Art Monthly*, No 53, February 1982, pp 8-9.
Gareth Jones & Will Alsop, Drawings for Riverside, Extracts from Diaries, *Art Monthly*, February 1981, pp33-35.
Gareth Jones, The Riverside: The Artist's Story, *Cue Magazine*, November/December 1981, pp 10-11.
Gareth Jones & Will Alsop, Unpublished transcript of the address *Working Together* delivered at the Art & Architecture Conference, Institute of Contemporary Arts, February 1982.
Interview with Will Alsop, November 1984.
Interview with Gareth Jones, September 1984.

The collaboration between architect Will Alsop and sculptor Gareth Jones at Riverside Studios has been a widely publicised partnership, partly because of the uniqueness of such a collaboration in this country and because both architect and artist are exceptionally articulate. Through published diaries, articles and lectures they have documented the relationship at some length.

The value of collaboration

In some ways it is difficult to make an accurate assessment of the Alsop/Jones collaboration, because it is a sustained relationship. Furthermore, the Riverside development schemes with which it has been primarily associated have not been realised. However these schemes have been much publicised and the partnership was the recipient of an Architectural Design project award in 1984. Gareth Jones' in-depth comments and writings also serve to pre-empt outside assessment, focussing as they do (often in a painfully honest way) on the differences of rôle, practice and techniques of the two professions. In an address to the Art and Architecture conference at the ICA in February 1982, he pointed out: 'The act of getting together is often applauded prematurely without a real assessment of how it is working: and how it is working is valued separately from what is or has been created.'[1]

The dynamic of the collaboration therefore relates to the conceptual stages of design rather than to a built project, and the fruits of the partnership are the numerous drawings and the written commentaries.

Drawing has been central to the partnership, 'manifesting the nature of the relationship between art and architecture', suggests Gareth Jones.

The First Development Scheme

The history of the collaboration is closely related to the complexities of the two development schemes for Riverside Studios and Chancellors Wharf, Hammersmith, London. In August 1979 Gareth Jones took a term off from teaching to work with Will Alsop, as the recipient of a grant of £1,500 from the Arts Council of Great Britain which was initiating its Art in Public Places scheme.

Gareth Jones and Will Alsop had taught together for some years on a multi-disciplinary course at St Martin's School of Art. 'I think our relationship is a model', says Will Alsop, 'We have clearly established that for any collaboration to take place there has to be an existing relationship'. The firm of Alsop and Lyall had already designed a bookshop for Riverside Studios, and had offices on the premises when they were commissioned to undertake a feasibility study on extending the Riverside Studios complex. An art centre was an appropriate project to bridge the gap between the two professions.

There was no clear brief and even the £1.5 million budget was notional. Basically, the idea was to open up the river frontage of the Studios to a new range of functions, including rehearsal rooms and scene dock, cinema, art gallery and a pier.

Artist and architect spent the first months building up a 'bank of images', and indulging in what Will Alsop calls formalist play. 'The initial work was completely image-based', he has written, 'It was unhindered by considerations of plan, function or construction.'

Gareth Jones' drawings were initially observational; about the site, neighbourhood and the local community 'Drawing is a way of understanding, but how many architects earn the right to change something?' he asks. Drawings of this period also played with 'graphically demolishing the Riverside Studios to see what could be involved'.

In these works, Gareth Jones set aside his usual drawing materials in favour of architectural pens, rules, curves, templates and tracing paper. An entry in the artist's diary, dated 19 November reads: 'If I don't draw with precision and with line, my drawings will not assume an authority equal to the architect's. Line is definite: it is the icon of measurement. In comparison, every other image is a smudge . . . There is a definite convention in architectural drawings and if you don't enter into it you will not be taken seriously.' He was also concerned that the drawings should be of a quality to be clearly reproduceable in the manner of architectural drawings. 'We were not working in a private world for a client, but making public' drawings to catch people's imagination'.

By October, both felt the need to contain the ideas which had been floating around. 'The method', recalls Will Alsop, 'was to pull out interesting images from a whole range of drawings, and develop them together irrespective of who had generated them'. At the very end plans were drawn, following the team's beliefs that function should follow form and that

plans are tools of analysis and not initiating schema.

In February, the presentation was made to the client. The Trust was very enthusiastic about the pier with its unrestrained sculptural elements – the clearest icon of the collaborative process – but the local authority made it clear that no funds were available at that time.

There followed a lull in the project. Gareth Jones returned to teaching, but continued to work about three days a week on an unpaid basis with the design team in order to maintain contact.

Second scheme

At a later stage Will Alsop became interested in the idea of developing the adjacent Chancellors' Wharf site into a mixed office and housing development which would subsidize the art centre expansion. In January 1981 Alsop and Lyall took on new personnel to work on the project, including Gareth Jones on a part-time basis.

In retrospect, Gareth Jones sees that there were some difficulties in the collaboration at this juncture, mainly because he was working part-time while others were fully on the job. There were many more people involved: 'It had become a committee and one couldn't keep tabs on things. Before, collaboration had been so close that it was almost pleasurable to disagree.' As the scheme grew, with budgets, deadlines and other pressures, the firm reverted to a more traditional methodology of sequential plans and working drawings.

Feeling the importance of being full-time, Gareth Jones again applied to the Arts Council and received a grant from September until December 1981. He needed to counteract the 'slight feeling amongst some of the new members of the practice that having an artist was just an interesting experiment. There were times when I felt that I had to justify my position . . . Stresses were exacerbated because I was spending a considerable amount of time on each drawing. I became more involved with specific areas, for example, working on the gallery. I felt that I couldn't compete with the timing of the rest of the group.' His acute disappointment when the gallery was dropped because of budgetary constraints was noted in his published diaries.

In January 1982 the artist was employed full-time by the practice although it was difficult to determine fees; unlike architects, or other professional bodies, artists do not have any established scale of fees or professional body to refer to in these matters. In May/June, the political composition of the Borough Council changed, and the Riverside project was dropped. Gareth Jones left full-time employment with the practice in June 1982.

Continuing contact

Gareth Jones still maintains close contact with the practice, and teaches with Will Alsop in Unit 5 at the Architectural Association School of Architecture. They have collaborated on other projects for competitions, such as the National Gallery and Royal Opera House schemes. Will Alsop is hoping to include artist Bruce McClean in an extended collaboration working on a 'Palace of the Arts'. 'The collaboration between the two artists will be just as interesting as the notion of a single artist working with an architect'.

Comments

It is clear that the collaboration worked best when at the conceptual level of the project development and when on a one-to-one basis.

It was at the early stages that the artist and architect seem to have stimulated each other most to be inventive about procedures. The evidence of the enriching aspect of the liaison is clearest in the drawings and models of the first Riverside project. Many commentators picked up on the obviously sculptural quality of the pier, and Will Alsop has understood this aspect of the collaboration: 'The objects that we build and propose are not confined by the requirement to fit into an overall picture of art or architecture. Strictly speaking perhaps they conform to a third and unnamed category of activity.'

Gareth Jones' feeling about being less fully involved in the second project and being forced into a conventional role is highlighted in this diary entry: 'Whereas there has been a certain amount of questioning of my involvement in the form of the building, my role as colourist is received almost enthusiastically. The preconception exists that form is the architect's domain and colour the artist's. It is something I question strongly because it reinforces role playing and thus undermines the collaboration and its free exchange'

The only stresses in the collaboration centered on time, deadlines and the different response to creating finished drawings. The artist's problems might have been exacerbated by appearing to have adopted the role of architect *manqué*, for which he has been criticised by artists and architects alike. He believes this to have been a positive and deliberate strategy: 'I was ambitious enough about my own profession to want to influence the scheme. I didn't want to be a back-room boy – who supplied ideas, but left it to the architects to do them. I wanted to encroach upon their territory. But I'm also aware that there is a categorical prejudice against someone who tries to see the contiguousness of the two art forms, and so appears to fall between two stools'.

Alsop and Jones have now structured their collaboration, and Jones' recommendations for other firms are that the artist should not be confined to the drawing board, but be free to nourish creativity by continuing studio practice. Consultancies it would seem, are more fruitful than continuous employment, and the artist should be brought in at the conceptual stage, and then again when he or she can make an imaginative contribution.

8 Sue Ridge at DEGW

Timothy Ostler

Although artist Sue Ridge is not employed by the firm of DEGW she has a continuing relationship with the design team, consulting on murals, interior designs and colour schemes and assisting with client presentations.

A Developing Relationship

Over a period of some five years, artist Sue Ridge and the design firm of Duffy Eley Giffone Worthington have developed a close working relationship. Trained at Kingston Polytechnic as a painter, Sue Ridge's first commission for the firm involved painting water-colour illustrations for a client presentation. This led to her being asked to design the graphics for the conversion of Unipart's central warehouse in Birmingham. In the course of this job it occurred to partner Luigi Giffone how appropriate it would be to have a large internal mural in this huge space. Sue Ridge's original design extended around all the walls of the building and although the scope was later reduced, the main space of the warehouse is now dominated by a large semi-abstract design on an industrial theme.

Supergraphics

During the later job of refurbishing accountants Ernst & Whinney's headquarters, Sue Ridge was treated as an integral member of the design team. The building is on the South Bank opposite St Thomas' Hospital, and already boasts an energetic yet conventional plaza sculpture by Bernard Schottlander. Her brief was to help DEGW overcome some of the problems arising from the client's requirement for enclosed offices. In order to relieve the monotony of the long internal corridors, she designed no fewer than 67 different decorative wall schemes each co-ordinated with the particular colour predominating on that floor. These are of necessity fairly simple, but help each floor establish its own identity for ease of recognition. The artist produced detailed, scaled and colour-coded elevations of each mural: the decorators Dedows did the rest, but Sue Ridge later visited the building to make final amendments.

More elaborate than the corridor 'supergraphics' is the mural designed for the ground-floor computer suite. It features punched paper tape, here (ironically the reverse of the case in Graham Crowley's Oxpens mural, described in chapter 12) representing the old as opposed to the new. The punch tape spells out

'Ernst & Whinney': one hopes that the client doesn't mind being associated with antiquated technology.

Sue Ridge was also asked to design a carpet which would tie in with the internal design, but with a relatively busy pattern to conceal accidents such as coffee-spills. For this she had the enjoyable experience of using the carpet company Brinton's computer-aided design facilities. This involved feeding the machine with previously prepared water-colour designs, which were then developed interactively on the screen.

Car-parks and Warehouses

Other commissions have ranged from an unusually stylish hoarding erected outside DEGW offices during refurbishment, to a mural in an underground car park belonging to the firm of Jacorossi, in Rome. Although unglamourous, each of these examples highlights the potential development of a common enough problem. Underground and multistorey car parks, thanks to their identification as an extension of the road rather than as buildings which people use, are usually some of the most inhospitable spaces built by man. In the Jacorossi project, Sue Ridge's mural attempts to overcome this problem and is designed to take account of the marks made by car exhausts opposite parking spaces.

Her most recent collaboration with DEGW on the internal transformation of a new architect-designed warehouse for the pharmaceutical company Alfred Benzon, in Copenhagen, is similar to the Unipart commission although more extensive. Benzon's policy was clear about the need for the building to be strictly functional. As interior designers and planners, part of DEGW's role was to develop a co-ordinated approach to colour within the building. For this purpose, Sue Ridge designed separate flowing shapes for each bay, to serve as an effective foil to the stark forms of the warehouse itself.

Not an artist in residence

Sue Ridge is careful to point out that her position at DEGW is far from being an 'artist in residence'. She is more of a regular consultant with special skills working from home, though not directly employed by the client. A typical arrangement is for Sue Ridge to charge DEGW an hourly rate for the first stages of a

design; then if her proposals are accepted, to give DEGW a quotation for the work which would be built into the contract cost. DEGW are only the most regular of a number of her clients. Although not therefore an integral part of DEGW, Sue Ridge nevertheless works as a full member of the design team when called upon, and she assists DEGW in making client presentations.

She rarely executes the murals herself. This situation she considers an unfortunate necessity for foreign commissions, sometimes accentuated by union problems. In the case of two external murals for Digital Equipment Co's offices in Evry new town, near Paris, she was not happy with the execution which was intended to be painted very freely. She is aware that one of the effects of delegating execution is sometimes a 'bureaucratising' of the design itself to facilitate the communication of her proposals to a painting contractor. This results in the antithesis of her personal taste for faded textures. However, she says that the Digital murals, as they weather, are at last starting to resemble her original intentions.

Using subcontractors who themselves have an artistic training can reduce this problem. At Unipart, for instance, The Mural Company were subcontracted to paint the mural. Here Sue Ridge felt able to rely on their skill on matters such as questions of colour. There is very little user liaison involved in Sue Ridge's work, the only exception so far having been a follow-up study of the Unipart job, instigated by DEGW.

Role and Funding

None of Sue Ridge's jobs for DEGW have fallen within the scope of the Arts Council's Art in Public Places scheme, nor has external funding been applied for. She has however, independently of DEGW, taken on outside commissions funded in this manner, such as the ceiling for British Rail at Surbiton Station.

External funding tends to formalise the process of collaboration between artist and architects or designers. If the artist's contribution is fully integrated, it becomes a natural part of the architect's design solution. Applying for a grant then becomes about as appropriate as applying for assistance to pay the fees of the quantity surveyor. John Francis, a partner of DEGW, feels strongly that Sue Ridge's murals should not be seen as separate from the design concept as a whole.

Comments

A continuing working relationship between an artist and an architect like that between Sue Ridge and DEGW is rare in this country. This is probably because both parties are working in a particular way. Although Sue Ridge has executed several mural projects herself, her part in the arrangement is primarily that of a designer of internal murals and 'supergraphics'. Equally, DEGW, who describe their activities as 'architecture, planning and design', work largely on existing buildings, placing much greater emphasis on interior design and decoration than most architects. A partner of DEGW suggests that, in relation to the competitive design market it is far more productive to have an artist as part of the design team than constantly having to push one as outside consultant before the client.

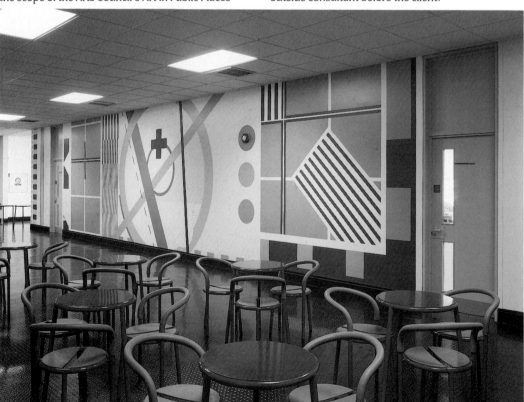

Sue Ridge, 1984, mural for audience lounge, HTV, Cardiff. Eggshell paint, 3 x 17.75m. Commissioned by Peter Leonard Associates for HTV
Photograph: Richard Bryant

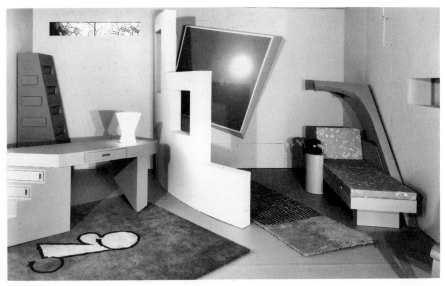

Artists as Designers

Anthony Caro, *Child's Tower Room*, 1983, part of *Four Rooms* at Liberty 1983, Japanese Oak. ht. 3.81m. Commissioned and funded by ACGB *Photograph:* by courtesy of Anthony Caro

Marc Chaimowitz, 1983 one of *Four Rooms* at Liberty 1983, mixed media. Commissioned and funded by ACGB. *Photograph:* Marc Chaimowitz, by courtesy of Nigel Greenwood Gallery

Graham Stevens *Airplay bouncer* in Highbury Fields, Islington 1975. The structure can assume a variety of forms – tube, pillow, dome, mattress, tent - to enable exploration of pneumatic and tensile forms. *Photograph:* Graham Stevens

Anthony Caro, 1981, project for bridge for extension to library in Los Angeles, steel, 0.73 x 2.00 x 0.73m. Architects: Barton Myers. Exhibited at ICA during *A New Partnership* exhibition and Art and Architecture conference 1982 *Photograph:* Stephen White, by courtesy by ICA

9 The Redditch Mosaics

Timothy Ostler

Eduardo Paolozzi's mosaic mural in the Kingfisher shopping centre, Redditch forms part of an honourable tradition of important civic works of art donated by mercantile patrons; in this case, Redditch Development Corporation and the local needle industry. Because of the prestige and size of the project, a primary consideration in the selection of the artist was his distinguished reputation.

The Mosaics

The murals are mounted at a high level above shop fascias in one of the centre's main squares. There are twelve panels, each measuring approximately 7 × 3 m. In true Eduardo Paolozzi tradition, the overall effect is one of a collage of images of a technological nature, with here and there an image picked out in irregular mosaic to give it significance.

Initiation

In January 1980, Redditch Development Corporation decided that the fourth square to be laid out in the new Kingfisher Shopping Centre should, like the previous three, contain a feature of some kind. For 250 years, Redditch has been a world centre of the needle industry, and so it was decided that the feature should be an art work to commemorate this link. The Needle Industries Group agreed to participate in the project as joint donors.

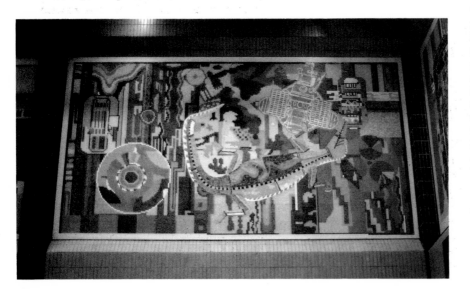

Eduardo Paolozzi, 1982, glass mosaic panel 7 x 3m, Kingfisher Shopping Centre, Redditch, Funded by Redditch Development Corporation, Needle Industries Group with the support of ACGB, Commissioned by Redditch Development Corporation
Photograph: Timothy Ostler

The process of selecting an artist proved to be a lengthy affair. None of the artists put forward was considered acceptable, and so at the suggestion of Sir Hugh Casson, then the President of the Royal Academy, the Arts Council was approached. By now it had been decided that the art work should take the form of some kind of wall treatment on the twelve panels above the shop fascias as this would not interfere with commercial considerations, obstruct pedestrian flow or reduce options for future replanning of the square.

In March 1981, the artist Eduardo Paolozzi was selected. Amongst his other commitments, Paolozzi teaches in the ceramic department of the Royal College of art, and has undertaken mosaic, mural and sculptural commissions elsewhere.

Artist's brief

The brief sent to Eduardo Paolozzi on 26 March 1981, called for 'a feature/art work related to the historically primary industry within RDC, namely needles.' Designs were to be submitted to a committee representing Redditch and the needle industry. As the building contract was well advanced no structural modification would be possible. Timetabling was considered particularly important: site fixing of the art work was to take place during February/March 1982, as the square was due to be open to the public in March 1982.

The brief caused some problems for the artist in its requirement to pay specific reference to the needle industry, because, as he put it: 'to illustrate needles in mosaic is a patent absurdity'. After some discussion with the client and joint patrons, it was agreed that imagery would make references to the industry but not take the form of a historical tableau or literal representations. During a visit Paolozzi explained the design in great detail: for example, the use of spacecraft imagery relates to NASA's use of Redditch needles to sew tiles on to the Space Shuttle, and the plants depicted produce raw materials for thread.

Administration of project

Unusually for a project of this scale, there was no written contract between the Development Corporation and Eduardo Paolozzi. An exchange of letters confirmed the terms of the brief, while it was

agreed in conversation that Eduardo Paolozzi's responsibility was for design, fabrication and installation from start to finish. It was part of this understanding, however, that additional expenses arising would be paid by the client. The total sum agreed was divided into the artist's fee, material and installation costs, to be invoiced in three stages.

There was no legal contract between Eduardo Paolozzi and the main contractors, who were only required to assist with information on the panel sizes. The Development Corporation architects department, who designed the building, had little involvement beyond supplying original drawings showing dimensions of the panels. The square's enclosure on which the panels were to be mounted was already designed when the artist came to work on his design: the architect's intention had been for the panels to be left blank.

The artist suggested using the firm Langley London Ltd., and Italmosaic s.p.a., as they had previously worked with him on a Cologne mosaic project. The former were to give technical advice and interpret his designs into a form suitable for mosaic production, while the latter were to assemble the glass mosaics at their studios in Italy.

The artist's designs were not full scale. Langley London's chief designer made a number of visits to Italy as did Paolozzi during various stages of production.

Langley's relate that work went fairly smoothly, with the exception of a continuing problem in establishing the exact panel dimensions which did not conform exactly to the drawings the architects had supplied.

Eduardo Paolozzi, 1982, glass mosaic panel 7 x 3m, Kingfisher Shopping Centre, Redditch, Funded by Redditch Development Corporation, Needle Industries Group with the support of ACGB, Commissioned by Redditch Development Corporation
Photograph: Prudence Cuming Associates Ltd. by courtesy of the Commission for the New Towns

Fabrication and installation

Production of the mosaics started in Italy during March 1982. They were assembled in reverse on paper, and divided up for easy crating.

Fixing was carried out by Birmingham Art Flooring Ltd using mobile scaffolding some six months after the rest of the building work was complete. At this time several of the shops had already opened, and fixing was completed in less than two weeks in order to minimise disruption.

Individual sheets were first backfilled, and then applied to the adhesive on the walls, and later the joints between the tesserae were grouted. Unfortunately it was necessary to cut into the panels to accommodate movement joints which had not been included in the original site drawings. In addition, the green ventilation ducts which emerge at two points in the wall had to be cut into the mosaic, as it had not been possible to prelocate them. Luckily the 'collage aesthetic' of the design means that neither of these two problems appears to matter. But Langley London's quotation was expressed as a rate per square metre, so the artist was faced with additional expenses when the size of the panels turned out to be greater than previously indicated.

Maintenance responsibility

For an initial two-year period, the fixing firm were liable for any defects in the mosaics. Following the recent sale of the shopping centre by Redditch Development Corporation to private clients, provision has been made for the murals. A Lease Deed between the new owners and the Redditch Borough Council governing Paolozzi's work, stipulates that prior to any proposed modification of the mural, or its relocation, and before any maintenance takes place, the owners are required to consult the artist and the Arts Council. Samples of all the tiles have been supplied in case replacements are needed.

Public reaction

Twelve months after installation the Chairman of the Arts Council unveiled the panels. On 5 July 1983 the Queen also unveiled a plaque naming Milward Square. About six months after the mosaics were fixed, seating was installed in the centre of the square to allow people to sit and contemplate the panels while waiting for friends. The Managing Director of RDC says these are well used. Whether the panels actually attract people to shop in the square is impossible to gauge without a proper market research study, although in questioning a random sample, people professed admiration for the work.

It seems that the mosaics inhabit a happy territory in which shoppers find no difficulty in enjoying what is by no stretch of the imagination an easy 'populist' design. The bright colours, the 'craft' quality of the mosaics (they look rather like tapestry or embroidery), the complexity and the choice of popular and recognisable images all seem to play a part in this success. The artist is especially pleased that, since completion, a number of local school groups have visited the murals to draw and talk about them.

Eduardo Paolozzi, 1982, glass mosaic panel 7 x 3m, Kingfisher Shopping Centre, Redditch, Funded by Redditch Development Corporation, Needle Industries Group with the support of ACGB, Commissioned by Redditch Development Corporation
Photograph: Prudence Cuming Associates Ltd. by courtesy of the Commission for the New Towns

Site

In terms of the design of the square, Eduardo Paolozzi's mosaics were an afterthought. The designer of the square intended the panels to be left blank, and it was the client's decision to embellish them. Photographs of the square show the panels to be upstaged by the illuminated shop fascias and the busy space frame roof. An increase in lighting of the mosaics could go some way towards overcoming this problem. Floodlighting of the mosaics was suggested, but Eduardo Paolozzi preferred the lighting to vary naturally with the time of day. He maintains a similarly *laissez-faire* approach to the shop fascias. Although in October 1981 the development corporation made a public presentation of the designs, at no time during the commissioning process were the prospective shop tenants consulted.

Cost

Out of the approximately £130,000 cost of the mosaics, the bulk was contributed by RDC. Part of their agreement with their joint donors was that the exact extent of their contribution should not be publicly disclosed. The Arts Council for their part contributed about £6,500 to Paolozzi's fee, under the Art in Public Places scheme. For accounting purposes, the cost of the mural was treated as part of the cost of the Kingfisher Centre. Treatment of the panels in an ordinary architectural material such as ceramic tiles would itself have cost some £70,000.

Comments

The keynote for the entire project seems to have been informality and flexibility. The smooth-running of the project was greatly assisted by the freedom and respect Redditch Development Corporation offered Eduardo Paolozzi as an artist of international repute. Prestige was an important motivation in commissioning the artist. At a conference at the ICA in June 1982 members of the Development Corporation were proud that the mosaics would 'put Redditch on the map'.

There was a clear need for a project co-ordinator and the architects of the Kingfisher Centre, if more closely involved, could have played a crucial role in considering the question of shop fascias, and co-ordinating information such as the location of movement joints. They could also have done more to avoid the continuing uncertainty over the sizes of the panels, a prime cause of the delays which affected the project. The technical adviser and supplier's representative also would have preferred to work through the architect's department, as there was more work involved than envisaged on the initial quotation. All these matters could have been dealt with more satisfactorily if the art work had been commissioned at an earlier stage of the development.

10 The Royal Wedding Commemorative Gates, Winchester Great Hall

Lesley Greene

Background

In 1981 Hampshire County Council organised a limited competition for the design of two pairs of gates for the east end of Winchester Great Hall. The 13th century Great Hall, the only part of Winchester Castle remaining after demolition on Cromwell's orders after the Civil War, has been used for centuries for judicial purposes. In 1873, new Assize Courts were built on to the east end, and the old and new halls were linked by cutting a lofty twin-arched vaulted passageway through the 10 ft thick end wall. These courts were demolished in the late 1930's, and new courts designed by Louis de Soissons & Partners were completed in 1974. The architect's intention to fill the arches with plate glass screens was objected to on security grounds, as Winchester Crown Courts have been the scene of some important and politically sensitive trials.

To mark his period of office as High Sheriff for the County of Hampshire in 1980/1, Maldwin Drummond offered to raise the money needed to pay for wrought iron gates, which would serve as a security screen. It was understood that the County Council would pay for the installation of the gates and whatever additional security measure might be required. Michael Morris, Hampshire County Council Architect in charge of the restoration of the Great Hall assumed responsibility for the project. About this time the engagement of the Prince of Wales and Lady Diana Spencer was announced and it was agreed that the gates would be a commemoration of their wedding, to which the people of Hampshire would be asked to subscribe.

Selection and Brief

The architect decided quite early on that this was the opportunity to commission a designer-craftsman, with experience in hot metals who would feel for the plastic potentiality of the material. He knew of the *Forging Iron* conference organised by the Crafts Council in 1980, and through the Crafts Council was also put in touch with the Keeper of Metalwork at the Victoria & Albert Museum. Having been shown the results of recent competitions for gates for St Paul's Cathedral and the Victoria & Albert Museum, he was convinced that a similar competition should be held for the Great Hall, and this was approved by the County Council.

Five artist-craftspeople from all over Britain were invited to submit designs for a limited competition, with the unsuccessful entrants to receive a fee of £250.00 for their designs. Before the final brief and drawings were prepared the architect visited each craftsperson individually to explain the background to the commission. The gates were to be completed by 29th July 1982, and each entrant was informed that the gates were to be the subject of a fundraising effort. According to the architect, none of the craftspeople expressed doubts about these financial arrangements, nor about their ability to complete the gates in the proposed six months.

The most important part of the brief concerned security: it stipulated that the grille should be narrow enough to prevent an explosive device being pushed through the interstices. Each pair of gates would measure 6 by 2.4 m, with a fixed screen in the curve of the arch. The gates were to be coated to prevent corrosion and minimise further maintenance. The initials of the Royal couple were to be an identifiable feature, and the architect mentioned his fondness for the dull grey glint of armour and mediaeval weaponry. It was a peculiarity of the brief that an itemised budget was not requested, and the materials, manufacture and fee were to be contained within a budget of £25,000.

The designs were submitted in September, and the selection panel consisted of a representative from the Crafts Council and the Victoria and Albert Museum, the High Sheriff and former High Sheriff, the County Architect and County Council Chief Executive. Two proposals were costed at more than £25,000, and in all cases the designs submitted went far beyond what had been asked for in terms of ideas and presentation. The commission was awarded without hesitation to Antony Robinson.

Commission and Finance

The models and designs were exhibited in the Great Hall for the judging and in order to initiate the public subscription campaign. Tony Robinson was delighted by the scale of the commission, and recalls 'I thought it was like winning the pools! My ideas were based on the idea of a mediaeval trident. The shape is slightly changed to give it a leaf form which has modern references, but it is also related to the mediaeval painted design on the walls of the Hall. So I was using traditional ideas in a modern way. There is no

41

traditional jointing, which technically made the job easier. I thought the design should emphasize the beautiful proportions of the Hall, and decided that the material should be stainless steel because of the darkness of the place and the way stainless steel is sensitive to light.'

After the awarding of the commission, an independent committee was set up with Maldwin Drummond in the chair to organise the fund-raising. Difficulties in obtaining charitable status delayed the launch of the appeal until March 1982. Despite excellent local and national press the public response was not good, and the Royal Wedding Commemorative Gates Appeal Committee obtained an overdraft in order to pay Antony Robinson his first instalment to commence working. The artist's first problem was to modify his workshop, and this absorbed, as agreed, the first payment. Obtaining the chosen material of stainless steel was problematical, because there was not yet sufficient money. However, at the artist's suggestion, Michael Morris approached the British Steel Corporation and a visit was made to Sheffield to discuss the project with the corporation's Special Steels Division. They were extremely helpful and offered to supply the material at a 50% discount, and a post-dated invoice. The British Steel Corporation also arranged for the Swedish firm ESAB to supply welding materials and equipment free of charge.

By mid-May 1982, however, it became clear that the gates were going to take longer than anticipated, and at the same time the public subscription campaign had slowed down, although a professional fundraiser was temporarily employed. No assistance was requested from Southern Arts, or the Crafts Council. Tony Robinson found that his own expenses were heavier than anticipated, but the project was assisted for seven months by three smiths from Switzerland and a leading workshop in Germany who donated their expertise and labour because of the importance of the commission. Several English smiths also worked voluntarily for different periods. Tony Robinson believes he could not have completed the gates without this generosity, which is typical of the burgeoning metalsmithing world.

By the end of January 1983 more than half the payments (less the discounted materials) had been made to the artist, and by April the remaining money had been raised by public subscription. British Steel then generously agreed to waive payment on all the steel used.

Installation and Unveiling

The gates were installed in August 1983. Lansing Bagnall provided the forklift trucks which were used to position the four gates, free of charge. A scaffold had to be erected to position the spandrel infill, and the weight of the operation called for special shoring below the floor.

A formal and festive unveiling was held on 9 September, when the Lord Lieutenant of Hampshire, Lord Ramsey unlocked the gates with a ceremonial key designed by the artist, to the sound of a dramatic fanfare of Light Infantry trumpeters.

The Design of the Gates

The two pairs of gates reflect the pointed Gothic arch which is a principal feature of the Great Hall in the glowing medium of forged stainless steel, in a design that is both inspiring and appropriate. The close grilles of the gates are decorated with scrolls which elongate progressively along the length of the bar, finally changing form into tridents. Towards the top of the gates the tridents enlarge, flatten and project outwards, almost like the wings of a butterfly when they meet the horizontal bar. The initials C and D with the date 1981 are incorporated into the central part of the design. The gate handles are designed to look like mediaeval lances, and generally the design is a remarkable fusion of the contemporary and the historical.

Comments

The clients were not in a position to supply a contract because the money had not been raised when the commission was awarded, and this proved a crucial factor in the commission. Although those responsible for the appeal personally underwrote a considerable overdraft so that the work could begin, raising money by public appeal proved to be a slow and frustrating business, and did not simplify the problems of the commissioned craftsman.

The choice of material also caused problems – firstly that of cost, and secondly technical problems, so that the time-scale for working the material was radically under-estimated. What is remarkable about this project is that in spite of these not inconsiderable difficulties, the gates are a triumph of technique and originality within a historical context.

Antony Robinson, 1982-83, stainless steel commemorative gates for east end of Winchester Great Hall. Ht 2.4m. Funded by public subscription with support from British Steel. Commissioned by Hampshire County Council
Photograph: Chris Fairclough, by courtesy of Hampshire County Council

Church Commissions

Oisin Kelly and Leslie MacWeeney, *Last Supper and Stations of the Cross*, 1963, laminated teak carving and set of 14 embroidered wall hangings, 2.44 x 6.40m Church of Corpus Christi, Knockanure, County Kerry. Architects: Scott Tallon Walker, commissioned by Parish of Moyvane
Photograph: John Donat, by courtesy of Scott Tallon Walker

Graeme Willson, *Madonna and Child*, 1983, oil on octagonal canvas, 2.44 x 2.44m, Thamesmead Ecumenical Centre, South London. Commissioned by the Ecumenical Centre. Funded by Edwin Austin Abbey Mural Trust.
Photograph: Graeme Willson

Louis le Brocquy, *Madonna de la Strada,* 1957, glass mosaic, 2.44 x 2,74m, Madonna de la Strada shrine, church of St Ignatius College, Galway, Architects: Scott Tallon Walker, commissioned by St Ignatius College
Photograph: Deegan Photography, by courtesy of Scott Tallon Walker

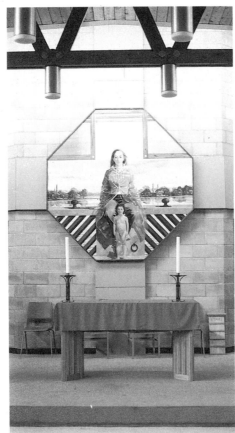

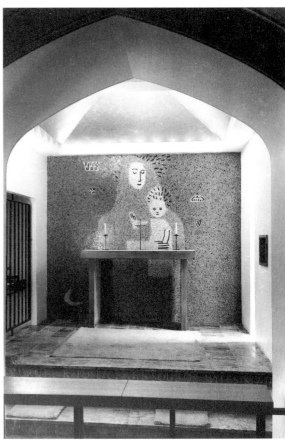

11 Art for Colchester General Hospital

Peter Coles

This project has involved art commissions on a scale not encountered before in a new National Health Service hospital. It is also a good example of public and private collaboration, in that although the scheme was initiated and administered by the Public Art Consultant of Eastern Arts, most of the funding was raised by public subscription.

Background

Colchester District General Hospital represents the second phase of new buildings commissioned by North East Essex Health Authority. The incorporation of a range of sculpture, mural paintings and photographic pieces in the building has been the result of an intense local appeal.

Design for the hospital project included extensive landscaping of the grounds, and from the beginning, the architects, Percy Thomas Partners envisaged siting a sculpture in one of the six internal courtyards. A project for more extensive incorporation of art works in the new building began in 1982, as the result of initiatives by the Public Art consultant for Eastern Arts, Isabel Vasseur. The possibility of a matching grant under the Art in Public Places scheme encouraged the Hospital League of Friends to widen an existing Amenities Appeal to include works of art.

Launched in 1982, the appeal raised £19,000, supplemented by a grant of £6,500 from Eastern Art, and also attracted offers of art and crafts from local schools.

The aim of the scheme as outlined by the commissioning officer was to '. . . create an identity for the new hospital as well as to get the community interested and involved . . . to provide quality art works to distract patients from thoughts of illness, as well as serving as focal points for direction-finding . . . and putting [National Health Service hospitals] on par with the private hosptials.' In addition, the commissioning team had a policy, wherever possible, to avoid contract furnishings in favour of designer fabrics, seating and fittings for the hospital. For the art programme, an art selection panel was formed, made up of the Chairman of the Health Authority, the District Administrator, the Commissioning Officer, the Chairman of the hospital's League of Friends and Senior Partner of the architects, with advice and guidance from the Public Art Consultant who endeavoured to act as a resource and catalyst, rather than as an arbiter of taste. The team commissioned a

sculpture and a series of murals and photographic installations, as well as acquiring and siting two other works.

The Sculpture Commissions

The main hospital building is a two and three storey grid, with six internal courtyards. For one of the courtyards the architects commissioned a sculpture from Bruce Gernand, a Norfolk-based sculptor. The work was designed in relation to plans and drawings, but the artist was not able to view the proposed courtyard site before submitting his designs, although he was keen to do so.

The work is an elaborate pavement composition of dyed cement relief patterns arranged in a spiral within a circular surround. Three bronze vessels are placed at points on the final curve of the flat spiral, and the open motifs cut out of the sides of the vessels echo the leafy shapes of the pavement. The vessels mark stages in the evolution of the enclosing spiral and embody references to growth and evolution.

The piece is strong enough to hold its own against the diverse landscaped elements in the courtyard when seen from above; at ground level, where it has to compete with a very busy space, it lacks coherence.

The artist was able to work directly with the clerk of works, which he considers an advantage as it 'avoids too many committees'. The commission did not allow for major changes in the design of the courtyard, so Bruce Gernand has responded to the site as it is, albeit rather over-designed. What building work was done was separately funded in order to preserve the value of Bruce Gernand's rather modest fee. The contractors helped the artist lay the dyed cement screed for the relief shapes using fibreglass moulds, and it appears they enjoyed utilising professional skills outside the usual confines of building work.

Method of selection

The three 'off the shelf' pieces were selected by the panel from the 1983 Art Council's *Sculpture Show* at the Hayward and Serpentine Galleries, and an exhibition at Kenwood House. The Hayward sculpture show apparently caused the distinguished panel to beat a hasty retreat, but they found succour in the sedate tranquillity at Kenwood, where they purchased two pieces by John Foster, *Nightwatch* and

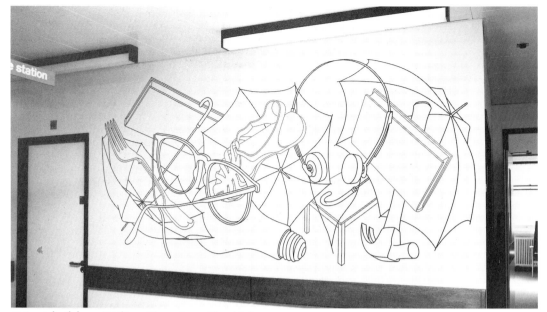

Michael Craig-Martin, 1984, mural, nursing station, Blackwater River Wards, Colchester District General Hospital, Architects: Percy Thomas Partners. Commissioned by North East Essex Health Authority. Funded by Hospital League of Friends with support from Eastern Arts
Photograph: by Edward Woodman, courtesy of Eastern Arts

Cut-out, both large (11 ft) cast iron pieces. The third bought piece is in carved stone by Paul de Monchaux, *Mnemonic*, and was selected from the Serpentine sculpture show.

The purchased sculptures

The bought sculptures inhabit their courtyards very much like afterthoughts. As landscaped spaces, the courtyards are varied, interesting and sympathetic places in which to sit, to pass by, or to look out upon. But they are far too detailed for the siting of acquired works. Perhaps the worst offenders are the large boulders transported down from Scotland, which are sculptural in their own right; one senses the animosity between natural and sculptured objects.

Paul de Monchaux's sculpture, not intended for an outside site, was coated with a protective silica resin which rather muffles its natural patina. The small carved piece in Portland stone, is almost lost among a cacophony of large boulders, plants and ornamental brickwork. It is placed on top of a low brick plinth in the centre of an ornamental pond. The sculptor managed to persuade the architects to replace the brick cladding for the central plinth with zinc, giving the piece at least a small space of its own in which to breathe.

The 'off the shelf' pieces were stored at the artists' studios pending completion of site work, for over a year. It was undoubtedly safer to do this than store them on site. The size and weight of John Foster's two sculptures meant that careful planning was needed for installation.

Murals

The hospital has nine wards – three to a floor – and each has a mural, sited in front of the nursing station at the ward entrance. The commissioning policy was to commission a different artist for each floor, to develop a theme, and reinforce ideas of 'place'.

John Foster, *Cut Out*, cast iron, ht. 3.35m, courtyard, Colchester District General Hospital, Architects: Percy Thomas Partners, commissioned by North East Essex Health Authority, funded by Hospital League of Friends with support from Eastern Arts.
Photograph: by Edward Woodman, courtesy of Eastern Arts

Artists Michael Craig-Martin and Geoff Archer were selected by the panel from the 1983 Tolly Cobbold Eastern Arts Fourth National exhibition. The choice of John Loker followed a special slide show of artists' work arranged for the panel by the commissions adviser.

Michael Craig-Martin was the only artist of the three to paint directly on to the walls, waiting until the hospital had been handed over to the Health Authority by the contractors. The murals are on the level known as the Blackwater floor, adjacent to the geriatric and the children's wards. They consist of line drawings of familiar objects: spectacles, an umbrella, headphones, scissors, a shoe, floating on a coloured background. The aim was to provide a thematic continuity for all three murals, with a content which could appeal to the elderly patients, the children and the medical staff.

Geoff Archer draws upon urban landscape imagery for his photorealist paintings and the three long canvases are like shop windows, with all the multiple plane complexity created by reflections. The linear format was, to some extent, imposed by the need to negotiate clocks on each of the walls intended for the murals. The 'windows' are busy, with a variety of images, some of them taken from Los Angeles' Chinatown, chock-a-block with masks and neon signs. They create a very different atmosphere to

other parts of the hospital, where rural themes predominate.

John Loker is the only artist of the three whose style could be described as abstract, yet his work goes the farthest to embrace the particular identity of its site. The floors of the hospital are each named after a river in East Anglia, and each ward is named after a village on that river. John Loker's floor was named the Stour and during the summer of 1984, he worked from his Norfolk studio, making day sorties by bicycle along the river, collecting images and ideas. The left-hand panel of each set of paintings appears like a map of a specific area of the river, while the right-hand sections freely interpret the subject. Dedham ward, for example, is named after the town on the Stour estuary, and the painting terminates in a haze of blue reminiscent of the river gaping into the sea. At another point, a vertical green gash refers to the instrusion of the A12 motorway on Constable's country.

Practical issues

The mural sites are each roughly 9 by 6 feet, and confront visitors as they approach the ward. By an extremely unfortunate lack of foresight, the designated walls were furnished with a large black-rimmed clock, which the architects claimed

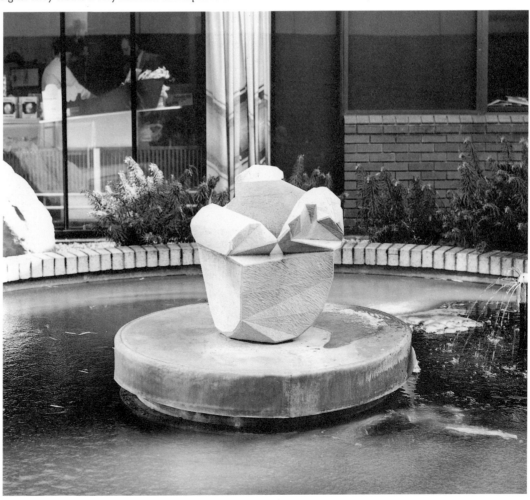

Paul de Moncheaux, *Mnemonic*, portland stone, courtyard, Colchester District General Hospital, Architects: Percy Thomas Partners, commissioned by North East Essex Health Authority, funded by Hospital League of Friends with support from Eastern Arts.
Photograph: by Edward Woodman, courtesy of Eastern Arts

could not be easily moved. Each artist, therefore had to take account of the clocks in his design, either by adjusting the height of the paintings, or like Michael Craig-Martin painting on the adjacent wall to the one originally designated, or simply removing the clock and patching over the holes. Continuity of theme, so carefully thought out in the commissions was trivially unbalanced by the siting of the clocks.

Photographic Essays and other Works

Three photographic essays were commissioned for each floor. Simon Read's photographs were taken from his barge and show scenes along the river Blackwater. There are six mounted installations, each 20 ft, made up of successive images. Nigel Henderson's three intricate photomontages illustrate the Colne valley, through the use of shifting perspectives of repeated images. Simon Marsden's twelve framed prints for Stour floor have an eery quality, created by dramatic camera angles and the use of infra-red film. The work is vulnerable to bleaching where it is sited, and also to theft, as a low budget precluded secure frames for fixing to the walls.

In order to choose from the enormous response from amateur artists and craftspeople to the local appeal for art, a special exhibition was organised at the Minories Gallery, from which the panel made a selection. Works from local artists David Britton and Christine Woddman were purchased, and other works have been donated. School children from local schools have painted mural panels and paintings, and toys and other craft have been donated from the community.

The Courtauld Institute have lent a number of framed contemporary prints to the hospital for a nominal fee and Eastern Arts has lent a large painting by Peter Kalkhof from its loan collection. It is also envisaged that waiting rooms will host small temporary exhibitions.

Community Involvement and Administration

Although the community did not have a direct say in the selection of the artists or their work, they were all represented on the selection panel. It is important in such a large project, for the client to be the motive force, and so both commissioning officers were involved in all aspects of the project, as were the works department, who helped install the art works, supervised by the Public Art Consultant. It seems likely that the art programme will expand to include other commissions, changing exhibitions and the like, and probably the works department will take on the curatorial duties. Expert guidance will inevitably be needed once the works begin to suffer wear and tear.

Contracts and Financial Arrangements

The contract for each of the mural commissions was essentially an exchange of letters, stating who the artist would deal with, what was being paid for, how much the fee would be and when the work should be completed. Half the fee was paid on acceptance and half on completion of the commission.

Bruce Gernand's contract was more complex, being a modified version of the architect's standard contract for building work. In Bruce Gernand's words, it was a 'fifty page contract of bumf as if I was putting in windows', and he would have preferred a simpler contract.

As the fund-raising appeal was for Art and Amenities, not all of the £19,000 raised could be used for art. An additional grant of £6,500 towards the cost of art works was awarded by Eastern Arts Association through the Art in Public Places scheme. The value of Bruce Gernand's sculpture commission, £3,000 plus one day's building costs, was met by Percy Thomas Partnership, Architects, and the bronze casting cost £1,200. The two John Foster sculptures and the Paul de Monchaux were bought for a total of £5,000. The three mural artists were paid an undisclosed sum.

Comments

In terms of providing a wide range of art works, in different media, with a mix of bought, borrowed, and commissioned work, before the building opened to the public, the project seems to have achieved its aims: nevertheless the works could have been much better integrated with the architecture if they had been considered at design stage. The care and attention which all the commissioned artists paid to siting and the thematic content of their work, draws attention to aspects of the project which could have been improved upon, mostly architectural. The siting of wall clocks unnecessarily complicated the mural commissions and the extensive landscaping of the courtyards militated against integration of the sculptures.

It is laudable that the art project was launched when the building work had only just started, and the scale of local response is a testimony to the extent to which the users take an interest in their public buildings if they are given the opportunity. It is clear that the existence of the basic hospital structure gave the project a concrete reality and stirred the imagination, and that the presence of the Chairman of the Health Authority District Management Team provided the project with credibility and authority within the Health Service hierarchy.

Positive spin-offs from the project are that the League of Friends are keen both to continue the art programme and to extend it to cover other existing hospitals in the district, and the Regional Health Authority has agreed to commit some money for this extended programme.

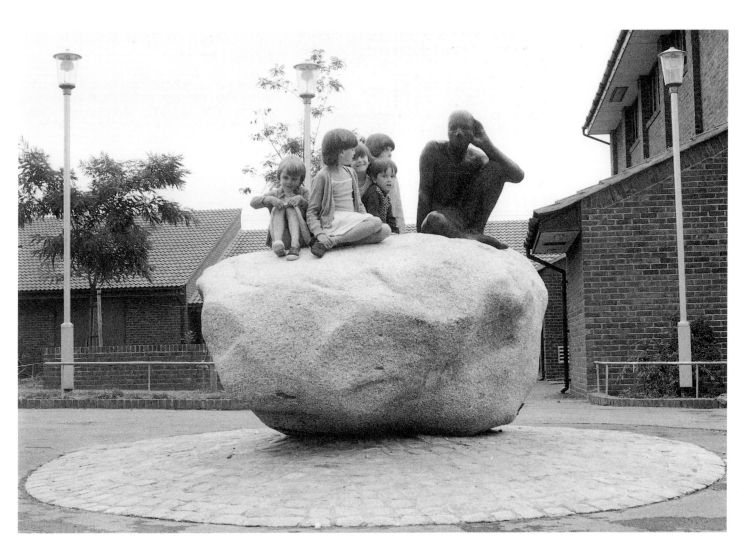

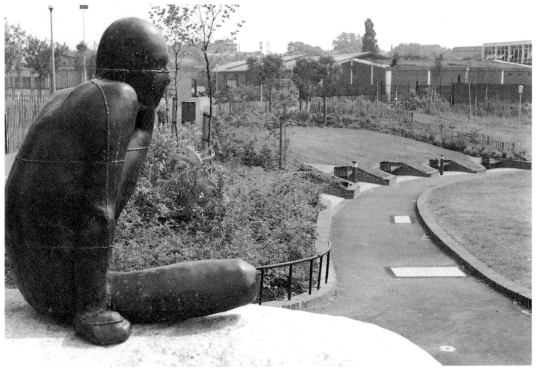

Peace Sculpture

Antony Gormley's timeless, listening man, sits on top of a glacial boulder in Maygrove Peace Park, London in a pose which is both vigilant and contemplative

Antony Gormley, 1984 granite and bronze, ht. 1.98m, Maygrove Peace Park, Maygrove Road, London NW6
Photograph: by courtesy of London Borough of Camden

Antony Gormley, *Untitled*, 1984 Architects: Department of Architecture and Surveying, London Borough of Camden. Commissioned by Camden's Department of Libraries and Arts. Funded by London Borough of Camden
Photograph: by courtesy of London Borough of Camden

12 Graham Crowley's staircase murals, Oxford

Timothy Ostler

This commission is unusual in that it was initiated by one artist, but awarded to another. Graham Crowley, veteran of several very successful and technically innovatory mural commissions, collaborated closely with the users of the building in creating an appropriate and lively iconography.

Background

Graham Crowley's staircase murals at Oxford College of Further Education in Oxpens, are of interest for the innovatory use they make of sign-etching laminate, and for the creative effect the collaboration had on the architect's approach to the rest of the building.

The third phase of the building project including laboratories was designed by Derek Stanhope of Oxford County's Department of Planning and Property Services. Although predominantly brown, the building stands out from its drab surroundings due to the use of primary yellow glass-fibre external trim in prominent positions on the elevations. It possesses a remarkably jaunty aspect, as do the murals. They take the form of a large number of inscribed cut-outs of red, green and yellow Vynalast laminate, scattered confetti-like across the white walls of each staircase, over its entire height. The pieces refer in a stylised fashion to the technical subjects that are taught in the college.

Artists' involvement

Early in 1983 an Oxford sculptor approached Derek Stanhope. He was seeking to arrange what is something of a Philosopher's Stone in the world of art and architecture: a close collaboration between artist and architect right from the start of a project. The time was right as plans for the college building were at an early stage.

Derek Stanhope became enthusiastic, and it was agreed to seek funding for a period of collaboration lasting six months, with a view to full integration of work with the building fabric. Areas under consideration included the stairwells, corridors and functional surfaces in the laboratories, and it was hoped that a ceramicist would also participate. The artist and architect estimated that a budget of £6,100 would be required for the exercise, and in March 1983 made an application to Southern Arts for a 50% contribution, under the Art for Public Places scheme. The Regional Arts Association agreed to Derek Stanhope's idea of a collaboration but they demurred as to his choice of artist. The architect was aware that

the building programme was proceeding inexorably, and the original aim of close collaboration from an early stage was rapidly becoming impracticable. So after delays, the situation was resolved at a meeting in September, when it was agreed, with the cognisance of the original artist, that the painter Graham Crowley be commissioned.

Brief to artist

Due to the unusual lead-up to the project, the architect was in the position of having a budget available before the artist's proposals were known. Partly because of this, he did not give Graham Crowley a formal brief, but asked what the artist could provide for the money. It was agreed that the staircases which, although small, are the main social areas, were the ideal place for a mural. The artist accepted the architect's suggestion that the mural relate to the primary colours used externally.

Client and user consultation

After talking to staff and investigating the college equipment, Graham Crowley set to work on his design, producing the first of two maquettes in late November 1983. He found that the criticisms made of his proposals tended largely to reflect specialist interests and indicated a very literal approach to the imagery. It was pointed out, for instance, that punched paper tape, used as a linking device in the composition, is no longer widely used for computers and that the saw-tooth roofed factories with chimneys belching smoke were an anachronism.

The architect explained that the mural was stylised and thematic to avoid becoming dated too rapidly and its 'comic strip aesthetic' was geared to the younger generation. This zany quality links it also to Graham Crowley's interest in investing inanimate objects with an anthropomorphic quality, as a means of suggesting a human presence. By mid-December 1983 the artist had produced a third version of his large maquette, and this was approved by the College Principal and Heads of Departments.

The contract

In February 1984 Derek Stanhope drew up a Specification for Decorative Wall Panels to enable Graham Crowley to prepare his quotation and conform to Oxford County Council's normal procedures.

Graham Crowley, 1984, vynalast staircase mural, Oxford College of Further Education, Oxpens.
Photograph: Timothy Ostler

Graham Crowley was employed directly by the client, Oxford County Council Education Department. He and his fixing sub-contractor were required to have Public Liability Insurance in the sum of £750,000. Because of the normal practice that no payment is possible until the materials are on site, it was agreed that the part of the fee to be paid by Southern Arts could be passed on to the artist as an interim payment. In fact payment was made when fabrication was virtually complete. Fixing costs were more than originally estimated.

The design

Graham Crowley's murals differ considerably from his easel paintings, due to his belief that the medium requires a fundamentally different approach. His work at Oxford shares the same dynamic 'streamer-like' quality as the mural for the Chandlers Ford Library in Hampshire, and in the waiting room at Brompton Hospital, London (both of these were carried out in stove-enamelled aluminium). Here, the colours match the primary colours of the building, such as the red doors, the red window-frames, the red handrails just below the mural, the yellow external trims and the white walls. Some of the green shapes are analogous to landscape, while the presence of car doors is apparently a homage to the nearby Cowley Car Factory. Linear elements are routed out of the laminate, but because they can be closely observed within the stairwells, the resulting chipped laminate, and dabs of paint used to touch up lines, are rather disturbing.

Graham Crowley, staircase mural, 1984. Architects: David Stanhope, Oxford County Council Department of Planning and Property Services. Commissioned and funded by Oxford County Council Education Department with financial support from Southern Arts Association.
Photograph: Timothy Ostler

Materials and Fabrication

The fabricating material Vynalast, normally used for signs, was suggested by the architect. Although more expensive than stove-enamelled aluminium, it promised to be simpler to work, and to modify on site. Fixing methods were a combination of mechanical and thick-bed adhesive; the pieces were backed with flameproof expanded polyurethane. (Vynalast itself has a Class 1 Spread of Flame certificate for interior use.)

The fabricators were BCD Contract Development Ltd, a firm of sign-makers, with whom the artist had previously worked. The original intention was for the mural to be installed after the building had been handed over, as artist and contractor were both worried about possible damage to the work. In the event, the building was not complete by the deadline. To avoid inconvenience to BCD, who had stored the work since fabrication, and to allow final payment to be made, Graham Crowley pressed for installation before handover. The mural was therefore installed over Easter, after the walls were painted, but before fixing of the handrail or suspended ceiling.

Installation

The pieces were light and easy to handle, nevertheless installation took twice as long as expected. Unfortunately on completion of the building in June 1984 the ceiling was installed at a lower level than Crowley had anticipated, resulting at one point in its being jammed uncomfortably against one of the mural pieces.

Unlike the murals at Chandlers Ford and Brompton Hospital, this mural is not demountable. The architect's view was that the extra cost likely to arise in repainting around the mural would be more than offset by the complication of dismantling and reassembling and in increased vulnerability.

Comments

The architect deserves credit for his gallant attempt to work closely with an artist on the building from its early stages. The final commission integrates well with the building and accentuates its optimistic atmosphere. The fuller design in the main staircase seems more successful than that in the secondary escape, which was somewhat diluted to bring the design within budget. It undeniably invests the two staircases with a special quality, however the murals are very much 'bolt-on' works. In his description of the scheme submitted to the client in December 1983, the architect explained that the work was not intended to be contemplated at length, but designed for an area of fast transit. For that reason, despite the care with which it has been fixed at the edges, its resistance to unofficial attempts at demountability will be a severe test. The glossy laminate's resistance to scratches also remains to be seen. The staircase does seem a little tight to contain all these vigorous goings-on. Perhaps this might have been improved had the architect had the opportunity of working with the artist earlier in the project.

The architect considers the project to have been both educational and stimulating, providing the opportunity to discuss the building's appearance as a whole with another professional who actually considers aesthetic criticism to be important. The result has been to increase this self-confidence, with regard to the use of colour throughout the whole building.

51

13 Seattle: A model for art in the city

Lesley Greene

The City of Seattle administers an enlightened percent for art programme which has inspired other American cities, and from which we could learn in the United Kingdom. Because of the rationalised programme of releasing money from city building projects, Seattle boasts a richly varied body of publicly sited art works and imaginative environmental projects. Artists are increasingly used to supply an imaginative input within design teams. Similar to Baltimore, Boston, Buffalo, Cleveland, Columbus (Ohio) and Winston-Salem which have based urban revitalisation on cultural programmes, the improvement of Seattle's urban environment has served to attract investment and commercial growth.

Background

For twelve years the City of Seattle has administered a Percentage for Art Programme whereby one percent of the costs of all new or refurbishment projects in the public sector is allocated to the commissioning of art. Over this period an estimated 550 artists have created works for the city's collection, with 26 major sited works and an art bank of paintings, photographs, prints, ceramics, glass and textiles. In addition the city's planning ordinances include a 'bonus formula' for encouraging the inclusion of art works in buildings in the private sector.[1] The programme has been so successful that it has become the model for percent for art schemes in other cities in the United States, particularly on the West Coast.[2]

The Percentage for Art Programme in Seattle was approved in 1973 following the city's worst economic recession in history caused by the virtual closure of Boeing in 1971, Seattle's major employer. The city embarked deliberately on a programme of constructive economic rejuvenation, central to which was a positive cultural policy. 'The City of Seattle accepts a responsibility for expanding experience with visual art' and accordingly 'policies are established to direct the inclusion of works of art in public Works of the City'. These include 'any capital project paid for wholly or in part by the City of Seattle to construct or remodel any building, decorative or commemorative structure, park, street, sidewalk, parking facility or utility or any portion thereof within the limits of the City of Seattle.' Funds made available by this levy of one percent from the (total) cost of construction projects are appropriated to the 'Municipal Arts Fund' administered by the Seattle Arts Commission.[3]

Implementation of the Programme

The Seattle Arts Commission oversees the development and implementation of the Percentage for Art programme, annually reviewing the city's capital investment and refurbishment schemes and identifying eligible projects. The Commission keeps a comprehensive list of potential public sites for consideration, the 'site-bank' which is continually updated. The essence of the programme is flexibility and variety: art works may be commissioned either as an integral part of a construction project or may be placed in other publicly-owned spaces. The greatest contributor to the fund is Seattle City Light, the city's electricity board. Although many of the construction projects undertaken by this body are unsuitable for art works, such as the installation of underground wiring, the percent allocation can be used elsewhere, for example to purchase works which will be placed in libraries or parks. The purchase is credited to Seattle City Light, who acknowledge benefits in terms of public relations.

Each eligible project is examined by the Seattle Arts Commission staff, following general guidelines and consideration of maintenance implications. Discussions of maintenance include the potential for accidental damage as well as vandalism, since many of the sites are functional. Increasingly, the projects are carefully assessed as to what scope there would be for the participation of the artist(s) in the architectural design process. The Arts Commission functions as an intermediary, 'anticipating the public's expectations and involving them, analysing the changing use of the City so that sites are not overlooked, and providing open and engaging opportunities for individual artists to create new works. The role of the Commission is not unlike that of a public library: whilst searching for the broadest range of visual arts experience for the public, the Commission must always be conscious of the need to promote work of enduring excellence' says Richard Andrews, former Co-ordinator of the Art in Public Places Programme, Seattle Fine Arts Commission.

Commissions follow codified procedures. For example it is standard practice that all projects are subject to an open selection process; where the jury exceeds a certain number, its membership must include an artist; there is a positive bias towards commissioning the work of local artists, and so on. The whole process is openly conducted, unless the jury takes a specific decision to the contrary. The jury are entitled to select

1 Developers who spend ½% or more of the cost of any building project on art, are permitted a percentage increase in building area. The emphasis is on art projects that 'enliven the pedestrian environment and enhance open public spaces'.
2 The City of Sacramento, which has followed Seattle in the organisation of its 'percentage for art' programme levies 2% for art, and applies this also to private development in certain specific areas of the city. Unlike Seattle, the administration of the programme is paid for from the 2% levied (Seattle's administration is paid directly by the city, not from the projects budgets). The private sector is entitled to use the Sacramento Arts Commission for advicce, administration and organisation, if needed. The Commission hopes to attract developers not bound by the percentage legislation into commissioning works of art by a 'bonus' package like that of Seattle, and by the annual presentation of City Design Awards with funds raised from the local newspapers and National Endowment for the Arts.
3 Details of the legislation are quoted from *Seattle City Ordinance* 102210

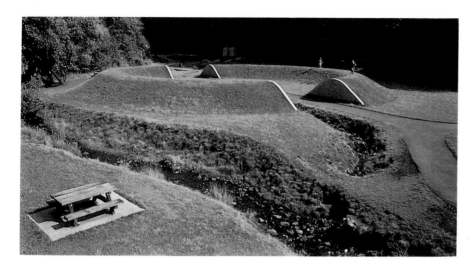

Herbert Bayer, *Earthwork,* 1981, earth, water, stones, trees and grass in 20 acre creek bed. Funded by City of Kent and Seattle Arts Commission, Percentage for Art Programme.
Photograph: by courtesy of Art on File, Chartier

Doug Hollis, *A Sound Garden,* grove of linear steel towers supporting wind activitated organ pipes on hill, 1983. Funded by NOAA with assistance from NEA and Seattle Arts Commission, Percentage for Art Programme.
Photograph: by courtesy of Art on File, Chartier

4 *Seattle Arts Commission, Procedures for Development and Implementation of 1% for Art Projects,* 6/1/78 & 4/20/81.

an artist directly for a commission, to invite a limited number of artists to prepare maquettes, or propose a second stage in a competition, and all artists' proposals are paid for. The proposal might take the form of the artist working with a city department to prepare a feasibility study on the basis of which other artists might then be involved. The concern is to choose artists for their ideas. Richard Andrews explains: 'The premium is always on the conceptually toughest artist, because they will retain their identity and strength through the design process. Very often these are not the artists which the architects want, because the work might appear to have, say, a strong social or political stance, and how does one work easily with that? To many architects or designers the job is an eight to five job, not a cause, whereas from the artist's standpoint it is likely to be a once-in-a-lifetime opportunity. We do not wish to institutionalise public art – we want artists of all kinds to look creatively at all opportunities.'

Selected projects require the approval of the Arts Commission, following technical reports on feasibility and maintenance by the project architects or designers. Once the commission is awarded or a work purchased, a contract is drawn up, and administration for the progress of the work is the responsibility of the Arts Commission.[4] There are strict procedures for the documentation, registration, care and installation of all art works, and maintenance is contracted out to a private art conservation company.

Plan for the City

The Arts Commission contributes to the annual 'Municipal Art Plan' which is incorporated into the city forward planning programme. A recently drawn-up document 'The Network of Primary Public Places' specifies what kind of art works could be included in developments. 'Effectively placing art in the public domain demands an understanding of the complex urban networks which make up a city, the uses and characteristics of potential locations, and of the range of art works being created' says Richard Andrews. Artists contribute to planning projects of this kind through detailed studies of small areas. For example, the placing of large formal sculpture is not viable in

downtown Seattle, so encouragement is given to projects such as the design of manhole covers and street furniture, which provide much needed contact between urban planners, architects and artists.

Viewland-Hoffman Electricity Substation

The building or refurbishment of electricity substations form a large part of City Light's architectural work. The Viewlands-Hoffman substation, which converts hydro-electrical power for residential use was one of the first of such schemes to qualify for the percent for art, and was the idea of architect Richard Hobbs of Hobbs, Fukin, Davison Partners. 'If you're going to have to work with someone on a project then it seems sensible to bring them in before anyone has any preconceived ideas'. The artists selected for the design team were Andrew Keating, Buster Simpron and Sherry Markovitz, working from the planning stages with the architect, engineer, landscape architect and residents of the neighbouring community. They recommended acquiring works from Emil and Vera Gerhrke, two local folk artists; their colourful and witty painted wooden whirligigs are set in a compound adjacent to the main electricity area with especially modified fencing to allow them to be enjoyed. Andrew Keating designed the painted abstract mural and the 'danger' signs. All the artists worked on the pastel colour schemes, and the colour-coding for items of equipment.

The sub-station has won many design awards and has set a precedent in turning an unattractive technological necessity into a work of art. It has also improved social relationships with regard to those living in the vicinity of the sub-station: 'The city is shown to care enough about its communities by such actions, and the issue of resistence to electricity sub-stations in Seattle has been markedly affected', says Richard Andrews. As this was the first design team experiment it took the artists, architects and engineers some time to sort out their relative positions, but also meant the establishment of tighter procedures for the following collaborations. Now artists are given an introduction to the schedules, budgets and restrictions on the project before the first collaborative meeting.

NOAA

As a new Federal programme based in Seattle, the National Oceanic and Atmospheric Administration is a major co-operative enterprise between national and local agencies, the United States Department of Commerce, City of Seattle and the National Endowment for the Arts. The project is concerned with attracting the public back to a former army base situated along a derelict water front, and has been pitched at a very high level, with artists of national reputation working alongside architects, landscape architects and engineers.

The brief has required the out-door art works to be in keeping with the architecture, to draw attention to the aims of the Centre and improve the beauty of the surroundings. The artists therefore have worked closely with the landscape architects to develop a shoreline walk, along which there are art works to be walked over, sat on, or listened to. The walk commences with Martin Puryear's concrete dome, from which the visitor can get a panoramic view of the whole area. Scott Burton's *Viewpoint* incorporates carved glacial boulders for seats, and careful planting and the placing of stones on the geometrically patterned raised platform encourages the visitor to sit and contemplate. Siah Armajain has made two footbridges of pink aggregate concrete inlaid with strips of terracotta tiles, decorated with quotations from Moby Dick (appropriately for an oceanic research station.) George Trakas has carved a small 'shipping dock' jutting into the lake, a conceptual piece which invites people to sit

at the water's edge. Doug Hollis' tall steel tubes are wind organs, playing a different set of musical chords according to the strength of the wind.

Broadway Dance Steps

Jack Mackie was the artist member of the design team for the improvement of this run-down area of Seattle, and was involved in the discussions from the start. The project was concerned with pedestrianisation of the area, and in a car-oriented society, encouraging people to walk and use the street. The team designed amenities like street furniture, planting and shopfront refurbishment: one of the more imaginative ideas was the provision of bronze footsteps set into the paving. These are arranged in the patterns of different dance formations, and by following them one can learn dances like the tango, foxtrot and rumba. They are found in eight different locations along Broadway, and are varied according to area by small details: for example there is a coffee bean in the latin-american rhythmn steps outside the coffee-shop.

This commission challenges the uniformity of American urbanisation, and adds humour and a distinctive quality to the street-life of this area of Seattle.

Comments

The flexibility and variety of Seattle's Percentage for Art programme comes from the ability to pool the percent levied. This flexibility facilitates the development of the artists' role in the city as maker, thinker and catalyst, because funds can be shifted into strategically important areas to support specific projects if they warrant a higher investment.

The one percent law means that art and the rôle of the artist has to be considered at the very beginning of a project, and increasingly this has meant the involvement of an artist, or a group of artists, on the design team. In all projects the quality of the idea is considered important, not questions of authorship. An artist is hired for an imaginative contribution, the 'random element', not necessarily for the reproduction of a stylistically predictable studio work. The artist therefore is regarded as supplying the team with something specific and different in kind from the contribution of the architect, designer, and engineer.

The Arts Commission representing an elected authority and acting as jury and administration also believes itself, in the words of Richard Andrews, to be an advocate for artists: 'My ability to say "Well, why not?" on behalf of an artist has been the key to solving many problems within a bureaucracy where it's much easier to say "no"'.

Seattle's commissioning programme has undoubtedly provided an exciting urban fabric, and has attracted considerable publicity and national awards. In existence for twelve years it has not yet been voted out by the electorate.

Nathan Jackson, *City Hatchcover,*
1976, 0.91m diam. cast iron in
sidewalks. Funded by Seattle Arts
Commission, Percentage for Art
Programme, and Seattle City Light.
Photograph: by courtesy of Art on File, Chartier

Jack Mackie, *Dancers Series: Steps*,
1982, cast bronze in concrete, along
Broadway Avenue, Business District.
Funded by Seattle Arts Commission,
Percentage for Art Programme, City of
Seattle Engineering Department and
Broadway Local Improvement District
Photograph: by courtesy of Art on File, Chartier

14 The longest art gallery in the world

Lesley Greene

1 Hans Akerblad, Chairman of the Advisory Committee for Art, Stockholm County Council Public Transport Board quoted in *The Jarva Line, Artists at Work*, published by the Stockholm Lans Landsting.
2 This has become obligatory since the setting up of the special Art in Public Places programme of the art department at Lund University. The department has an extensive archive, and a museum devoted to public art.

Brussels, Amsterdam, Toronto, Munich, Prague are some of the cities which have programmes for enlivening their Metro Systems with commissioned art works, but Stockholm Underground is probably the richest and most consistent, with 110 decorated platforms. The Stockholm Underground Art Board is committed to commissioning works of quality: 'For many [people], an encounter with art in the underground railway can mark the beginning of an interest in art, whereas for others it offers a deeper insight into good art.'[1]

Background

Stockholm Underground is one of the most amazing and pleasurable metro systems in Europe, with its 110 decorated platforms, some of them conceived as total environments. Increasingly, it has become a tourist attraction in the city. Advertisements are only to be found sparingly in the metro system, which is heavily subsidized. The investment in art has been a strategy for making the system more attractive, as increased usage is considered a priority. Figures show a steady annual increase in commuter use and in 1983 74% of Stockholm's commuter population travelled by public transport.

The system is relatively new, construction having begun in the early 1950s; and from the start artists have been involved in the project. The artists' contribution grows out of a strong national policy towards art and design. Sweden was one of the earliest European countries to introduce a mandatory percentage for art but this was rescinded during the war years. Although the measure was never formally re-introduced at a national level, most authorities operate a percent for art scheme at local level and all new government buildings incorporate art works. In addition, Sweden has a powerful arts lobby, headed by the official artists' union, the KRO. When planning commenced on the underground, an Art Board was set up with KRO representation, to discuss how artists could be involved in the new system. Stockholm is a city built on granite, which meant that the metro system was required to be blasted out of the bedrock, then lined at considerable cost, to give the conventionally smooth appearance of traditional tunnel systems. It was the artists in discussions with the planners who suggested that the blasted tunnels should be left raw, without concrete linings. They proposed to capitalise on the grotto-like appearance of the tunnels by decorating directly on to the rough surfaces. This radically

simple solution was accepted, saving millions of kroners and allowing for a unique concept in metro design.

Commissioning methods

Although a formal percentage for art does not apply to this scheme the commitment to art is intrinsic to the planning and design of the underground which is now in its last stages of construction. The artists are selected by a Transport Art Board, consisting of the architects, representatives from the government and Stockholm City, an art in public places adviser from the government art programme and a representative from the Artists' Union and an art historian.[2]

Art works are commissioned directly or through limited or open competitions, with some simple guidelines for selection. For example, since maintenance considerations are important, highly complex or vulnerable art works are not commissioned (there is, for example, no neon-light work on the Underground). The notion of orientation is also a priority and artists are asked to consider how their proposals will assist the commuters in the recognition of each particular station, and give clues to access routes.

Social Protest

Although it is stated in the commission briefs that political propaganda is not considered appropriate, schemes of an overtly ideological nature have been carried out. The station of Östermalmstorg, for example, was decorated by leading feminist artist Siri Derkert in 1965 with imaginative sandblasted drawings and texts related to the Women's and Peace Movements. These caused much controversy initially, but are now accepted by transport and tourist authorities, as well as by members of the public, as works of considerable artistic achievement. The station of Solna Centrum has large murals by Kare-Olof Björk and Anders Åberg which show realistic cityscapes, chimneys belching smoke and black rain falling on leafless forests. These are contrasted with green landscapes, filled with animals and flowers, and reflect the current concern in Sweden about questions of environmental pollution.

Integrated projects

So far as possible all the art works have been integrated into the station design, and installation is part of the

Ake Pallarp and Enno Hallek, 1973, Stockholm Underground, coloured wooden signs on Stadion Station.
Photograph: by courtesy of Stockholm Regional Transport

Plate 9

Art in Seattle, USA

Andrew Keating, Sherry Markovitz, Lewis Simpson, Mr and Mrs Gehrke, 1979, mural, colour coded electrical equipment, whirligigs with folk art objects, Viewlands Hoffman Substation. Funded by Seattle City Light and Seattle Arts Commission, Percentage for Art Programme

Robert Irwin, *Nine Spaces, Nine Trees*, 1983, cement planters, plum trees, wire mesh fencing. 6.71 x 6.71m. Funded by Department of Administrative Services, National Endowment for the Arts, Fentron Building Products and Fabrication Specialists

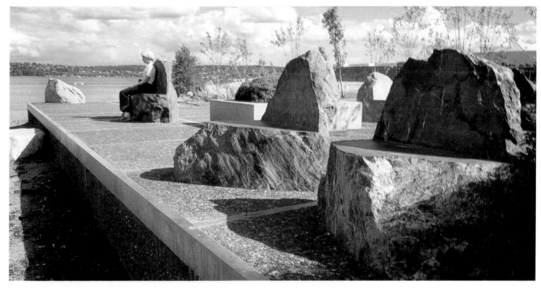

Scott Burton, *Viewpoint*, 1983, concrete, stainless steel, glacial erratics, trees and shrubs, approx. 12 x 12m. Funded by NOAA with assistance from National Endowment for the Arts and Seattle Arts Commission, Percentage for Art Programme

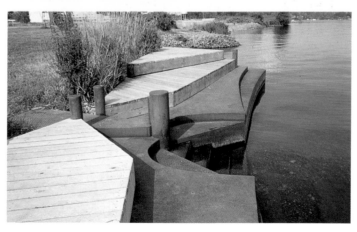

George Trakas, *Berth Haven* 1983, steel and wood. Funded by NOAA with assistance from National Endowment for the Arts and Seattle Arts Commission, Percentage for Art Programme

Plate 10

The longest art gallery in the world

Swedish artists proposed that Stockholm Underground, blasted out of the granite bedrock, should remain unlined, thereby saving the authority millions of kroners. The 110 decorated stations attract nearly as many tourists as commuters.

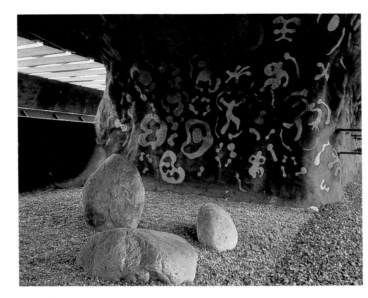

Olle Angkvist, painted decoration and formally placed natural stones on Alby station 1975
Photographs: by courtesy of Stockholm Regional Transport

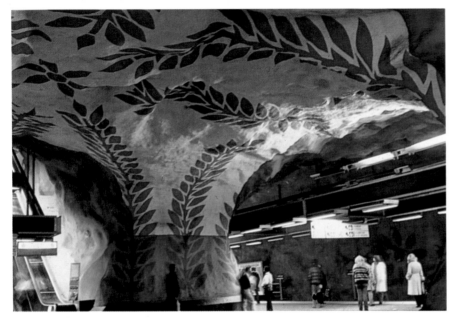

Per Olov Ultvedt, blue painted leaves and flowers on blue and white ground, and silhouettes of craftsmen, Järvabanan station, 1977

Ulrik Samuelson, painted harlequin arabesques on Kunsträdgàrden station, 1977

Elis Eriksson and Gösta Wallmark, motifs from the *World of Children*, 1975, painted sculptures in Hallonbergen stations

3 *The Jarva Line, op.cit.*
4 ibid.

building contract, although murals are usually carried out after completion of building-work. The artist's contract is with Stockholm Local Transport and is kept as simple as possible. As they are involved from the beginning, the artists are aware of any problems in the project and can be flexible in relation to the overall contract.

T-Centralen, the biggest central Underground station in Stockholm, was the first station to be decorated, following an open competition. The quality of entries was so high that the jury decided to allocate areas for decoration to many individual artists. Although some interesting work has resulted in glazed ceramic tiling, sculptural benches, mosaics, decorative brickwork, and iron grilles, the result does not lend overall coherence to an extremely busy station. The Art Board now follows a policy of commissioning individual artists or artists groups (selected from open or limited competitions) to deal with spaces as a totality.

Special stations

One of the most exciting stations is the Kungsträdgården, designed by artist Ulrik Samuelson. Completed in 1977, the scheme relates to the Kings Gardens, the seventeenth century royal hunting park nearby, and is a baroque fantasy of extraordinary playfulness and variety. The artist worked directly on the crude blasted rock surface, spraying on concrete and painting brightly coloured harlequin designs, interspersed with pink and grey polychrome sculptures, reminiscent of classical statuary. The floor is patterned in grey, red and white terrazzo inlaid with mosaic, with an occasional intrusion from the twentieth century in the form of bottletops embedded in the design.

A petrified waterfall, through which actual water drains through cracks in the rock strata during bad weather above ground, is an inventive solution of a functional problem. Painted gondola posts remind the traveller that Stockholm is the Venice of the North.

At T-Centralen, new and older platforms are connected by 100 m-long moving platforms. Four artists, were given the considerable task of decorating 50 m of wall. Connecting halls were painted by one of Sweden's leading younger artists, P O Ultvedt assisted by a team of housepainters and students painting with silicate paint directly on to the plaster. Blue leaf shapes form a continuous decorative pattern in one area, huge silhouettes of working figures in another. Ultvedt was influenced by the ideas behind Moscow Underground: 'It has to be as beautiful as possible, as they see it, in a place which is owned by all and which all have the right to use. They have moved their palaces underground, and I have the same basic idea.'[3]

Changing exhibitions

Some of the older stations have exhibition cases along the platform walls. Unlike the formal exhibition cases

for museum exhibits at the Louvre station on Paris Metro, these are intended for exhibitions by children, local craftspeople and other groups, and are changed frequently. Two stations have special arrangements for exhibitions by professional artists. There is also work by local community groups, such as the colourful carvings in traditional folk style at Midsommar-Kransen station.

Signing

Graphics and signing are uniformly discreet throughout all the stations, but wherever possible artists have been encouraged to include signs as part of their brief. Sometimes this is as straightforward as the large pointing hand cut-outs on the walls of Stadion station, signalling exists in bold red, yellow and blue. At Danderyds Sjukhus station, the metro serving a large hospital, glazed plaques depicting medicinal herbs and tiled floors decorated with the coiled serpent-symbol make the appropriate connections for travellers. Latterly the Art Board has recognised that location can also be identified by the 'signing' of the artist's own hand and style, and have allowed the newer stations to be influenced by the personality of the artist chosen. Some artists, however, have preferred not to impose their personalities: 'I don't want to impose myself on people, so on the floor I lay texts, fragments of poems, figures which children have made; you must be able to make your own associations', writes Lizzie Olsson-Arle.[4]

Comments

The Stockholm Underground has come about because of a fundamental belief in the right of the public to well-designed facilities: 'It is an inspiring task . . . to contribute towards making the milieu encountered by the passengers and public transport staff as stimulating and interesting as possible. Few places provide such great opportunities for contact between so many of the people living in a community,' states the Stockholm Underground Art Board. In addition, the art programme has been facilitated by the board's policy against aggressive advertising, although this is a political controversy which has never been completely resolved. The powerful, well-organised and socially responsible artists' lobby has also played a considerable part in the scheme. Some stations are less aesthetically interesting, or successful than others, but the sheer quantity and variety of work has guaranteed the public success of the project. Both aspects of the public art debate have been satisifed: overall the Underground is a place where the community can enjoy art and be opened up to new experiences, and the individual artist can find expression within a public context.

Most importantly, the Transport Art Board does not just see its role as providing bland decoration but has a commitment to innovatory works of quality, which it unashamedly calls 'good art'. There are plans for extending this involvement to areas in the city's transport system beyond the Underground.

Ake Pallarp and Enno Hallek, 1973, Stockhölm Underground, coloured wooden signs on Stadion Station.
Photograph: by courtesy of Stockhölm Regional Transport

57

Metro Art

European Metro Systems employ art in characteristically different ways. Brussels Metro System deploys a wide range of art works including large – scale narrative murals in public concourses. Some of the art works for Amsterdam Metro are overtly political, others are very formal or witty.

Jan Sierhuis, *Demolition Ball*, Nieuwmarkt Station, Amsterdam Metro, 'The hanging up of the demolition ball in the Metro station in our district is a lasting token of resistance.' Jan Sierhuis.
Photograph: Photo Ed Suister, by courtesy of Amsterdam Metro

Antoine Mes, Gaasperplas Station, Amsterdam Metro.
Photograph: Photo Ed Suister, by courtesy of Amsterdam Metro

Paul Delvaux, *Nox Vieux trams Bruxellois*, 1978, Bourse Station, Brussels Metro. Oil on canvas 2.35 x 13.25m.
Photograph: Photo Ed Suister, by courtesy of Brussels Metro

SECTION 3
How to commission

The commissioning process step by step

Each commission is bound to be different, but there are certain basic stages common to all commissioning procedures. In order to make these clear and allow for easy reference, four models have been set out step by step, in an attempt to cover as many situations as possible. The items are cross-referenced to the following chapters where they are dealt with in greater detail.

The most comprehensive model, designated **The Perfect Patron Model**, sets out most of the stages which will be encountered in a straightforward commission. It is accompanied by a diagrammatic flow-chart. In **The Advanced Architect Model**, additional information is supplied for the architects who iniate commissions, and guidelines on establishing policies are provided in **The Complex Collaborative Model**. Artists often set up commissions themselves and the stages of this model are shown diagrammatically in the flow-chart of **The Artist Initiator Model**.

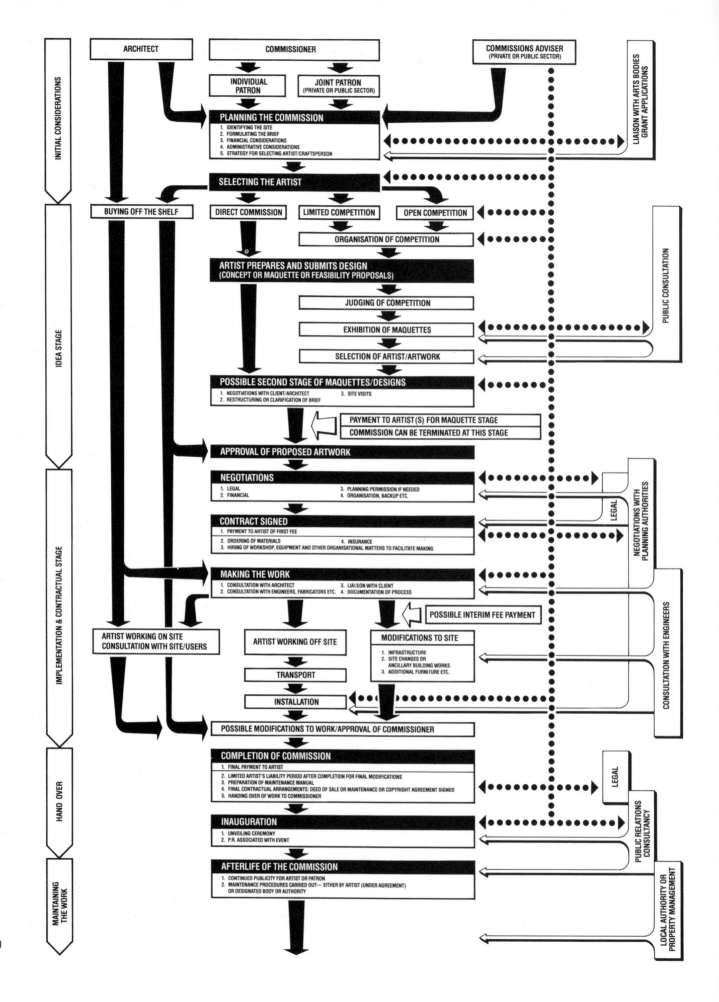

ARCHITECT

COMMISSIONER

COMMISSIONS ADVISER
(PRIVATE OR PUBLIC SECTOR)

LIAISON WITH ARTS BODIES
GRANT APPLICATIONS

INITIAL CONSIDERATIONS

INDIVIDUAL PATRON

JOINT PATRON
(PRIVATE OR PUBLIC SECTOR)

PLANNING THE COMMISSION
1. IDENTIFYING THE SITE
2. FORMULATING THE BRIEF
3. FINANCIAL CONSIDERATIONS
4. ADMINISTRATIVE CONSIDERATIONS
5. STRATEGY FOR SELECTING ARTIST/CRAFTSPERSON

SELECTING THE ARTIST

BUYING OFF THE SHELF

DIRECT COMMISSION

LIMITED COMPETITION

OPEN COMPETITION

PUBLIC CONSULTATION

ORGANISATION OF COMPETITION

ARTIST PREPARES AND SUBMITS DESIGN
(CONCEPT OR MAQUETTE OR FEASIBILITY PROPOSALS)

IDEA STAGE

JUDGING OF COMPETITION

EXHIBITION OF MAQUETTES

SELECTION OF ARTIST/ARTWORK

POSSIBLE SECOND STAGE OF MAQUETTES/DESIGNS
1. NEGOTIATIONS WITH CLIENT/ARCHITECT 3. SITE VISITS
2. RESTRUCTURING OR CLARIFICATION OF BRIEF

PAYMENT TO ARTIST(S) FOR MAQUETTE STAGE

COMMISSION CAN BE TERMINATED AT THIS STAGE

APPROVAL OF PROPOSED ARTWORK

NEGOTIATIONS
1. LEGAL 3. PLANNING PERMISSION IF NEEDED
2. FINANCIAL 4. ORGANISATION, BACKUP ETC.

LEGAL

NEGOTIATIONS WITH PLANNING AUTHORITIES

CONTRACT SIGNED
1. PAYMENT TO ARTIST OF FIRST FEE
2. ORDERING OF MATERIALS 4. INSURANCE
3. HIRING OF WORKSHOP, EQUIPMENT AND OTHER ORGANISATIONAL MATTERS TO FACILITATE MAKING

IMPLEMENTATION & CONTRACTUAL STAGE

MAKING THE WORK
1. CONSULTATION WITH ARCHITECT 3. LIAISON WITH CLIENT
2. CONSULTATION WITH ENGINEERS, FABRICATORS ETC. 4. DOCUMENTATION OF PROCESS

POSSIBLE INTERIM FEE PAYMENT

CONSULTATION WITH ENGINEERS

ARTIST WORKING ON SITE
CONSULTATION WITH SITE/USERS

ARTIST WORKING OFF SITE

MODIFICATIONS TO SITE
1. INFRASTRUCTURE
2. SITE CHANGES OR ANCILLARY BUILDING WORKS
3. ADDITIONAL FURNITURE ETC.

TRANSPORT

INSTALLATION

POSSIBLE MODIFICATIONS TO WORK/APPROVAL OF COMMISSIONER

HAND OVER

COMPLETION OF COMMISSION
1. FINAL PAYMENT TO ARTIST
2. LIMITED ARTIST'S LIABILITY PERIOD AFTER COMPLETION FOR FINAL MODIFICATIONS
3. PREPARATION OF MAINTENANCE MANUAL
4. FINAL CONTRACTUAL ARRANGEMENTS: DEED OF SALE OR MAINTENANCE OR COPYRIGHT AGREEMENT SIGNED
5. HANDING OVER OF WORK TO COMMISSIONER

LEGAL

PUBLIC RELATIONS CONSULTANCY

INAUGURATION
1. UNVEILING CEREMONY
2. P.R. ASSOCIATED WITH EVENT

MAINTAINING THE WORK

AFTERLIFE OF THE COMMISSION
1. CONTINUED PUBLICITY FOR ARTIST OR PATRON
2. MAINTENANCE PROCEDURES CARRIED OUT— EITHER BY ARTIST (UNDER AGREEMENT) OR DESIGNATED BODY OR AUTHORITY

LOCAL AUTHORITY OR PROPERTY MANAGEMENT

15 The Perfect Patron Model

This is the most straightforward method of commissioning when the clients (or patrons) know more or less what they want, why and where they want it, and money for the commission is to hand. Here the client is a clearly identifiable individual or body (whereas in practice a number of different agencies, authorities and funding bodies can be involved in a commission in addition to the commissioning client.) [See Chapter 30] In the initial stages, the client will choose an artist and formulate a brief. Although these two series of activities have been set out consecutively for clarity, they will run in tandem during commissioning.

Choosing the Artist

The client has three options:
1 To buy an art work off the shelf, that is, directly from a gallery or studio.
2 Commission an artist directly.
3 Commission by means of a limited or open competition. To facilitate the process, the client can seek advice from various arts bodies and consult slide registers [See Appendix III] or delegate the choice of the artist to:
[a] A professional who has a reasonable knowledge of the process – perhaps an architect, interior designer, or free-lance arts administrator,
[b] A specialist public art consultant. [See Chapter 24]

1 Buying off the shelf

Buying directly is viable if there is a choice of sites, or if the work is not required to fulfil environmental, architectural and programmatic requirements as in the case of a site-specific commission. In buying directly from a gallery, the client and/or adviser will need to consider whether the work purchased is appropriate in terms of scale, subject matter and material. (An artist preparing a work for a gallery exhibition might not necessarily consider matters of durability of material and finish which would be of importance if the work was sited in the open air.)

The cost of a work bought from a commercial gallery will include commission; in the case of a London West End dealer this could be as high as 60%. However the dealer will also provide professional attention and advice. Public or local authority galleries take a much lower commission on works sold, usually between 20%

and 35%. Not all artists are contracted to galleries or represented by dealers, and their work can be seen and sold directly from the studio. Most organised studio-complexes have annual 'open studio' exhibitions advertised in the art press, and studio visits under these auspices are a very useful way of seeing a range of work, and comparing prices. It is impossible to give guidelines on art prices, as these depend on many factors; but it is as well to remember that an artist can still have a high reputation without being represented by a dealer. Quoted art prices may be open to negotiation.

It is advisable to exchange a Contract of Sale agreement, as this will protect both client and artist with regard to copyright, resale matters or maintenance of the work after it has been bought. [See Chapter 30]. When buying off the shelf the 'brief' will probably be in the form of a checklist of dimensions, prices, etc. which the client prepares for personal use.

2 Commissioning directly

Studio visits are also important if the client commissions directly from a craftsperson or artist, in gaining an understanding of the artist's capabilities and establishing a *rapport*. For a major commission, the client should be confident that the artist can work on a more ambitious scale than normal studio practice, but lack of experience should not be a deterrent.

The relationship between artist and client is a vital part of a commission, and can be very rewarding. The artist is making 'to measure' and will expect a close dialogue with the patron, not only with regard to material specifications but also in terms of aesthetic response. The client may be pleasantly surprised at the creative nature of this close involvement. Nevertheless the parameters of the collaboration need to be quite clearly stated from the beginning, even to the extent of the client establishing whether the artist will welcome visits during the making of a work, or wishes only to have a dialogue during initial design or drawing stage.

A brief needs to be drawn up and a contract agreed and signed – even if the latter is only an exchange of letters – because misunderstandings can occur later. The contract lays out a time-table for payment, delivery, options for refusal, and so on, and is a protection for both parties. [See Chapter 30]. If the artist is contracted to a gallery, the dealer will be entitled to take a commission on the cost of the project (probably

Arnolfini is situated on a breezy quay-side in Bristol and a major determinant in the brief for a neon sign was that it should be wind-resistant.

Jane Moore *Untitled,* Neon tubing and steel structure, 6.47 x 2.0 x 2.75m, Arnolfini, Bristol. Commissioned by Arnolfini Gallery Ltd. with matching funds from ACGB.
Photograph: by courtesy of Arnolfini

negotiable as to percentage) but will also assist in the paperwork and negotiating stages.

Formulating the Brief

In all commissions, formulating the brief is an important tool for clarifying ideas and expectations on both sides. Even when the artist is responding to a pre-set competition brief, there should be enough flexibility for the artist and client to modify the specification in practice. A tight brief might be too aesthetically restrictive for some artists while others will welcome definite guidelines, and the client will need to take these personal responses into account. It must be borne in mind that art making is to a large extent a dialogue between idea and process with the one constantly modifying the other. [See Chapter 20].

The brief provides a framework for environmental factors, timing and finance as well as form, content, social responsibility and symbolic requirements. Although these facts are all essential, it is also important to devise an *imaginative* brief which can stimulate a creative response in terms of concept, materials and techniques.

Liliane Lijn, *Split Spiral Spin,* 1980-82, perforated stainless steel, 11.58 x 6.10m, acts as an emblem for Warrington Science Park Commissioned by Warrington Development Corporation.
Photograph: Stephen Weiss

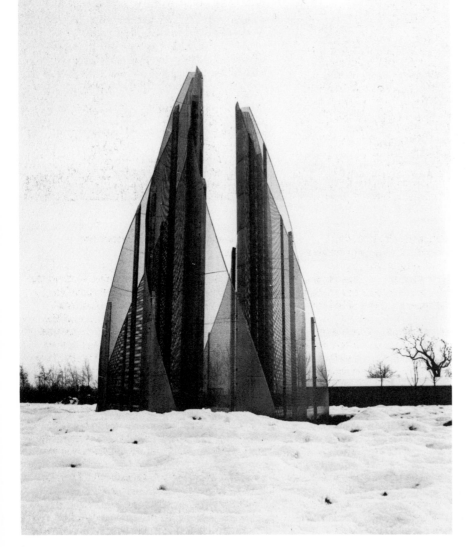

Factors for inclusion in the brief

■ Indications of *Materials and Medium* are required, although these are often a matter for discussion.
■ Details of *Site and Technical Aspects*. In addition to providing plans and elevations of the site, and clear dimensions and indications of scale, the brief will need to make clear the technical or environmental considerations which might affect the work. For example, whether the work needs to be fireproofed, whether a site is particularly windy, its public vulnerability, whether an area is spatially restricted, load-bearing considerations, access for cleaning or maintenance purposes, and so on. It is always useful to provide photographs of the site, and elevations or perspective drawings, as the artists might not be trained to read the implications of a plan. At the same time the brief should be clear about access to the site and specify the architect's, engineer's or contractor's responsibilities for site modifications or installation.
■ *Content*. The client may want references to a specific event, narrative or symbolic content or programme of ideas to be expressed in the work. For example, the need for a piece to act as an emblem (such as the Liliane Lijn sculpture *Split Spiral Spin* for Warrington Science Park which makes references to wind technology); to signal the importance of a building or cultural institution (such as Ron Haselden's neon 'sculpture' outside the concert hall of Nottingham's Royal Centre); to be a memorial (such as Antony Robinson's gates for Winchester Great Hall, commemorating the wedding of the Prince and Princess of Wales), or to function as landmark. The London Life Association employed an historian to research the programme for a mural in their new headquarters in Bristol, which established very precise images to which the artist Patrick Caulfield could respond. A richly iconographical brief can be very important in establishing a linking rationale with architecture or site.
■ *Social Responsibility*. The commissioning individual or group may wish a commissioned art work to reflect the aspirations of a particular community or arise out of a process of consultation with that community. Certainly it is a fact that works are least vandalised and are considered most successful if they have been placed within a climate of consultation and care. These notions can become part of a revised brief, as happened with artist Kevin Atherton. After spending some time in Langdon Park School in East London, he restructured the brief and devised *A Body of Work* which is specific to the school community. Consultation procedures call for administrative back-up for the artist(s). [See Chapter 25].
■ *Maquettes or designs*. It should be stated clearly whether initial designs or models are preferred, the fees for the maquette stage, and when and where maquettes should be presented.

3 Commissioning by competiton

Competitions for major public works or large-scale commissions have a long historical tradition, from the competition for the bronze doors for the baptistry of Florence Cathedral in the 15th century to the competition for the *Unknown Political Prisoner* in 1953.

Kevin Atherton's body casts in the grounds of Langdon Park School, London arose out of his observation of the school community.

Kevin Atherton, *A Body of Work*, 1982, bronze, life size, Langdon Park School, Poplar, London. Commissioned by Tower Hamlets Arts Committee. Funded by Tower Hamlets Arts Committee, Alloy and Metal Holdings, British Petroleum, Moderoch with support from GLAA.
Photograph: David Hoffman

A major international competition in the post-war years for a sculpture of the Unknown Political Prison *was won by Reg Butler but never commissioned.*

Reg Butler, *Monument to the Unknown Political Prisoner*, 1955-6, working model, Forged and welded steel, ht 2.21m. Prize money privately donated.
Photograph: by courtesy of the Tate Gallery

The organisation of a competition is obviously administratively complex and more expensive than a direct commission, but has several advantages:
■ For a relatively modest financial outlay the client can be presented with a wide variety of ideas and art works which both client and architect would not otherwise have known about.
■ The multi-faceted nature of a competition attracts publicity and media attention to the patron and artist.
■ Competitions give the chance for the work of young, unknown or ignored artists to be seen, and widens the opportunities for further contacts between artists and patrons.
■ Although admitting that competitions are a much more democratic procedure, artists are divided as to their preference for competitions or direct commissioning. However, competitions are tactically important for arts funding bodies and elected authorities who can be seen to be making the widest opportunities available to the greatest number of artists of all kinds. The Welsh Arts Council has a policy, worked out in association with the AADW (Association of Artists and Designers in Wales) that all public

commissions are circulated to artists in the Association's newsletters.

The intention of an **Open Competition** is to attract the widest variety of talent and the greatest possible publicity. It should be advertised in craft, art and architectural journals and the local press, and if the competition is for a large-scale and well-funded work, it is worth advertisement in the national media, and a public poster campaign. It is difficult to predict which kind of competition will attract a high standard of entrants; unlike architects, artists do not traditionally work on competitions when their practice is slow. Probably the major factors that affect entrance are the size of the commission, the amount of publicity and the quality of the jury. There is not much point in arranging an open competition for a small-scale commission.

In a **Limited Competition** between two and six artists (but potentially any small number) are invited to submit work. This can be a two-tier operation, with an open submission of slides and artist's portfolios, followed by a selected short list of artists who are asked

to prepare designs and maquettes. The time-scale, therefore is about the same as for an open competition: the advantage is that artists are paid a development fee for their designs, and there will be a higher level of presentation than in an open competition, where the quality of presentations can vary enormously. Pre-selection (by a jury or art specialist) is also designed to exclude technically incompetent artists, but unless the request for portfolios is widely advertised this method will not throw up new and surprising talent.

Steps for Organising a Competition

There are no abiding rules and regulations for art competitions as there are for architectural competitions, but certain basic procedures will have to be followed, and regulations set up to bind both artists and jury to fair practice. All competitions require an agreed time-scale, budget and procedure and should be organised by one body or individual who takes administrative responsibility throughout.

1 *Selection of Jury*
■ The number of jurors depends upon the size and complexity of the project, but very large juries should be avoided. It is advisable that the jury has specialist art knowledge and is drawn from artists, art critics or journalists, art historians, art administrators, museum curators, lecturers from art colleges or universities. There should also be representation from the community where the work will be sited; and representatives of staff as well as management, in the case of a commission for a place of work. Juries of three or more should include at least one artist.
■ Although there is a view that jurors should not be paid in order to maintain neutrality, in the case of artists or self-employed or free-lance jurors for whom it might be a financial burden to serve, consideration should be given to paying a jury fee (as is the case in the United States on most percent for art jury schemes) and certainly in defraying expenses.
■ Jury members should be circulated with a letter detailing the project and brief, responsibilities and method for arriving at a decision.

2 *Advertising the Competition*
■ In the case of a large competition, it is advisable for the advertising material and entrance forms to be handled by a designer, to attract good returns.
■ It is necessary to check deadlines of all relevant art, craft and architectural journals as well as local and national, press for advertising copy. (Some journals require up to two months' notice or appear irregularly).
■ To reach the greatest number of artists, it is useful to supplement advertising by direct mailing (not all artists subscribe to journals). Mailing lists are obtainable from national, regional and local arts associations. [See Appendix III].
■ The advertisement should clearly set out the following information: the nature of the commission and the site; the level of budget and prize money; the deadline for entries; details of sponsors or client; details of jury; name, address and telephone number of the individual from whom further information and application forms are obtainable.

3 *The Competition Brief, Procedure and Rules*
The higher the quality of presentation of the brief, the higher the professional quality of the entries, so that where possible the information should be well designed and professionally printed. A standardised application form is also useful in processing the entries.

In addition to the matters listed under Formulating the Brief [above] the brochure should include information about:
■ Submission Requirements. It should be made clear what is required in terms of photographic slides or prints; drawings, designs and models (to a size specification); a written description itemising materials; and a first-stage costing and time estimate. A statement on why the artist wishes to undertake the commission (or residency cum commission) might be considered necessary. A *curriculum vitae*, catalogues or information about previous work are also useful.
■ Dates for presentation and times when artist must collect material after judging.
■ Procedures and stages of the competition. It should be made clear whether the artist will be expected to develop ideas at a second stage, and whether maquettes will be exhibited before the award is made. (If it is intended that votes will be taken from a public-consultation process, this information must be included.) It should also be made clear if shortlisted artists are required to make a presentation.
■ Names and professional status of the Selection panel.
■ Name and address, telephone number of organiser.
■ Prize and budget money, whether short-listed artists will be paid for maquettes and whether this automatically purchases the maquettes or not. (Ownership is vested in the artist unless agreement is made to the contrary). [See Chapter 30].
■ Rules of entry. Typical codes of conduct and eligibility specify:
No relations of sponsors, organisers or jury are eligible for entry.
The competition is open to any professional artist but students are encouraged/debarred from entry.
The competition is international/limited to artists resident in the country.
Insurance of the work is the artists'/sponsors' responsibility while the work is being stored and judged.
The judges decision is final and not open to discussion.
The judges can choose not to award a commission in the event of there not being any entry considered suitable.
The jury will be in closed session/open to observers.

4 *Receipt of Entries*

All entries must be acknowledged, catalogued and arranged for a clear presentation to the jury. A slide projector will probably be required, and it is advisable to label and keep all packaging.

5 *The Selection*

The jury should be familiar with the brief and the rules, and should have been taken to visit the site. The appointment of a chairperson will obviously facilitate the proceedings and allow for a casting vote in the case of a divided selection panel. One of the criticisms most often levelled at public or large-scale architectural

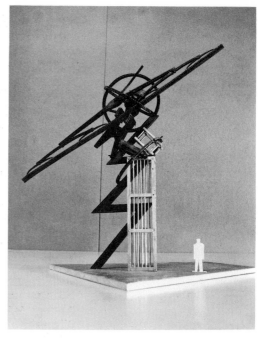

commissions is that they appear to be 'lowest-common-denominator' decisions, representing the least controversial work on which everyone could agree. It is important therefore to arrive at optimum decisions, of the best possible work rather than a compromise choice – even if this means calling for a second stage of short-listed entries. If maquettes/designs have been put on display in order to test out community response, or for the purposes of a popularity vote, these results will have to be considered by the selection panel as an important item in reaching a decision.

6 Exhibition of Maquettes and Consultation

It is advisable, if commissioned works are going into a multi-use building or public or semi-public site that the 'users' are given a chance to see the works and express their opinions. This might take place after the judging, but it is more useful if the information gathered from such a process influences the selection of the work. [See Chapter 25]. It is advantageous for the artist to present the designs in person.

7 Further Maquette Stage

Once maquettes have been presented, and a selection made, the patron can decide not to proceed with the commission and end the relationship with the artist(s) by paying maquette and development fees. It is also within the right of the patron to ask for modifications from the artist of the selected designs and produce new maquettes and drawings, subject to financial agreement. [See Chapter 23].

8 Return of Entries and Short-listing
All work must be returned well packaged, and the entrants informed of the results of the competition. It is important that the letter should not be brief to the point of being curt, and it is a courtesy to the unsuccessful artist to be informed who has won the competition or been short-listed, and for what reasons.

It is useful to inform the short-listed artists of the selectors' comments and to ensure that they are accompanied to the site by the architect, commissions adviser or commissioner in order to have the fullest information necessary for the next stage.

The Commission

Even in the case of a direct commission between a client and artist who have an established relationship, a contract is recommended.

The contract should be drawn up by a lawyer, with reference to the guidelines suggested in Chapter 30, and negotiated between artist and client, dealer and agent.

According to the financial terms of the contract, the first fee should be paid to the artist in respect of materials so that the work can commence.

Contractual obligations need to be clearly established so that for example application for planning permission, [see Chapter 29], or arrangements with building contractors and so on will be set in train.

Working and Consultation
■ The time when the artist is working on the commission is the opportunity for the development of a mutual support system between artist, client and commissions adviser. In addition to consultations connected directly with the art work, and depending on contractual arrangements, the artist will probably be grateful for organisational back-up with regard to ordering materials, writing letters, arranging meetings, keeping accounts and so on. If it is a first commission, the artist could be relatively inexperienced in such matters, and the client may well be in a situation to offer expertise.

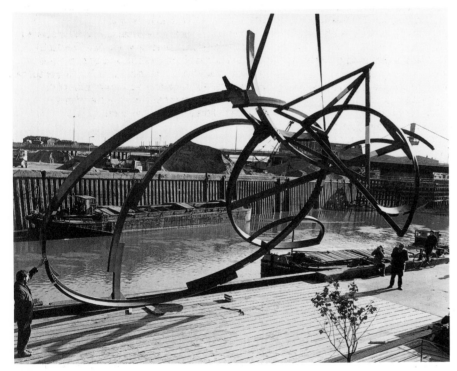

Norman Ackroyd at work in his studio preparing the designs for the stainless-steel plates commissioned for the curved facade of the West Indian Cultural Centre, Haringey, London

Norman Ackroyd, *Etched Mural* 1983 on austenitic stainless steel 20.5 x 2m. Architects: Richard Napper, Commissioned by the London Borough of Haringey with the support of GLAA and GLC.
Photograph: by courtesy of Norman Ackroyd

The sculpture Red Wave *being lowered to the wooden deck of its riverside site in Hull.*

Peter Fink, *Red Wave,* 1984, welded painted aluminium, ht. 10.5m, Hull River walkway. Commissioned by Hull City Council. Funded by Lincoln and Humberside Arts, Angle Ring Company, British Alcan Aluminium and International Paints.
Photograph: Courtesy of Hull City Museums and Art Galleries

■ Other consultations necessary at this stage will be with engineers and fabricators. Every new commission is a prototype in the sense that it has never been made before for that particular site, and therefore will require some development work with regard to fixing methods, safety testing, wind resistance, durable finishes, and so on.

■ While the commission is being made, the architects will need to design and supervise those modifications necessary for the placing of the work: reinforcing the deck which is to receive the work, or specifying the depth of the foundations; designing lighting or hydraulic systems, or perhaps reconsidering access to the site and so on. This will be the period of the closest collaboration between the artist and architect, and calls for mutual trust and confidence. The artist will look to the architect for technical decisions and design back-up while the architect will need to be open to the special requirements of the art work and also the invention and ingenuity of the artist. [See Chapter 20]. Conversely the artist will need to appreciate any technical or design difficulties confronting the architect.

Installation

■ The installation of the commission is a tense time for all concerned, but especially for the artist who will be able to assess the work *in situ for* the first time. There needs to be understanding by those working with the artist that an art work is not just a compilation of parts to be manhandled into place, but represents an emotional investment of the highest order.

■ Installation will involve collaboration with other professionals, such as engineers, and often the use of a skilled labour force.

■ The installation can involve elaborate logistics with regard to organising ancillary building works to coincide with the delivery of the finished work. The timing of these operations is crucial, especially with the installation of craft commissions which become part of the built fabric.

1 Prior to the installation, *ancillary building works* will need to have been carried out according to specification by the main building contractor or sub-contractor. These may include:
■ Laying on water (for a piece involving a reflecting pool or fountain)
■ Drainage
■ Power cables and installation for lighting the piece
■ Concrete foundations or reinforcement of pavement or deck
■ Construction work relating to base, or plinth or water feature
■ Landscaping and planting
■ Paving and hard landscaping
■ Installation of benches, lighting and other street furniture in relation to the work.

2 *Installation* of the work may involve:
■ Road clearance for special heavy-load transport (the police might have to be notified, or a transport manager hired)
■ Hiring of a crane or special lifting equipment

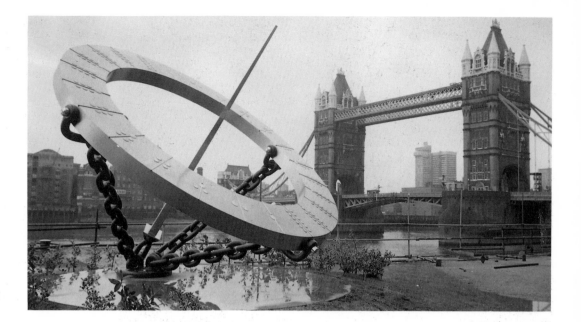

Wendy Taylor's Timepiece *has been used in promotional literature about the St. Katherine's Dock area in London.*

Wendy Taylor, *Timepiece* 1973, Stainless steel, forged steel and bronze. Diameter of dial: 3.6m. Tower Hotel, St Katherine's Dock, London.
Photograph: by courtesy of Tower Thistle Hotel and St. Katharine by the Tower Ltd.

■ Erecting scaffolding for fixing a mural, wall relief, stained glass and so on
■ Employing specialised labour, such as skilled craftspeople to help with installing stained glass or tiling, or hiring security guards if the work is left unfixed overnight
■ Working at awkward hours, if the building or space is being used during the day
■ Cordoning off a public area or diverting traffic during installation, for which police and local authority permission will have to be obtained
■ Taking out special insurance during installation
■ If a mural is being done over a long period of time special security measures may be needed to guard against unauthorised access (for example to scaffolding) when the site is unattended.
■ Awareness of appropriate safety precautions and use of safety apparel (especially if the artist is using unskilled personnel or students to assist in the installation)
■ Clearance with local union representatives if casual help is to be used on the site.

Inauguration of the work

■ On a designated date after the work has been installed the artist will hand over responsibility for the commission to the client, who then becomes the owner of the work. This will be the occasion for final payments to the artist and possibly the signing of an additional Contract of Sale, or Maintenance and Copyright Agreement. [See Chapter 30].
■ Depending on the details of the contract there will probably be a period of some weeks when the artist is still responsible for the work and might be required to make final modifications or correct any faults.
■ The artist will prepare a maintenance manual (independently or in association with the architects) with regard to future care of the work. [See Chapter 27].

■ This is the stage when the artist will probably be required to prepare a brief statement about the work, either for use in the publicity launch or for a plaque or notice to be placed beside the work.
■ There will be some form of public or private opening ceremony to launch the new work. [See Chapter 31]. This is important both for client and artist in terms of publicity, and also for the users of the building or space.
■ The artist may wish to mark the occasion of the launch by presenting maquettes or associated drawings of the project to the client.

After life of the commission

The work of art certainly doesn't cease to exist for artist and commissioner once it has been installed on site:
■ Images related to the commission might have long-term implications in being associated with a firm's identity, or in terms of exhibitions, catalogues and books about the artist or the building or institution where the work is placed. [See Chapter 31].
■ The work of art will require regular maintenance during its life. [See Chapter 27].
■ The work might well be re-sited, if buildings are demolished or an urban area is affected by new planning proposals. In this case, the work will be subject to a process of re-assessment. The present fashion for pedestrianising many town shopping precincts creates opportunities not only for new commissions, but also for the effective siting of existing public art.
■ The historical processes by which the work of architects and artists are continually being critically re-assessed mean that works can suddenly become highly regarded again after a period of neglect. [See Chapter 2].
■ Vandalism, hostile public reaction, or neglect as well as the consequences of low-budget short-life schemes means inevitably that some art works will not survive. [See Chapter 28].

16 The Advanced Architect Model

1 'Art and Architecture are indivisible. Developers and other patrons should think of art not just as painting in the boardroom but as a valuable intrinsic part of their project. Artists have as much to contribute as architects and planners.' Patrick Jenkin, then Secretary of State for the Environment, on 28 September 1983. PSA policy on art and craft works as an integral part of design is set out in guidelines for project managers.

2 *Art and the Built Environment*, Circular issued by the Royal Fine Art Commission, December 1984. 'The Royal Fine Art Commission . . . wishes to draw the attention of government agencies, nationalised industries, developers and patrons of architecture generally to the importance of commissioning works of art in and around the buildings they promote'.

3 'The large sculpture in the plaza of a new corporate headquarters provides what economists call 'external benefits' – that is, benefits to people other than the parties involved in a transaction in the market – in this case, the sculptor is the seller and the corporation the purchaser; everyone else who passes through the plaza and sees the sculpture partakes of its positive externalities' or external benefits. External benefits are basic characteristics of public goods.' 'A pure public good has two characteristics: first, one person's use of it does not prevent others from making use of it: second, no one can be denied access to it, whether or not he pays for its use.' *The Subsidized Muse: Public support for the arts in the US.* Dick Netzer, Cambridge University Press, Cambridge 1978, pp.21 & 22.

It is often the architect who first has the idea of commissioning an art or craft work. According to a survey commissioned by the Art and Architecture Research Team, in 61% of the architectural practices represented in the survey, the idea for the commission originated with the firm – and the figure was slightly higher in the case of private practices. [See Appendix II].

If it is the architect who initiates the commission, then consideration needs to be given to putting forward the idea in a positive and persuasive light to the client. In this model, strategies are listed for the architect to follow in the initial stages. Once the commission has been approved by the client, the stages will be similar to those outlined in The Perfect Patron Model.

Positive strategies

■ *Imaginative presentation* of drawings or photo-collages showing the proposed art works together with models, and slides and information about the artist. This can be a collaboration between the artist and the architect, with measured elevations or perspectives accompanying the artist's sketches or maquettes.

Allen Jones' painting *Summer* forms the centrepiece of the Summer Dining Room of Charles Jencks' 'Thematic House' in London. Jencks and Jones collaborated on the symbolic programme for the room, and the sun motif is picked up in the table and chair designs, the radiating ceiling joists, the paint work.
Photograph: Richard Bryant

■ *Estimated costing* [see Chapter 23]. A list of alternative costings, which compare the cost of the special commission with standard components and finishes will be useful in this exercise. A listing of types of funding available for grant-aiding the project will also be useful. [See Chapters 22 and Appendix III].

■ An outline of the *planning benefits* to be gained from including art works, in the light of recent encouraging statements by the Secretary of State of the Environment,[1] and the Royal Fine Art Commission.[2] An appreciation of the benefits to the community and public amenity will often be of interest to the Planning Authority. Special consideration is given to Listed Buildings and in the case of Unilever House, a Grade II listed building, the two storey addition was suitably embellished by a series of sculpted figures on the roofline. [See Chapter 3].

■ Consideration of art as a benefit for increasing the *lettability* of housing stock and office rental space. Developers such as Greycoat Estates have a policy of installing works of art in foyers of new buildings as a positive factor for attracting lets. [See Chapter 4].

■ Consideration of the sense of intimacy and humanising *scale* which a work of art gives to architecture or urban planning. [See Chapter 26].

■ Consideration of the *social* consequences of works of art, for orientation and landmark and other positive public benefits. [See Chapter 26]. Corporate clients are concerned not only with the well-being of their staff (and attracting staff) but with notions of social responsibility to the communities where they are established, as any public authority would be. Works of art in public places are what economists call 'public goods', that is they are of benefit to all who can pass by and enjoy them, as well as the artist and client who have been directly involved in the commercial transaction.[3].

■ The *climate for art*. The present decade is marked by a return to a socially responsive architecture, and the re-introduction of the language of classicism or vernacular. The use of colour, attention to scale, detailing and ornamentation have once again become important, making this exactly the right moment for working with artists and craftspeople who can help to enrich the language. [See Chapters 1 & 2].

■ *Timing*. Suggestions for art commissions will be best received by the client if they are part of the very *first project proposals* and are sustained through subsequent revisions, as an intrinsic part of the overall concept. It is a matter of psychology: if the art works are offered as an optional extra, or in an apologetic fashion, they may be regarded as dispensable items if budgetary economies have to be made.

17 The Artist Initiator Model

THE ARTIST INITIATOR MODEL

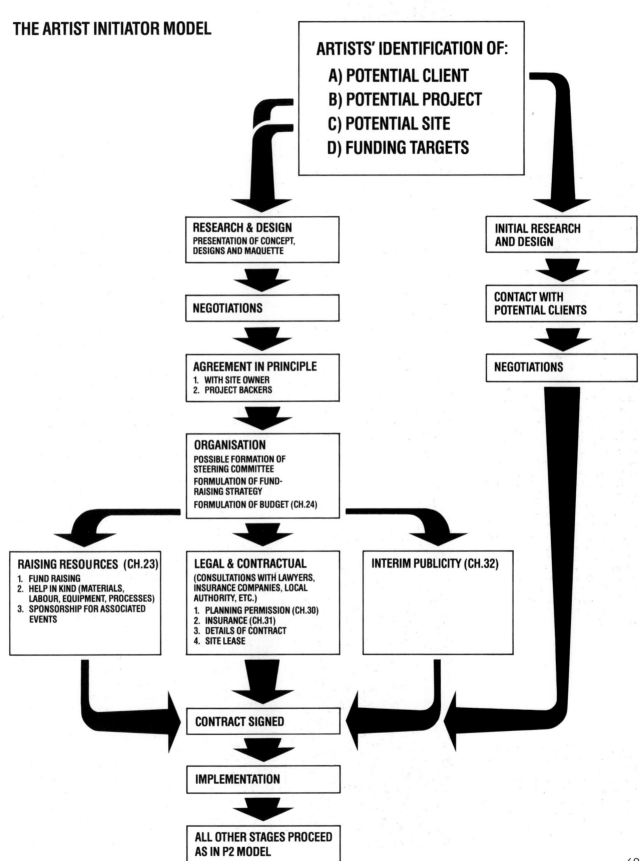

ARTISTS' IDENTIFICATION OF:
- A) POTENTIAL CLIENT
- B) POTENTIAL PROJECT
- C) POTENTIAL SITE
- D) FUNDING TARGETS

RESEARCH & DESIGN
PRESENTATION OF CONCEPT, DESIGNS AND MAQUETTE

NEGOTIATIONS

AGREEMENT IN PRINCIPLE
1. WITH SITE OWNER
2. PROJECT BACKERS

ORGANISATION
POSSIBLE FORMATION OF STEERING COMMITTEE
FORMULATION OF FUND-RAISING STRATEGY
FORMULATION OF BUDGET (CH.24)

RAISING RESOURCES (CH.23)
1. FUND RAISING
2. HELP IN KIND (MATERIALS, LABOUR, EQUIPMENT, PROCESSES)
3. SPONSORSHIP FOR ASSOCIATED EVENTS

LEGAL & CONTRACTUAL
(CONSULTATIONS WITH LAWYERS, INSURANCE COMPANIES, LOCAL AUTHORITY, ETC.)
1. PLANNING PERMISSION (CH.30)
2. INSURANCE (CH.31)
3. DETAILS OF CONTRACT
4. SITE LEASE

INTERIM PUBLICITY (CH.32)

INITIAL RESEARCH AND DESIGN

CONTACT WITH POTENTIAL CLIENTS

NEGOTIATIONS

CONTRACT SIGNED

IMPLEMENTATION

ALL OTHER STAGES PROCEED AS IN P2 MODEL

David Kemp, *Flight of Rooks* 1984, wooden 'pointings'. Liverpool Garden Festival. Commissioned by Merseyside Development Corporation and Merseyside County Council with support from ACGB
Photograph: John Mills, by courtesy of Merseyside Development Corporation

William Pye, *Quillion,* 1970, stainless steel, 2.90 x 2.74 x 1.83m. Canary Wharf, London Docklands. Environmental sculpture garden commissioned by London Docklands Development Corporation.
Photograph: Edward Woodman, by courtesy of Public Art Development Trust

18 The Complex Collaborative Model

4 In 1983 Peter Coles undertook a research commissioned by the DHSS, Gulbenkian Foundation, ACGB and Southern Arts Association into the potential contribution of the arts in the Isle of Wight District Health Authority. At the same time community artist Peter Senior consulted with architects Ahrends, Burton & Koralek on Phase III of the District General Hospital at St Mary's Newport, Isle of Wight to identify sites for art and craft within the hospital. See *The Arts in a Health District*. Peter Coles DHSS, 1985.

5 *Partnership* is an environmental art organisation which 'encourages, designs and makes works of art for public places.' It consists of a multi-disciplinary team of artists undertaking environmental commissions, but also acts as an agency to put 'artists/craftsmen in direct touch with potential commissioners.' It is funded by the Arts Council, North West Arts, the Gulbenkian Foundation and the Granada Foundation.

In this model strategies are set out for the commissioning procedures associated with long-term development programmes. These schemes have been designated 'complex and collaborative', because they relate to commissions where more than one artist is concerned, and a number of authorities and funding bodies are involved over a long period of time, or a wide range of commissions. Patrons are usually from the public sector, although not necessarily so, and typical projects will be those associated with a new town development, with upgrading a depressed inner city area, with a public service such as a new or refurbished transport system or with improving an existing amenity. Recent examples of such complex collaborative schemes have been the art commissioned for the Liverpool Garden Festival and for London's Docklands; Art in the Metro on Tyneside, Milton Keynes' on-going Special Features programme or the Forestry Commission's scheme for Haldon Forest, Exeter where an artist designed and constructed a forest trail over a period of time. In the United States and Europe, projects of this order are usually associated with percent for art legislation and with a clearly determined administrative structure [see Chapter 13]. In this country schemes are conducted in a more ad-hoc manner. It is advisable, therefore, that prior to the standard commissioning procedures outlined in the The Perfect Patron model, the interested parties formulate a clear commissioning policy.

Advisory Panel

A useful way to establish a commissioning policy and monitor commissions is to set up a small advisory panel. The panel might also be involved in fund-raising.

The panel should be composed of an officer or employee from the authority or company concerned and outside experts, but should allow for considerable fluidity with regard to its role as a selection panel. If there is no arts or recreation authority, it is advisable to use the services of a commissions agent or adviser. This person will satisfy the need for continuity (commissions can take many months), liaise with the chairman of the client body in presenting proposals for approval to executive management committees, and be concerned with administrative matters. [See Chapter 24]. The commissions adviser could also be called in at the outset to set up the panel structure and outline policies.

An exercise of this nature provides an excellent opportunity to employ an artist to identify sites and assist in formulating proposals. The public arts funding bodies could be approached to fund such a residency. Artist Peter Senior has acted as a consultant in this way to the architects designing the new St Mary's hospital at Newport, Isle of Wight.[4] An advisory role is also provided by artist teams such as The Environmental Art Team in Manchester,[5] and the Blackness Public Arts Programme in Dundee in addition to carrying out their own publicly-sited commissions.

Formulating a Policy

This should be a long-term planning document, drawn up in consultation with planners, architects, local artists and advisers. Policies should be concerned with:

■ Identifying present and future *sites for development* and establishing short-term and long-term commissioning programmes. [See Chapter 26].

■ Providing for *equal opportunity* by ensuring that, for example, women, ethnic minorities or local artists are invited to participate in competitions, and represented on selection panels.

Dame Elizabeth Frink, *Horse*, 1978, bronze, ht. 2.44m, Lloyds Court, Milton Keynes. Commissioned by Milton Keynes Development Corporation and Lloyds Bank.
Photograph: by courtesy of Milton Keynes Development Corporation

Forestry Commission project for Haldon Wood, Exeter Forest designed and constructed by Jamie McCullough. Although this scheme has never been advertised, leaving it to walkers to come upon the trail by chance, it has proved so popular that it has suffered wear and tear and has had to be modified and inevitably altered.
Photograph: Martin Orrom

Forestry Commission project for Haldon Wood, Exeter Forest designed and constructed by Jamie McCullough.
Photograph: Martin Orrom

■ Examining *community relations,* and determining whether consultation should be invited for all commissioning projects, or only in certain situations. [See Chapter 25].

■ Determining the *range of works* that could be commissioned, with reference to matters such as:

Durable materials

Appropriate scale

Mix of experimental and conservative works

Mix of two and three-dimensional work and time-based, performance or short-life commissions

Mix of one-off commissions from outside artists, and work arising out of artists' placements or community-arts procedures.

■ *Commissioning procedures,* either direct commissioning or by limited or open competition, or a mix of all these methods. An open policy would allow for the method of commissioning appropriate to the value and scale of the commission being contemplated.

■ Attracting *international artists* for specific important large-scale commissions.

■ Setting up *residency schemes* or long-term placements.

■ Applying for *outline planning permission* in advance of specific commissions where appropriate.

■ Determining *short and long-term funding levels.* [See Chapter 22]. In addition to project funding, there will be the need for revenue funding for administration, however minimal. It will be useful to establish policies and procedures whereby money can be carried over from one financial year to another or be aggregated into a special fund to meet the particular demands of commissioning.

■ Building-in procedures for regular *policy revision.*

■ Determining *panel membership,* payment of members and length of service. A policy of bringing in new or additional jurors for specific competitions or commissions might be preferable to a static membership.

■ The drawing up of standard commissioning and maintenance *contracts,* and procedures for funding works.

■ Laying-down *panel procedures* for suggesting sites, proposing artists and advertising commissions. In addition to proposals put forward by members of the panel there should be opportunities to view the work of a wide range of artists.

Plate 11

Tess Jaray's terazzo floor design speeds passengers along the concourse at Victoria Station, London in an enlarging and diminishing sequence of diamond shapes. The plum-coloured terrazzo has been carefully muted in sympathy with the station's original brickwork. In 1988 a corresponding floor will be laid to give centralised emphasis to the main concourse

Tess Jaray, 1985, tile floor, 450sq.m, south east concourse of Victoria Station. Commissioned by British Rail. Funded by James Sherwood with the support of ACGB.
Photograph: Richard Bryant by courtesy of Public Art Development Trust

Plate 12

Art on the move

Recent commissions for British Rail and Tyne & Wear Metro

David Kemp, *Iron Horse,* 1982, metal assemblage, Four Lane Ends, Newcastle Metro. Commissioned by Art in the Metro. Funded by a consortium of arts funding bodies, local authorities and local business and engineering firms
Photograph: by courtesy of Northern Arts

Mike Davis, *Shipyards,* 1983, stained glass window, Monkseaton Station, Newcastle Metro. Commissioned by Art in the Metro. Funded by a consortium of arts funding bodies, local authorities and local business and engineering firms.
Photograph: John Welsh by courtesy of Northern Arts

William Pye, 1984, ceiling mural in Vauxhall Railway station, London, 30 x 10m. Emulsion paint. Commissioned by British Rail. Funded by British Rail with assistance from GLAA and Blundell Permaglaze Ltd.
Photograph: Edward Woodman by courtesy of William Pye

Radford and Ball, in collaboration with Clifford Rainey, 1984, 72 panels of 12mm toughened glass, sandblasted, 3,35 x 40m. Lime Street Station, Liverpool. Commissioned by British Rail. Funded by British Rail with support from Crafts Council and Merseyside Arts.
Photograph: Alex Laing

GUIDELINES

19 Some guidelines on commissioning

Patrons should be adventurous and open-minded in the choice of an artist for a commission. A good work of art will always contain something unexpected or stretch the viewer in some, perhaps indefinable, way. If the artist supplies the client with something that exactly meets the specification and no more, then it might be a good piece of problem-solving design but could lack the vital ingredient that makes it art.

In the case of a publicly accessible commission, the commissioner will have to come to terms with the fact that it is impossible to predict what people will like or to find a work of art which will be universally popular.

Inevitably works in public places arouse some response, but this should be regarded as a positive factor.
Reaction to art is essentially emotional, so that a work of art may become the focus of a variety of unpredictable responses, which are *not necessarily related to the work itself*. Therefore if a piece does provoke anger it is necessary to distinguish between genuine grievance (for example something which offends religious beliefs) and a more general expression of discontent or aggression.

Consultation and information with regard to siting an art work may go a long way towards diffusing a hostile reception and making the unfamiliar more acceptable.

There still exists a division in people's minds between 'abstract' or 'figurative' art, with all the subsequent prejudices about whether such an art form is accessible or 'difficult'. A conventional patron will probably automatically assume that figurative work is safe and acceptable, whereas an architect might just as readily be convinced that only a decorative abstraction can relate to the building. What needs to be remembered is that there is *good* and *bad* art, irrespective of whether it is figurative or abstract and that standards vary within any artistic milieu. (There is just as much risk in choosing a work from a Royal Academy Summer show as there is from a neighbourhood exhibition of unknown young artists.) There are two kinds of bad art: the slick and the inept.

There is a commonly-held assumption that although a patron can be adventurous in a private commission, art for multi-use buildings should be cheerful, bright and bland or simply part of the interior decoration scheme. Art deals with every sort of emotion, and just as many people will be irritated by a bland piece as might be challenged or interested by an art work which deals with more profound feelings.

The commissioned work of art should be well-made, not only for the obvious reasons of longevity and safety, but because in lieu of an aesthetic judgement, the one factor to which people respond is the question of technical skill. Employees' concern about expenditure on a work of art could be expressed as open dissatisfaction if a commission seems to be shoddily made. In this respect, a low budget which does not allow for substantial materials or proper fabrication is counter-productive.

However, some artists deliberately make works which appear to be spontaneous, unfinished or even tacky, and this is a contradiction which would need to be explained when the work was presented to its 'users'.

A stock response to any work of art is the cliché 'my three-year old could have done better.' (Recently an architect used his three-year-old's drawing for a swimming-pool mural, but his explanation that he couldn't find any artists who could do better rather takes the edge off the joke.) Nevertheless, there is a significant reason why people who would be timid at pronouncing judgements on areas such as nuclear physics, medicine or even plumbing feel confident to pass judgement on works of art! This is because it is commonly and rightly assumed that art belongs to everyone, and is a means of communication. When people feel frustrated by an inability to 'read' what is being communicated, they tend to respond by blaming the work, and assume that the work is too simplistic or primitive to be read. The real issue is that every work of modern art has an autonomous language which can only be learned by looking. It is very important that a new work is presented with some information about its 'language', its context (in relation to the artist's other work and contemporary art in general) and some of the meanings present in the work.

It can happen that the very people to whom the client has turned for advice on commissioning, prove to be conservative. If the architect or interior designer feel that they lack specialist knowledge and are therefore vulnerable to the unfulfilled expectations of the client, they might respond with prejudice or unshakeable convictions about their own taste. It is

wisest, therefore, for would-be advisers to put their cards on the table and either call in someone with real expertise or admit bias. The advantage of professional arts administrators is that apart from knowing the field very widely, they are trained to be open-minded about what might be suitable. However the excitement of commissioning is precisely the involvement with choices about art, and the patron shouldn't be too ready to abrogate the thrills and spills of decision-making.

Michael Sandle, *Mickey Mouse Machine Gun* **Memorial 1979/80, Ink & Watercolour 1.00 x 1.50m**
Photograph: Prudence Cuming Associates Ltd. by courtesy of Fischer Fine Art

20 Architects and artists working together

Difference of Methodology

It is useful for architects or planners when working with artists, to have some understanding of the difference of their respective working methods. Obviously every artist has an individual way of working, but there are some useful generalisations which can be made in relation to the methodology employed by an architect, planner or designer.

Designers and architects, as much through their systems of training as the specific nature of their tasks, precede the actual creative design process by an analysis of the relevant data.[1] (Of course things often happen concurrently in practice, so the distinction between gathering and processing information in the analytical phase, and synthesising in the design stage might be a difference of procedure rather than a logical chain of events.) Nevertheless, apart from the first concept sketches, the process is a linear one as reflected in functionally differentiated and sequential drawings of plans, elevations, working drawings leading to the final presentation perspective or axonometric.

The artist works directly in relation to materials and process. The distinction is defined by Claude Levi-Strauss as the difference between the *bricoleur* and the engineer.[2] For the *bricoleur*, or handyman, materials do not have pre-ordained functions nor do they need to be subordinated to a strict procedure or set of objectives; they are simply there to be imaginatively recombined. The engineer, architect and designer gives form to function or meaning, while the *bricoleur* gives meaning to form.

The autonomy of drawing and making

Most architecture is product-oriented, and the drawings and models are preliminaries for the final built form. However beautiful the interim drawings might be, their intention is referential and accumulative, whereas for the artist every drawing, sketch or maquette also exists in its own right *qua* drawing.

To the artist, each drawing is important (to a greater or lesser extent) in itself because process and the act of making are as important as the idea or the finished object. For some artists therefore it is difficult to ensure that the final work is identical to the maquette or presentation drawings, because the act of making the actual art work becomes an independent process. Making a full-scale work will activate a whole different set of decisions and modifications from that of the maquette, especially, if the maquette is not in the same material as the final commission. This is an area where client and architect should allow some latitude, because to insist, for example, that a mural is identical in colour and nuance to the gouache-on-paper design would be to disallow the prime dynamics of making.

Some artists, of course, demand total fidelity of the finished work to the drawing: this is the case, for example, with artist Michael Sandle, where ideas for his bronzes are finalised in detail in elaborate wash drawings prior to models and casting. Those artists working in transformative processes like casting, or printed textiles or graphic procedures, where the work is materially transformed at the end of the process by some technical means, will usually work with exact drawings and accurate maquettes. But this will be far more difficult for an artist carving directly into stone, or assembling and welding metal, or painting. Artists working in this way, will be far more prone to work on site, as Caro did for the sculpture for the entrance foyer of I M Pei's National Gallery Extension in Washington DC. Caro needed the immediacy of real space and scale to make the sort of fine adjustments of his normal, spontaneous working methods. Whatever the medium used, most painters will probably also prefer to work on site so that they can see the effect of the light source on their colours, or will insist on light conditions as close to their studios as is possible. This is an area where there needs to be close consultation between artist and architect.

Use of Materials

The 1960s were the era of systemic art, of multiples, of kinetic art and technological experiments; generally of methods of production which were closer to that of the designer. (It is not coincidental that artists of this generation like Lichtenstein and Warhol, and in this country Bridget Riley, began as designers with advertising agencies.) Since the late 1970s most contemporary artists have reasserted the importance of working directly with materials. Painters have returned to using oil paint, and sculptors freely use materials from different sources

1 In *How designers Think*, The Architectural Press Ltd, London 1980, Bryan Lawson queries the traditional architectural methodology of assimilation, general study, development and communication as laid out in the *RIBA Architectural Practice and Management Handbook* of 1965. He suggests instead that '. . . the early phases of design are often characterised by what we might call analysis through synthesis.' p.147 He makes a distinction between artist and architect: 'The creative process which may give rise to a work of art undoubtedly shares much in common with the design process, and many of the same talents may be needed for both. What is usually different however is the nature of the source of the problem. . . . The artist deals with issues and solves problems which seem important to him.' p.63
2 Claude Levi-Strauss, *The Savage Mind*, Weidenfeld & Nicholson, London 1966, pp. 21-22

3 Quoted in Jack Burnham, *The Structure of Art*, George Braziller, New York, 1971, p.138
4 Performance artist Stuart Brisley on a placement in a furniture factory, closely observed movements on the shop floor and made suggestions which radically changed procedures and led to savings. Of course this sort of activity is not very different from that indulged in by a designer faced with an imprecise brief who escalates the parameters of the problem. See Bryan Lawson, ibid, p.40-43

Tess Jaray, 1983, pencil on paper, proposed floor design.
Photograph: by courtesy of Tess Jaray

Graham Stevens Solar Membrane; *a self-inflating structure inducing condensation of atmospheric moisture. It is shown here floating over the Arabian Desert in Kuwait.*

Still from the film *Desert Cloud*, 1974. Film distribution: Concorde Films, Ipswich.
Photograph: Graham Stevens

in new combinations. Contemporary art ideologies are democratic and distinctions are not made about one sort of material being more valuable than another.

The close involvement of artists with their materials, and the struggle to find a means of expression within and through those materials is of a very different order from the drawing-board architect. The architect has access to technical information and orders from samples and catalogues; materials can be pushed very far to serve design ends, but always through the relatively alienated procedure of drawing and models, and remote methods of production. The artists's awareness has to do with a close and intense knowledge of the immediate (if not the scientific) qualities of materials, with tactile values, with how the materials age or change under different light sources or combinations. The response to material is immediate and relative: the principle is 'let's try it out' rather than 'let's calculate it.' The evidence of the eye and touch are considered more pertinent than received notions.

It is within this area that the architect can have a most fruitful and unexpected relationship with the artist.

Lateral thinking

It is relevant that the kind of training that artists receive in most contemporary art colleges does not separate technique from process, and that students are encouraged to acquire skills through making, just as they sometimes learn to discover idea and subject matter through process. Every new work incorporates new technical considerations, and this method of working continues for most artists in practice. The artist approaches each work empirically, as a fresh association, independent of *a priori* structures. Because of this emphasis on lack of a rigid methodology, the connections between problem and solution can be so wide and free-floating as to appear totally disjunctive. As American artist Robert Morris once wrote, the artist can do 'the most discontinuous, irrational things in the most reasonable way.'[3]

This way of thinking is lateral rather than directly problem-solving, and is a very significant aspect of the way an artist can contribute to a collaborative project, by coming up with inspired ideas. It is the aspect which the Artists Placement Group set out to explore by placing artists in industry or government departments as 'Incidental Persons'. The artists have looked at organisational structures as part of a searching for new ideas and relationships, and have sometimes been able to come up with imaginative notions relating to much wider issues than the host bodies had expected.[4] The artists in association with Stockholm Underground planners have also worked in this way. [See Chapter 14]. Whereas the planners had gone to great lengths to find a solution for an existing problem, the artists simplified the issue by redefining the problem.

The use of artists as consultants on design teams to exercise these special skills is becoming an accepted practice in the United States. To date it has not been exploited in this country, where rôle definitions are rigidly demarcated, but it has great potential. A practical method for testing potential collaboration is for an artist to be employed for a brief period on a feasibility study with a design team.

21 Guidelines for artists

Presentation of material is of the utmost importance. Many artists subscribe to the view that the quality of the concept is paramount and therefore it will shine through a sketchy presentation. However, a jury will be prejudiced against an artist who makes a shoddy presentation, as an indication of lack of care and organisational skills.

Portfolios

- If portfolios of photographs are requested prior to a short-listing, care should be taken that every slide or photograph is individually marked with the artist's name, dimensions of the work and indications of which way the work is intended to be viewed. There should also be a separate listing in the case of slides, to be consulted during viewing. The photographs should not be numerous but representative of the artist's work, and if possible, relate to the type of work required for the commission. The portfolio needs to be sufficiently robust to withstand handling.

- In cases where a gallery is handling the matter, it is useful for the artist to check what is being sent out, and make sure that the information is comprehensive. The gallery might assume that an artist is so well known that a full portfolio is not necessary.

- A portfolio should include a brief curriculum vitae and recent catalogues if possible.

Preparing maquettes and presentation

- Every possible effort should be made to visit the site. There is usually money in the budget for this, or the artist can request travel assistance. Personal photographs and drawings of the site will be far more valuable than those standard views provided with the brief. If the site is for an incomplete building, the artist should arrange to talk to the project architect about design intentions or problems.

If the site is in existence, it is very useful to talk to local people living or working nearby, and observe and record the way the site is used, or discover something about local history or attitudes. Any research is useful in informing and enriching the project, even if it is jettisoned at the moment of actually creating the work.

- It is important for artists working on first-time projects to work within tried and tested practices, as taking on unfamiliar methods at the outset can be very inhibiting. As the project advances the special requirements of the commission will become obvious.

- Important issues to keep in mind all the way through are scale and relationship to the architecture or site.

- If the artists are not familiar with making or reading measured drawings, they should obtain assistance. The cost of commissioning measured drawings will not be negligible, and allowance should be negotiated within the budget.

- There is, obviously, no 'right' or standard way to present a project, and what is required is originality and optimisation of resources. Whether the presentation is a collage, a film or video, a series of drawings, a well-made maquette or a scale model, what is essential is that it clearly conveys the concept, and gives the greatest possible amount of information about scale, material and relationship to site.

- Detailed and accurate costings even at maquette stage are very important. This information should not be guess work, but depend on estimated costings from engineers, fabricators or suppliers. Costings will include hire of plant, materials, fabricating processes, the cost of hiring specialist or non-specialist assistants, a time estimate and artist's fee. [See Chapter 23]

- The presentation should also include information about the artist's programme of ideas, and how it is intended to relate the work to site or social usage. These ideas need to be *appropriate*. There is a tendency for artists to justify their projects in terms of very wide-ranging symbolic or philosophical ideas – from Pythagorean number systems to Tao – but, for example, these might not seen relevant to a commission for a small market-town or a corporation foyer!

Working on the Commission

- Once the commission has been awarded, the artist will need to make a careful assessment of the responsibilities and timing involved. If taking on a

commission or residency implies giving up an existing teaching post for a period of time, for example, this should be reflected in fee negotiations.

■ It is up to the artist to insist on a binding contract and a schedule of fee-payment, [See Chapter 30] and the demarcation of responsibilities with regard to

application for planning permission, administration or fund-raising. Artists taking on a first-time commission, who have not had any training in practice management, tend to assume that the client or arts administrator will assume responsibility for these matters without prompting, but this cannot be taken for granted.

Jane Ackroyd in her studio at work on The Wave *for London Docklands Development Corporation, sited at Canary Wharf.*

Jane Ackroyd, *The Wave*, 1984, Painted steel, 1.83 x 2.74 x 2.74m, painted mild steel. Commissioned by **London Docklands Development Corporation.**
Photograph: Edward Woodman, courtesy of Public Art Development

22 Fund raising and financial matters

* In 1986 the Arts Council's Art in Public Places Scheme was devolved to be Regional Arts Associations.

No commission should be undertaken without adequate funding. Even in the case where the existence of the artist's design might be used as part of a strategy for fund-raising, there needs to be an assured sum to pay for the artist's initial input. Planning ahead for the funding of any commission is essential, all the more so if different methods of fund-raising are to be combined, as is the case with many contemporary commissions which are funded in a variety of ways by both the public and the private sector.

There are a surprisingly wide range of options for either directly raising money for commissions or tapping funds from existing sources. The first part of the chapter therefore deals with raising money from the private and public sector. The second section deals with the funding of specific projects out of building or special budgets, and identifies areas of funding from which money could be made available in the longer term. Some of these funding sources are underdeveloped in this country, and it would be of advantage for those interested in commissioning to develop and promote them. [See Recommendations] In Chapter 23 which follows, budget guidelines are discussed.

Strategies for raising money

1 Grants and seed-funding

Grants for commissioning projects will be more favourably considered by a public or private body if they are clearly and professionally presented. This is the area when an advocate for the art work (client, commissioning adviser or representative of a fund-raising committee) will probably be more effective than the artists themselves, except in cases where artists are trying to generate funds for their own projects. However, the artist must be prepared to make a presentation to any potential sponsor. It is essential that if the client is a small voluntary body, some funds, however small are used as seeding and back-up money to start off the fundraising.

The bodies most useful to approach for the part-funding or seed-funding of commissions are:
The Arts Council of Great Britain
The Crafts Council
Scottish and Welsh Arts Councils

Regional Arts Associations
Local, district and metropolitan authorities and development corporations. Relevant departments will be leisure, arts, development education, youth and community services.[1]
Arts or educational trusts with a policy of arts support.[2]
DHSS and Regional Health Authorities, as well as hospital charities[3]
Companies and company trusts.[4]

Before approaching any of these bodies it is advisable to undertake some research on their current policies (regional bodies could have a policy about only supporting projects in their region, for example), and to have some idea of the level of funding available. Local arts councils, for example, will only make small grants in the region of £50 to £200 which might not be appropriate in funding a large-scale commission, but could serve a small community mural.

The Arts Council of Great Britain's Art in Public Places scheme has been operating since 1979. Although in recent years the cost of individual projects has tended to rise, the size of the Arts Council component of funding for each has remained fairly constant, indicating that the Art in Public Places scheme has been successful in attracting other sources of finance in the co-funding of projects. The Arts Council of Great Britain strategy for a decade is set out in its policy document *The Glory of the Garden.** The Welsh Arts Council now operates a commissions service providing administrative, project management, legal, and financial expertise for those wishing to commission work, though direct grant aid is not normally available. The Scottish Arts Council also supports Art in Public Places projects, and primarily contributes to design fees in sustaining a healthy level of activity.

2 Private and Business Donations

Some large companies such as Marks & Spencer PLC give sums to art activities as part of annual expenditure from their charities budget. The tax laws only allow certain benefits from donations if they are made to registered charities. Most arts bodies are registered charities, like Art Services Grants which channelled funds for the Oxford Sculpture Project.

Individuals and private companies may covenant money to a charity, thereby enabling the charity to

1 The Association of Metropolitan Authorities publishes a Year Book containing useful names and addresses. Local arts councils usually consist of representatives of local arts groups and activities, and the councils are represented nationally by the National Association of Local Arts Councils.
2 Trusts are listed in the *Directory of Grant-Making Trusts*. Helpful information is also included in *Raising Money from Trusts*, Social Change Publications, 1984
3 Useful information on this is contained in Peter Coles, *Art in the National Health Service*, DHSS, 1983
4 There are various Social Change Publications of relevance: *A Guide to Company Giving* 1984
Raising Money from Industry 1984
Fund-raising; A Comprehensive Handbook, 1984
All available from: the Directory of Social Change, 9 Mansfield Place, London NW3

recover tax. The prevailing conditions and limitations affecting such arrangements are outlined under *Charitable Trusts* in the section *Long Term Funding* below.

Public companies are entitled for the purposes of Corporation Tax to treat the amount of the covenanted gift as an expense[5], and so obtain a tax deduction.

Business Expenditure on Art works
Under the Taxes Acts expenditure is allowable as a deduction in computing the profits of a business for tax purposes if it is of a revenue nature and incurred wholly and exclusively for the purpose of the trade. Expenditure on a work of art would normally be regarded as capital expenditure. A trader who incurs such expenditure on machinery or plant for the purposes of his trade is entitled to claim capital allowances. There is no definition of "plant" in tax legislation but, to qualify for an allowance, the asset must perform some useful function in the actual carrying on of the trade. Although paintings and other works of art will normally be regarded as no more than part of the setting in which a trade is carried on, they may nevertheless attract allowances where the functional test is satisfied.[6] In the event of disagreement with the Inspector of Taxes, a taxpayer has the right to appeal to the General or Special Commissioners.[21]

3 Commercial Sponsorship

Sponsorship is not a form of disinterested charity to arts or sports projects but a payment which is tax deductible for the firm only if it promotes the business name, its products or services and so meets the basic test for business expenditure of being wholly and exclusively for the purposes of trade. Therefore in applying for sponsorship of a commissioned art work, serious consideration must be given to how the sponsorship will benefit the company concerned in terms of publicity, media coverage or community relations,[7].

Large companies with marketing or PR departments prepare their sponsorship budgets over a year in advance, and even with firms which have discretionary budgets or small local firms, 3-6 months are needed for application and allocation of funding.

Local commercial companies will probably be more interested in sponsoring a project with impact on the community, or where there could be a possible spin-off in terms of future orders or contracts, but very large firms are also concerned with enhancing their corporate image. Rank Xerox (UK) Ltd for example sponsored the 'imaginative venture' of *The Oxford Schools Sculpture Project* a community-oriented project whereby six sculptors worked in schools in and around Oxford. Firms with a specialist interest related to art or architecture will be the most likely to sponsor an art work, where benefits can be directly felt. The sponsorship by Berger Decorative Paints at Surbiton Station, for example, was followed by a contract for Berger at Temple Meads Station,

Bristol. French Kier Construction, building contractors who specialise in hospital construction sponsored three mural commissions (by Jennifer Durrant, the late Ray Walker and Anthony Eyton) in Newham Hospital, London to a substantial degree. This was a considerable item of sponsorship in an overall budget of £10,000, and probably had some effect on recent contracts for St Charles Hospital where the firm have further sponsored landscaping and out-door furniture for a geriatric unit. Connections can be of another order: SeaCo Services Ltd, who also run the Orient Express from Victoria Station have recently sponsored a terrazzo floor designed by artist Tess Jaray for one of the concourses at Victoria Station. The quid pro quo, then, is an important aspect of sponsorship and presupposes a level of upper management involvement both on the side of the sponsor and the arts body applying for funding.

Many forms of sponsorship are eligible for awards under the government's Business Sponsorship Incentive Scheme (BSIS) administered by the Association for Business Sponsorship of the Arts on behalf of the Office of Arts and Libraries. Awards to arts bodies are given for such activities as 'commissions, exhibitions, buildings and refurbishments.'[8] New sponsorship of £1000 or more from businesses which have never sponsored the arts before will be matched pound for pound; additional sponsorship of £3000 or more from existing sponsors will be matched in the ratio of £1.00 for £3.00.

Ways in which sponsorship could benefit an art or craft commission could be:

■ Sponsoring an open competition associated with a commission

■ Sponsoring the celebrations or festival associated with inaugurating commissions, or celebrating a company anniversary.

■ Sponsoring a publication related to the project.

■ Sponsoring temporary art works, like inflatables, performances, or short-lived community projects as part of a festival.

Many firms are prepared to give sponsorship in kind, which can be just as useful as direct financing. British Steel provided the materials for the Winchester Gates, where it was demonstrably used in an innovative and adventurous way. Paint firms have been particularly generous with mural and community schemes, and ALCAN (British Alcan Aluminium Ltd) has provided free aluminium and fabricating assistance for sculptures in Warwick, Banbury and Hull.

In addition, some firms provide management and accounting skills and counselling, (although these are normally associated with an arts organisation with which the sponsor had a long-term relationship).

Sponsoring firms require as much publicity as possible for their involvement, but this could be equally useful to the artist architect or client, especially if the sponsor has a marketing and PR

5 More precise information on this is detailed on pages 32 & 33 Gifts to Charity by G. Laurence Harbottle in *Tax Policy and Private Support for the Arts in the United States, Canada and Great Britain*, Edited Hamish R. Sandison and Jennifer William, Published by the British American Arts Association (US) Inc, Washington DC 1981. See also *Covenants; A Practical Guide*, by Michael Norton, a Directory of Social Change publication.
6 In a recent case (ICC v Scottish and Newcastle Breweries Ltd, 1982) it was held that paintings were 'apparatus' providing the atmosphere necessary to the trade of an hotelier. Consequently this meant that, in this case, the paintings could qualify for capital allowances. See *Business sponsorship of the arts – a tax guide* ABSA and Arthur Andersen & Co, September 1985
7 Detailed advice on sponsorship is contained in Association for Business Sponsorship of the Art, *W H Smith Sponsorship Manual*, compiled by Mary Allen, 1983 and *Industrial Sponsorship and Joint Promotions*, the Directory of Social Change.
8 Business Sponsorship Incentive Scheme, Association for Business Sponsorship of the Arts, 2 Chester Street, London SW1X 7BB.

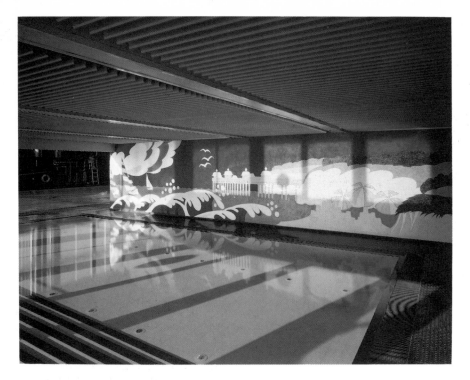

Terry Riggs, mural for the Learner Pool, Ringwood Sports Centre, 1983, ht. 2.3m x 12m. Architects: Hampshire County Council Architects Department. The special paint for the mural was donated by ICI who also sponsored the designer's fee.
Photograph: by courtesy of ICI

department or access to such skills for properly launching a scheme. It can also ensure continuing publicity after the inauguration of a work: ICI donated £40,000 worth of paint under their Dulux Community Projects Scheme to 148 groups during 1984, and photographs of the 'most creative and worthwhile' of these community projects were exhibited in the Concourse of the Barbican Centre and toured in 1985, to quote just one example.

Arts projects available for sponsorship can be submitted to ABSA's Register of Arts Sponsorship Opportunities. The register enables any business enquiries received by ABSA to be coordinated with available projects in the light of particular requirements or a brief, and to be referred to artists if appropriate. Generally raising sponsorship is a time-consuming activity and requires good organisation.[9]

Lotteries

This is a method for raising money for a commission which has been little used in this country, although Camden Council funded Barry Flanagan's. *Camdonian* sculpture in Lincoln's Inn Fields, London in 1981 out of a general amenities lottery. The advantage for local authorities in using lotteries as a means of raising funds is that there is greater freedom in the use of monies which do not come from the rates. The Lotteries and Amusements Act 1976 (Section 7) allows local authorities to raise money for any purpose for which they have power to incur expenditure. The local authority must register with the Gaming Board and comply with the Act's require-ments (which include provisions relating to adequate publicity as to the purpose of the lottery, ticket prices, monetary limits for prizes, and expenses). The advice of the Gaming Board should be sought on any point of doubt or difficulty. It is not possible for

people connected in a commercial way with projects, which the local authority may wish to support, to run a lottery themselves and comply with the law.

Small lotteries and private lotteries may also be organised as long as the proceeds are allotted to the provision of prizes and the purposes of the society and not for the purposes of private gain.[10]

Public Subscription

Collecting funds for public statuary by public subscription has a long history in this country, beginning with the memorials to political and military leaders in Westminster Abbey in the 18th century and reaching an apogee in Victorian times in the countless memorials to national figures and local heroes erected during the 1860s and 70s. The essence of the system is that the sculptures are commemorative of figures or events which have stirred the public imagination, as for example Edward Hodges Baily's *Viscount Nelson* erected in Trafalgar Square between 1839-43. The work for this proceeded when only £17,000 had been raised, and the rest was subscribed while the sculpture and plinth were being made.

A similar procedure was followed for a recent public subscription monument, the Yalta Memorial, in South Kensington, with a less happy result, as the work was vandalised a few weeks after its inauguration. The public subscription appeal was launched by a letter to the Times following the publication of two books about these tragic events. £15,000 was collected with donations ranging between £2.00 and £1,000. Only at that stage did the committee look around for a site, and after the small triangular park in front of the Victoria & Albert museum had been agreed upon, the sculptor Angela Connor was approached. When it was decided that the work should be a 'garden of con-templation' with a water sculpture, which would be an expensive installation, the appeal was re-launched. Many original subscribers gave second donations.[11]

In a funding drive of this nature, the ideological issue is of greater importance than either the site or the commissioned artist. Publicity and presentation are crucial to the success of the appeal. Photographs of the actual work or maquette are usually used to raise further money for an extended appeal, as in the case of the designs for Antony Robinson's Stainless Steel gates for Winchester's Great Hall commissioned to commemorate the wedding of the Prince and Princess of Wales. [See Chapter 10]. In this case the appeal was not successful, in spite of the popularity of the commemorative aspect of the commission and the employment of a professional fundraiser.

Public appeals do not only have to be associated with commemorative work for open-air sites, but they will obviously have to have local relevance, stir the imag-ination or be considered 'worthwhile' if money is to be raised from the public at large. A very successful Art and Amenity Appeal was launched in 1982 by the Colchester Hospital League of Friends [See Chapter 11].

9 Names of local business firms can be found through Rotary Clubs, Round Tables or Chambers of Commerce, all of whom will have lists of business members. Listings of larger companies can be found in libraries in publications such as *The Times 1000, Key British Enterprises, Who Owns Whom* and so on.
10 *Lotteries and Gaming, Voluntary Organisations and the Law,* published by the Bedford Square Press of the National Council for Voluntary Organisations, 1981
11 Interview with the Hon John Jolliffe, December 1984

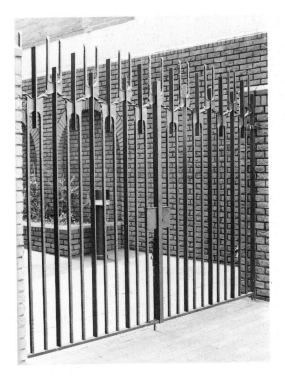

Alan Evans, Gates for Harrow Baptist
Church, 1984, mild steel 2.2 x 3.1m,
Commissioned by Harrow Baptist
Church, through R. Quinnell Ltd.
Photograph: Alan Evans

James Horrobin, Rampayne Street
Gates, 1983, painted forged steel,
Rampayne Street, London SW1.
Architects: Whitfield Partners.
Commissioned by Crown Estate
Commissioners.
Photograph: Colin Westwood.

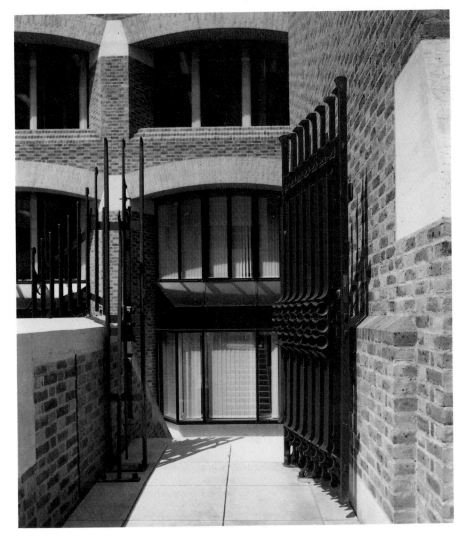

Strategies for making funding available

A Project Funding

1 *Direct allocation for an art work in the building budget*

This implies a clear decision on the part of the client and the architects to include art works in a building project from its inception, and might well be a bonus factor with regard to planning permission for the whole scheme. It is the most efficient and cost-effective way of funding a project from the client's point of view and guarantees that the art commissions are integral to the building and are not regarded as optional extras which can be cut in any cost revisions. It is also the method that will be looked upon most favourably by funding bodies such as Regional Arts Associations, to whom the client may wish to apply for additional funding. There could also be savings on the material costs of commissions, as a result of bulk-ordering by the contractor.

As elsewhere in the construction budget, there should be a small *contingency* allowance in the commissions budget. If the work is a one-off piece like a sculpture (although this will not be the case in a mural or textile hanging) minor price fluctuations might arise from fabrication or installation simply because the work cannot be subjected to the same minutiae of quantity surveying as other items in a construction budget. Even though budgeted at the beginning, the art work will probably not be installed until the end of the project. Costings will be subject to the same inflationary rises as the rest of the building contract, which should be allowed for at the standard rate for a building contract. (These are determined with reference to the Monthly Bulletin of Indices published by the PSA). If the artist is not sub-contracted to the main building contract, similar inflationary allowances should be considered by the commissioner.

2 *More imaginative use of existing materials budgets*

In prestige office projects, the budgets for cladding, glazing, and finishes are usually high. (The tendency has been to transmute what were the allowances for elaborate decorative features of an earlier era into simple but expensive finishes like polished stone, bronze finishes or hammered concrete.) There is scope for re-examining these budgets, as indeed there is even in low-cost schemes. The aim of the exercise is not to try and squeeze quantified costings, but to consider whether an artist or craftsperson could produce an original work within available budgets which will be far more effective visually than standard finishes or the incidental detail of functional or structural elements. This would be a particularly apt consideration in cases where expensive special features are being purpose-made for a building.

The price from an artist or craftsperson for original items such as gates, doors, stained-glass, lettering,

David Colwell, Trannon Furniture Makers, Fountain's Restaurant, Museum of London, 1984, steam bent ash with sycamore table tops and black stained sycamore seats, chair ht. 0.85m, table ht. 0.72m, diam. 0.80m. Commissioned by City of London Architects Department. Funded by City of London.
Photograph: by courtesy of Trannon Furniture Makers

12 State of New Jersey, *An Act to provide for the inclusion of fine arts in the design of public buildings constructed by the State of New Jersey,* 1978
13 John Beardsley & Andy Leon Harney, *Art in Public Places,* Partners for Livable Places, Washington DC 1981 and Kevin W Green, ed. *The City as a Stage: Strategies for the Arts in Urban Economics* Partners for Livable Places, Washington DC 1983
14 See *Growing up with Art: The Leicestershire Collection for Schools and Colleges* Catalogue of the exhibition organised by the Arts Council of Great Britain and the Whitechapel Art Gallery, 1980.
15 *Greater London Development Plan,* 1984. Urban Fabric.
16 *Percentage for Art Scheme;* London Borough of Lewisham, July 1984.

bas-relief, wall hangings and so on can compare very favourably with the cost of a commercial product. And in the cases where these especially commissioned items would exceed the cost of a catalogue equivalent, they might well attract additional funding from the bodies such as the Crafts Council, Arts Councils and Regional Arts Associations who can award up to 50% of the cost of such a commission. The cost differential is usually smaller than anticipated, as has been found by those architects open-minded enough to look further than standard suppliers.

An art work can even effect a saving. For example, rubble from building tips is expensive to dump, but a saving could be made if it was incorporated in an imaginative land-work or environmental sculpture. Murals and wall hangings can contribute to savings in maintenance costs which far exceed the initial capital outlay. [See Chapter 27]

3 Interior Design Budget
It is often only at the stage of furnishing a new building or refurbishment scheme that the possibilities for commissioning a work of art becomes apparent, although it is very difficult to fully integrate a commission into a completed building. Funding then has to come out of provision for the interior scheme, or a late application made to the client, which is not always well received. This was the case with the Robyn Denny and Richard Smith 1982 commissions for IBM United Kingdom's Headquarters in Cosham, Portsmouth. Although the clients were in accord with proposals from the interior design team of Arup Associate's to commission the works it was difficult to find generous funding at that late stage.

The budget for furnishing a prestigious new headquarters building or refurbishment of a large corporation, could well be sufficient for

commissioning paintings, prints, hangings, furniture and so on for office and reception spaces in addition to off-the-peg furnishings. The clients might also be keen to establish a corporate art collection at this stage, and various bodies, including the Contemporary Art Society supply expertise for such collections. Large international companies are sometimes the recipients of gifts from subsidiaries or clients on the occasion of the building of a new headquarters. This was the case with De Beers, when the Contemporary Art Society advisers put together a collection of contemporary work for their new offices partially using gift monies; and gifts were also part of the Unilever House refurbishment. [See Chapter 3]

4 The use of advertising budgets
Most large corporations have publicity and advertising budgets, and there is good reason to fund a commission from these sources if it can be used for future public relations benefit. Images generated by an artist in response to a commission can have possibilities of use beyond the original intention of the commission, provided that copyright agreements have been negotiated with the artist. The Alexander Calder sculpture *La Grande Vitesse* commissioned as part of an urban renewal programme for Grand Rapids in the United States has now become the city's logo, and is utilised from mayoral letter-headings down to emblazoning public utility vehicles.

B Long-term Funding

1 Percent for Art [See Appendix I]
A very significant measure for making funding available for art works is the percent for art system which operates in most Western countries, whereby a percentage of building costs is allocated to art and craft commissions. The keystone of this system is the insistence on integration of the art work into the built fabric, which can only be achieved if art is budgeted into a building programme from its inception. A percentage levy can come about either through a voluntary policy or appropriate legislation, and schemes of this sort have been operating at federal or state level for many years in the Netherlands, France, West Germany, Norway, Sweden and Finland, Italy and Canada. In the United States, The General Services Administration ran a percent for art scheme until 1978, while other Federal agencies, such as the Departments of Transportation, Housing and Urban Development have policies of percentage levy as a local option. Local percent for art schemes have now been adopted by many state and city governments across the country. For example New York city has recently enacted legislation, as has the state of New Jersey with its *Arts Inclusion Law* of 1978 which allows for up to one and a half percent of the total estimated cost of construction of a building, or group of buildings to be used for implementing the agreed 'fine arts elements included in . . . plans and specifications'[12]. It is noteworthy that, starting with cities like Baltimore and Philadelphia, percent for art laws have been adopted as part of urban revitalisation strategies, on the basis that new

17 Budget provision for special features is made each year. 'The budget is traditionally divided into two categories, being built elements and sculpture. The former allows for the provision in Milton Keynes of those interesting features often found in older cities, and for which there is no obvious financial source. In the past these have included such items as a clock tower and water-jet.' EMC.292.84

18 *Sculpture in Harlow*, The Harlow Development Trust, 1973

19 The Scottish Sculpture Trust was set up in 1978 to promote and present modern sculpture on public sites in Scotland. It receives financial assistance from the Scottish Arts Council, The Landmark Visitor Centre and the Highlands and Islands Development Board as well as private and corporate patrons. Other newly formed sculpture trusts are the Welsh Sculpture Trust. See A *Sense of Place: Sculpture in Landscape* etc., ed. Peter Davies and Tony Knipe, Ceolfrith Press 1984

20 The relevant Directory of Social Change Publications are; *Charitable Status: A Practical Handbook* and *A Guide to the Benefits of Charitable Status*

Philip King, *Dunstable Reed,* 1969, Steel aluminium and plastic, 1.65 x 3.80 x 4.25m Countesthorpe College, Leicestershire. Acquired by Leicestershire Education Authority with the aid of a grant from ACGB.
Photograph: by courtesy of Juda Rowan Gallery

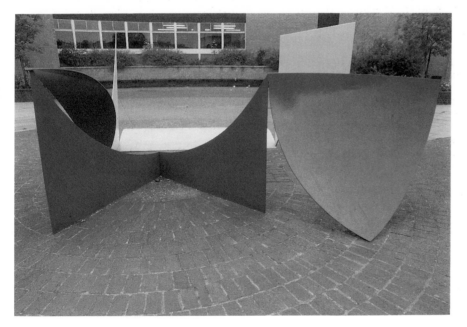

industry and investment will be attracted to those areas which provide the most pleasant environment and amenities[13].

In this country, since the 1950's there has been provision for local authorities to apply a percentage levy for art in buildings, and up to one and a half percent for educational buildings and refurbishments. The only local authority to take advantage of this system in a systematic way has been the Leicestershire Education Authority, which from the early 1950's spent a half percent (and later a quarter percent) of the cost of its building programme on works of art, in association with its enlightened policies of acquiring and placing art works in schools and colleges[14]. Universities and polytechnics, such as Liverpool University also exercised this policy in the construction of new faculty buildings in the 1950's and 1960's.

More recently a lobby has grown up in this country to bring Britain in line with the 1976 Council of Europe policy on percent for art, and recommendations to this effect were made by The House of Commons Select Committee on Public and Private Funding of the Arts in 1983. [See Introduction] In 1983/4 the Greater London Council approved a 'Percentage of Building Costs for the Arts Scheme' which recommended non-statutory expenditure of one percent [15]. West Yorkshire Metropolitan County Council adopted a similar scheme in 1985. Recently the London Borough of Lewisham approved a scheme whereby 1% is allocated for an 'artistic feature' from the cost of 'new building projects, refurbishment schemes of existing buildings and environmental schemes, including street improvement schemes and public spaces'[16]. A similar provision of one percent has been approved by South Glamorgan County Council.

A voluntary percent for art policy can operate just as effectively in the private as in the public sector, and is

a better method of using resources than *ad hoc* commissioning from special budgets.

2 Global Budgets

Milton Keynes Development Corporation makes a budget provision of £100,000 available every year for what it terms *Special Features* that is, 'built elements' or sculpture[17]. This provision has succeeded an earlier percent for art levy, and represents in effect an accruing of monies which otherwise would need to be spent in relation to the project where the funding had been generated. This is the system adopted by the city of Seattle which runs one of the most successful percent for art schemes in the United States. [See Chapter 15] However, Milton Keynes does not have a clearly defined arts policy and the limited *Special Features* budget has not been revised for some years, nor has it always been spent.

3 Charitable Trusts

Charitable Trusts to fund the acquisition or commissioning of works of art have been set up by a number of New Towns, such as Basildon and Cwmbran, for example, following the lead of the Harlow Art Trust. 'It seems to me that an Art Trust is an ideal medium for acquiring works of art for a town', wrote Henry Moore: 'It is not involved in local politics and it has no fears of public criticism. Being entirely disinterested, it can concern itself solely with acquiring the best work of art for each particular circumstance.'[18] Harlow Art Trust was established by Sir Frederick Gibberd, the Architect Planner of Harlow New Town with representatives from the Development Corporation, the Urban District Council and private individuals, and financed from subscriptions, donations and fund-raising schemes. The Trust continues to provide and site sculpture that can 'stand in the open air as part of the furniture of the town' and has also funded murals and mosaics. In addition to trusts concerned with town environments, a number of trusts have been set up in recent years to place works in parks and woodlands such as The Scottish Sculpture Trust, the Yorkshire Sculpture Park and the Welsh Sculpture Trust[19]. The funding of a trust of this nature varies, but even if funds are not very substantial, the advantage is that a trust is more or less self-perpetuating and will be associated with a long-term policy, with regular commissions and the possibility of a well-balanced collection of works for the town, or institution with which it is associated. The recently formed Portland Sculpture Trust, for example, has raised money from sponsorship as well as South West Arts to fund its bursaries to artists to work in Tout Quarries on the Isle of Portland. Those works which are integral to the quarry are intended to form the basis of a permanent sculpture park on the site.

One of the major advantages of a charitable trust as a method of funding works of art is that there are certain tax benefits, both to the individual donor (although only on the higher rates of tax), to the charity, which is exempt from most taxes, and to public companies who covenant funds. The most advantageous method of giving income to a charity is by a Deed of Covenant. To be effective this must be

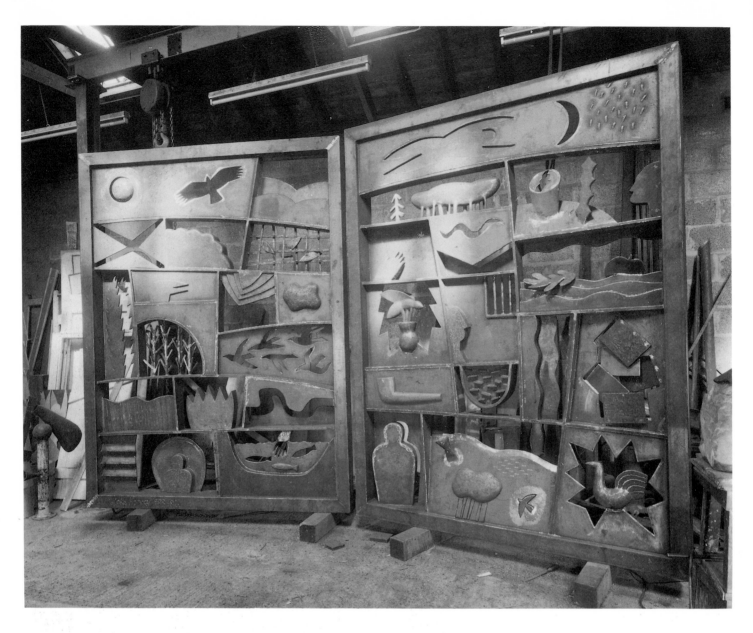

Pre-installation photograph of the Hugh MacDiarmid Memorial by Jake Harvey Commissioned by the Scottish Sculpture Trust, a charitable foundation set up in 1978. Funds were raised through a public subscription appeal.

Jake Harvey, *Hugh MacDiarmid Memorial*, 1982-4, corten steel and bronze casts, 3.66 x 4.80 x 1.83m, Lambhill, Langholm, Scotland. Commissioned by Scottish Sculpture Trust Funded by public subscription and Scottish Arts Council.
Photograph: Jake Harvey

21 In his 1986 Budget the Chancellor of the Exchequer announced three measures to encourage further giving:

tax relief for single donations by companies (other than close companies) from 1 April 1986

capable of lasting more than three years, and in practice is usually drawn up for a minimum period of four years. In these circumstances the charity may recover the tax although only at the basic rate. Even so this produces additional income for every pound donated to the charity. The individual donor can also claim relief at the higher rates of tax. Companies are entitled for the purpose of Corporation Tax to deduct the amount of the covenanted gift as an expense and again the charity recovers income tax at the basic rate[20, 21]

4 Residencies

The system of an artist employed directly by an authority is also a way of making funds available for art works on a long-term basis. The artist works closely with the architects and planning departments and either makes an artistic input into new building projects as part of the design team or is allocated

funding for independent projects. The willingness of a development corporation or local authority to respond to projects quickly is vital in such a situation. Although Town Artists have complained about not having regular budgets at their disposal, some shortfall has been made up by access to materials, processes and labour teams from public works departments. This is a system which has operated mainly in relation to Scottish New Towns where Town Artists have been employed by the development corporations, but similar systems have operated elsewhere. For example Rachel Fenner was Portsmouth City Sculptor from 1980 to 1983 working in the Department of Architecture and Civic Design. Her projects were funded as part of specific building contracts (like the brick sculpture for Hampshire County Council's Social Services Centre in Portsmouth) although her salary was paid by the Arts Council of Great Britain[22]. The Arts Council also funded the placement of Gareth Jones with the Alsop & Lyle architectural practice [See Chapter 7] and

Boyd & Evans, *Fiction, Non-Fiction and Reference*, 1984, Acrylic on 12 canvasses 11.88 x 3.96m, Central Library, Milton Keynes Commissioned by Milton Keynes Development Corporation.
Photograph: by courtesy of Milton Keynes Development Corporation

although this system does not release funds directly for art projects it means that the artist's place on the team is subsidized. North West Arts, the Arts Council, the Gulbenkian and Granada Foundations have funded *Partnership,* an Environmental Art Team in Manchester.

5 Revenue Funding

Residential community art groups such as the London-based Free Form and Greenwich Mural Workshop are revenue-funded by their respective local authorities and Regional Arts Associations and in addition receive one-off grants for particular projects.

Terry Eaton, gates, 1984, wood, entrance gateway to Laugharne Court, Sheltered Housing, Swansea, Commissioned by Swansea City Council.
Photograph: Terry Eaton, by courtesy of Swansea City Council

abolishing the £10,000 limit on higher rate relief for covenanted donations by individuals from 1986/87

introducing a new scheme for relief from April 1987 for donations by employees under payroll-giving schemes.

In common with other charities, the Arts benefit from these provisions in the 1986 Finance Act.

The 1987 Budget proposals included a reduction in the basic rate of tax from 29 per cent to 27 per cent, effective from 6 April 1987

22 See Four Commissions in Context in *Art within Reach,* Ed. Peter Townsend, Thames & Hudson 1984

23 Budgeting for commissions

Initial design fees

Generally speaking, these are pitched far too low. Average payments at the moment are between £250-£1,000 but it is important to recall that the maquette fees for the *Unknown Political Prisoner* international competition in 1951 were £250, (and inflation runs at about 100% against that figure)! All those invited to submit designs, whether or not successful, should be paid the initial design fee.

In determining initial design fees, the commissioner should take into consideration:

- The amount of creative work which is expected from the artist
- The travel costs and number of site visits required
- Cost of models, photomontages, photography, printing etc
- The standard of presentation required
- Framing, presentation and carriage costs if designs are to be exhibited.

It may be appropriate to have a development budget instead of a design fee. This would be applicable in situations where an artist was part of a project design team for a period of time, or artist in residence during the period when the choice of site(s) and formulation of the brief was being considered. This budget would be at an average salary level[1].

Exhibition Costs

In many commissions an intrinsic part of the selection process is an exhibition of the designs and maquettes. Exhibitions are valuable for publicity and community consultation, but they are administratively time-consuming. Transport, insurance, decoration of the exhibition space and installation and publicity costs are not substantial items, but must be included.

Extra Maquette Fee

If the client requires extra maquettes from the artist, these should be paid for, either at an agreed fee or on an hourly basis.

Commission Fee

In some countries (such as the Netherlands) the commission fee is based on a percentage of the total commission cost, similar to the professional practice of architecture. In this country there is, as yet, no such guideline. Negotiated commission fees will depend on the standing of the artist, and the complexity, time and scale of the commission and its installation.

It may be agreed between client and artist that fees are not designated but are discretionary within the context of the whole budget. This should, arguably, be the case with regard to murals or certain kinds of craft work where the process is entirely carried out by the artist.

In the case where commissions fees are specified, advice can be sought from the artist's agent or dealer, from a commissioning adviser or from visual arts administrators.

Material and Fabrication Costs

Material costs are sometimes inseparable from fabrication costs. Estimates should be obtained before specifying costs in any contractual budget. *It must be clear whether VAT is included or not.*

Installation costs

(In some cases, the items listed below will be part of the main building contract)
- Insurance and public liability insurance
- Engineers' consultation costs
- Transport and carriage costs
- Hire of specialist equipment such as excavators, concrete mixers
- Extra labour costs eg carpenters, electricians, engineers
- Landscaping or clearance costs (if these are not part of a building contract)
- Decoration after installation

Contingency

Some allowance should be made for unforeseen costs, and the amount included in the budget as a contingency sum (unless allowed for elsewhere) should reflect:
- Hidden development costs. Every original commissioned work of art is unique, and entails (on a small scale) the sort of development which in engineering or architecture would be separately budgeted for.
- Inflationary rises in materials and services.

1 Visual artists still do not have a recognised professional organisation which determines fees or conditions of employment, although there are international guidelines on these matters. The Association of Community Artists, however, can provide some guidance on salary scales. [See Appendix II]

- Delays relating to the main building contract, or other external delays beyond the artist(s)' control. Delays in installation could create contingent costs such as extra storage. It is relevant in this context to refer again to the survey *Architects Commissioning Works of Art* commissioned by the Art & Architecture Research Team. This showed that in the experience of 84% of architectural practices, commissions were completed within budget, whilst the experience of 78% of respondents indicated that commissions were finished on time (see Appendix II)

Method of Payment

Artists should be advised on the presentation of invoices. In some cases bills incurred by the artist may be invoiced directly to the client or a VAT registered art agency, thus avoiding VAT problems for the artist. (Many artists are not VAT registered.) It is essential that the artist be informed whether there will be a time-gap between invoice and payment, as very few artists can afford large overdrafts. Some might well have given up regular teaching or other employment to meet the demands of a commission.

It is recommended that payments are made in stages, depending on the scale of the commission. The following 4 stages are suggested:
1 Design/maquette fee.
2 Initial payment on the commission being awarded. This should be at least an advance of 50% on materials and a third of commission fee.
3 Term payment. The client may wish to see the work in progress before payment of the remainder of the materials fee and a further fee instalment. A resumé of costs and estimates for installation (see above), and transport costs would be usefully ascertained before the work leaves the studio.
4 Completion. All outstanding fees should be paid on installation.

Agent's fee

An agent's fee will vary according to the complexity of the commission. As a general guideline a client should expect this fee to be between 10%-15% of the total commission costs. In the event that a commission does not proceed, or that an agent advises only at the first stage of a project, the agent will probably charge an hourly fee for advisory work, which can vary from £25-£40 per hour. [See also Chapter 26]

Budgeting for Labour

At first sight certain projects such as murals appear to be ideal candidates for government funding, for example under the MSC Community Programme. However past experience has shown that potential advantages in terms of resources need to be balanced against the administration and monitoring associated with the training requirements of such schemes. These may place an administrative load on small arts projects, which could lead to delays in meeting deadlines. Individuals on MSC funded programmes are only eligible for training for limited periods (for example twelve months at a time) which may not always be long enough for relevant skills to be acquired, and may lead to a change of personnel during a project (as happened, for example in Easterhouse, see Chapter 5)

Thus when seeking government funding it is important to ensure that the project is appropriate in terms of duration and skills required. In particular, motivation and aptitude of those participating in the scheme are important considerations when choosing a suitable team.

However, for detailed information on current MSC schemes advice should be sought from Local Jobs Centres and Careers Advice Centres.

24 The role of the commissions adviser

1 The Public Art Consultant for Eastern Arts Association is involved with major commissioning projects in parallel with programmes of visual arts provision where the purchase or final product is part of an overall educational exercise. She is associated with such services as the *Artists in Schools* scheme, residencies and the Eastern Arts Loan Collection in assisting in the acquisition of works for the loan collections of education authorities, libraries and museums services. Application forms for people wishing to apply for grant aid for works of art and craft for public places should be directed to the Visual Arts Officer, Eastern Arts Association. The Public Art Agency is based at West Midlands Arts in Stafford. The agency's brief is to initiate and implement a programme for public art projects and related residencies throughout the region; to offer an advisory service to artists and commissioners, and to attract new sources of funds for projects. The West Midlands Arts slide index, *Artfile* will be expanded as a resource.
The Adviser on Art in Public Places for Yorkshire Arts Association is based at the Recreation and Arts Division of West Yorkshire Metropolitan County Council, County Hall, Wakefield.
Northern Arts retain a freelance Commissions Agent who has been closely associated with Art in the Metro, and Gateshead and Grizedale Forest schemes.

Arts administration expertise in the commissioning of art and craft has developed as a result of the Arts Council's Art in Public Places scheme set up in 1977. The scheme provided seed-funding for projects from both the private and public sector, and initially played a promotional and advisory role. Promotion and administration are now handled directly by the Regional Arts Associations. Specialist advisers have been appointed in some regions: the Eastern Arts Association has a full-time Public Art Consultant, West Midlands a newly appointed Public Art Coordinator; the Freelance Commissions Agent for Northern Art has been in office for some time, and Yorkshire Art has appointed an Art in Public Places Adviser.[1] North West Arts has a special environmental art panel[2].

In those regions without specialist advisers, the visual arts officers (and crafts and community Art officers where such appointments exist) will advise on commissioning and applications for part-funding

for public commissions under the regional Art in Public Places schemes and the Craft Council's Craft Commission Scheme[3]. Most Regional Arts Associations have registers of artists's work which can be consulted on application [see Appendix III for details] as does the Crafts Council (which runs a comprehensive advisory service) and the Scottish and Welsh Arts Councils[4]. Policies are reviewed periodically in the Arts Councils as priorities are assessed. The Welsh Arts Council, for example, believes that the advisory role is more significant than the availability of grants, and in future the officer in charge of commissions will act more as a consultant.

Private galleries and artists' agents can advise on commissioning, but obviously their advice will be related to the stable of artists whom they represent. There are also galleries which specifically relate to art for offices.[5] Public galleries will give advice on choosing works or contacting artists, as will specialist

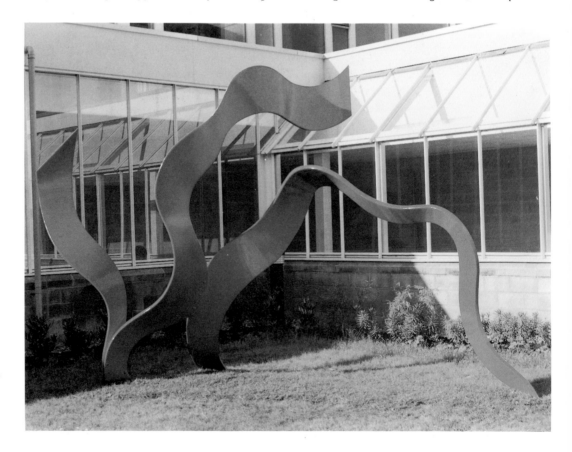

Bernard Schottlander, *Archway Sculpture,* **1984, painted steel 3.05 x 4.42 x 1.83m Lister Hospital Maternity Unit, Stevenage, Herts. Commissioned by North Hertfordshire Health Authority. Supported by Eastern Arts.**
Photograph: Department of Medical Photography, North Herts Area Health Authority

90

2 *The Partnership* team operating in the North West is located in Manchester, and has a slide and resource library of local artists and craftspeople as well as environmental and public art generally.

Town artists, for example in Glenrothes and Easter Kilbride, not only carry out their own commissions, but advise on the commissioning and siting of other works within their towns in association with architecture and planning departments.

3 The Art in Public Places scheme of the Arts Council of Great Britain has been devolved to the regional Arts Associations. Information about projects sponsored by the Arts Council is contained within the book *Art Within Reach,* Edited by Peter Townsend, Thames & Hudson, 1984.

The Crafts Council has a selected index of craftspeople available for consultation to anyone interested in commissioning. The index is open to the public and administered by a special staff, and slides of crafts works are available on loan for a small fee.

The Craft Commission Scheme is designed to encourage commissions in public buildings and spaces, and up to 50% funding is available in certain cases for public craft commissions. For full details and application forms contact the grants and services section. This scheme is run in partnership with the Regional Arts Associations. The Crafts Council publishes a book *Running a Workshop* which includes information for craftspeople on working to commission.

bodies like The Contemporary Art Society, or The Artists Agency in Sunderland. [See Appendix III]

An example of a service organisation which has been set up specifically to advise on commissioning is the Public Art Development Trust, which provides a general advisory service, helps to raise funding from public and private sources and administers projects. Fees are generally charged on a percentage basis, according to the complexity of the project, and to cover operating costs. The Trust is a non-profit making registered charity, with public liability insurance which implies full legal responsibility for commissions.

The post of commission adviser is very differently constituted in different parts of the country, involving salaried officers in some cases or part-time freelance advisers in others. The services offered, however, involve the following:
■ Advice on selection of artists and craftspeople. This is often through regional registers of artists and slide-indexes. (In the case of the Crafts Council, slides can be borrowed on a lending-library system.) Slide indexes contain examples of artists' works, but not necessarily of site-specific commissions, with which an agent will be familiar. The agent will be able to advise on specific artists appropriate for the type of commission and arrange visits to exhibitions and artists' studios.
■ Liaison and Supervision. This is particularly important because so many different bodies and individuals can be involved at different stages of the commission and there is need for a single line of communication. Liaison is also needed between artist and client in the initial selection and contractual

stages, between artist and fabricators, engineers, contractors and architects during the carrying out of the work and installation, and with press and PR firms during the launch. The agent will also be in the position to deal with and provide know-how about public authorities.
■ Fund raising. The agent will be able to advise on the format of applications for matching funds from the public sector and possible contacts for sponsorship, or materials in kind from the private sector.
■ Administration. A considerable amount of administrative work is generated by a large-scale commission. This includes the setting-up and minuting of meetings between the different parties, handling correspondence, assisting in the drawing up of briefs, contracts and budgets, handling VAT and ordering materials for the artists involved.

In addition the adviser should advise on the selection of juries and organisation of competitions, arrange the exhibition of maquettes and set up and monitor consultation procedures.
■ Launch & Publicity. The agent will arrange for photography, be in contact with designers and printers and to supply copy for competition or advertising brochures, organise launch and publicity, arrange interviews and have press contacts.

In the case of a simple 'one-off' commission there is a positive benefit from a close contact between client and artist. In more complex commissions, involving many bodies and a number of artists through competitive procedures, the co-ordination of a specialist commissioning adviser is a great advantage.

4 The Scottish Arts Council's Art in Public Places scheme has funded up to 50% of the cost of projects concerned with placing works of art or craft in public places but is now primarily directed towards design fees. The Council has been funding public commissions since 1972. There is no special officer, but advice on how to structure applications or select artists (through a register) is handled together with administration of all residency, grants and commission schemes. The Commissions Officer at the Welsh Arts Council, now has the role of General Art Officer, and advises

clients on commissioning more as a consultant. 'In practice we organise the whole thing, convening the selection meetings, exhibiting and transporting the designs, helping to find sponsorship, arranging publicity, organising opening ceremonies, etc'.
The Slide and Information Library contains information on around 1000 artists living and working in Wales. Textual information is computerised. The library is open every day, to all members of the public and can be consulted by appointment.
5 The Business Art Galleries Ltd.

housed at the Royal Academy arranges commissions.
Other galleries specifically working in this field in London are Art for Offices and the Aspects Gallery. [See Appendix III for addresses]
A useful reference for galleries and agents is the *Directory of Exhibition Spaces*, Edited by Neil Hanson and Susan Jones, Artic Producer Publishing Co. Ltd, Sunderland 1983. The book lists some 2000 venues showing art and crafts in the form of a geographical gazetteer. Also *London Art & Artists Guide*, Edited by Heather Waddell, Art Guide Publications, London 1981.

25 Public consultation and community relations

1 This view was expressed by interior designer Christine Liversidge about the policy of Arup Associates, in an interview partly recorded in *Art Within Reach*, ed. Peter Townsend, page 27.

Dame Elizabeth Frink, *Flying Men* 1983, bronze, Woodside Estate, Dunstable. Commissioned by Brixton Estate plc.
Photograph: courtesy of Jorge Lewinski

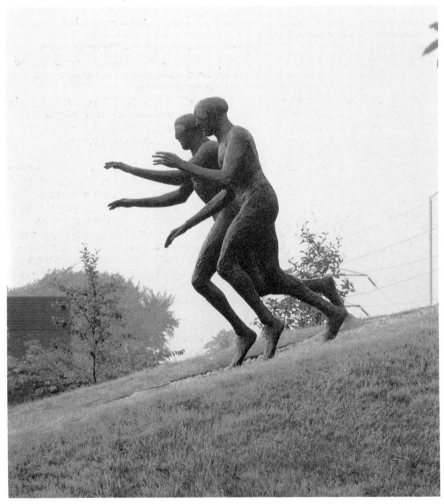

Why Consult?

In placing art in public places, choices are made on behalf of others and the art works bring about a change in the environment. It is important therefore that people do not feel that something has been foisted upon them without consideration of their needs, interests or feelings. Where the clients are a local authority, consultation is not only politically sound, if the work has been paid for out of public funds, but will help to diffuse hostile reactions which could be expressed as vandalism.

In the private sector, there is a sound investment reason for consulting users in a public situation such as a housing estate, where home-owners will be deeply concerned about the value of their property, amenities, or the improvement of the 'quality of life'.

Whilst the external appearance of a building may be readily accepted, people are eager to adapt interior spaces to their personal needs and taste. A work of art which, by its very nature produces an emotional response may be considered far more intrusive in such spaces than, for example, functional items of furniture. Consulting people about placing art works in a factory or office building is not only a courtesy, but fundamental to good labour relations.

Giving people the chance to experience a variety of works in a consultation exercise also allows them to make more informed choices about their environment in general.

When to Consult

If art works are integral with a new building designed for a specific client, then the need to consult is accommodated in the brief. If the future users of a building are unknown, the question of consultation also becomes hypothetical. In the case of an office or apartment development, the art works might have been incorporated for the very purpose of attracting users [See Chapter 4]. It is claimed by some architects in the field that users of office buildings more readily accept those works which they find already established and resist any attempts to remove them later[1].

The decision to consult therefore will depend on whether there is an identifiable community of users who identify with a place or space as an interest group, and whether the intended art work will imply a change of usage or status of the proposed site which will affect the community.

Identifiable communities
It is appropriate to consult an identifiable community if it is also an *identifying* community. This is not always easy to determine. Unaffiliated city office workers in adjacent multi-use office buildings, for example, might not seem to constitute an interest group. They might express their indifference by not responding to a questionnaire about the installation of an art work in the adjacent square where they eat their lunches in summer. If, however it became clear that such an installation would threaten facilities to which they had become accustomed, the response would be definite.

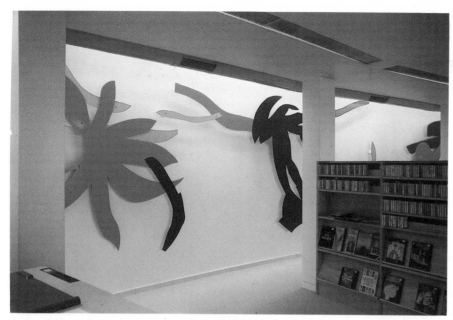

Graham Crowley. *The Four Seasons*, 1983, stove enamelled aluminium sheet 6 x 36.58m, mural in Chandlersford Library, Hampshire. Commissioned by Hampshire County Council with support of Southern Arts Association. Architects: Hampshire County Architects.
Photograph: by courtesy of Hampshire County Council

Jennifer Durrant, 1983, mural, acrylic on canvas, 2 panels 3 x 244m, Newham Hospital. Commissioned by North East Thames Regional Health Authority and co-funded by, King Edward's Hospital Fund for London, GLA, and French Kier Construction Ltd.
Photograph: Heini Schneebeli

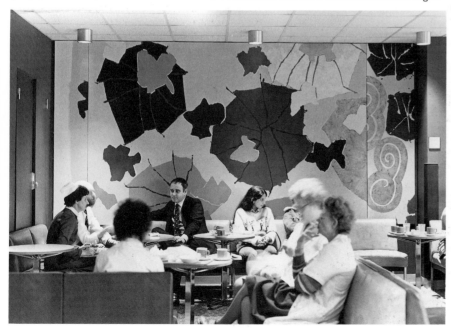

The degree to which people identify with a place or situation will determine not only the degree of response (and responsibility) but also the *quality* of that response. For example, employees in a very large corporation might transpose their discontent about a large mural, which they believed to be expensive, into an expression of worry about bonus payments if they were not consulted. Probably they would express concern much more directly if an art work was placed without consultation into a company sports facility with which they identified in their leisure time.

People directly associated with professional activities of a social, caring or environmental nature who stand in a particular relation to their clientele, such as the employees in a hospital, a school, or a church will be vitally concerned with what happens in their working environment. Communities in such situations might well be changing: a hospital has its permanent staff as well as a changing community of patients, and a school might have daytime, evening and weekend use by different groups. Nevertheless the rôle of such institutions is quite clearly defined and employees will be concerned that they are consulted as a measure of their professional standing. Equally they will wish to ensure that the art works are in some ways an expression of the appropriate ideology; for example, the healing aspect of a work in a hospital, the spiritual symbolism of a work in a religious institution.

Identifiable territory

People identify far more with the closely-bounded areas in which they live and take their recreation, than the more neutral city areas in which they work or visit occasionally. This identification takes the form of territoriality and protectiveness about place. [See Chapter 26]. Experimental art works will be far more readily acceptable in city areas which are not the 'turf' of any group. Any art work which is considered for siting in an area such as a village, housing estate or a community of retired people, will only be accepted if some consultation has been carried out, if the work is in popular taste or some dynamic from within the community has allowed the work to be appropriated. An example of such appropriation would be the bestowing of a humorous nick-name which catches the local fancy. Or a community might be roused by indignation to protect 'their' local art work if vandalised by a group of outsiders.

Community artists tend to work in such defined territories, and particularly within economically and culturally deprived inner-city areas or new-town estates struggling to create a sense of neighbourhood. Their consultation procedures, in the case of the visual arts, are geared to extrapolating very precise information to be used as the subject-matter of murals or public art works.

It is probably impossible to define the aspirations of a community in this monolithic way (especially if it contains ethnic minorities with different cultural roots) yet there are certain dynamics which can unite a very diverse community however negatively or momentarily, which must be addressed. There may be hostility against outsiders however well-meaning, or apathy in not responding to leafletting, attending meetings or filling in questionnaires. Hostility could be directed against outsiders as a group, against cultural hegemony or against what are considered infringements of cultural or religious taboos, particularly in the case of a numerically strong ethnic or religious grouping. People will question whether an art work adds to or detracts from property values, and will have deep-rooted feelings about the historical, political, symbolic or peer-group associations with a place. The importance of consultation is to become aware of these issues so that they can inform the art work, rather than to expect a community to propose 'what it wants.'

Change of use

The change of status of a place or area is of great concern to the resident community, as for example London Docklands, where local protests have been

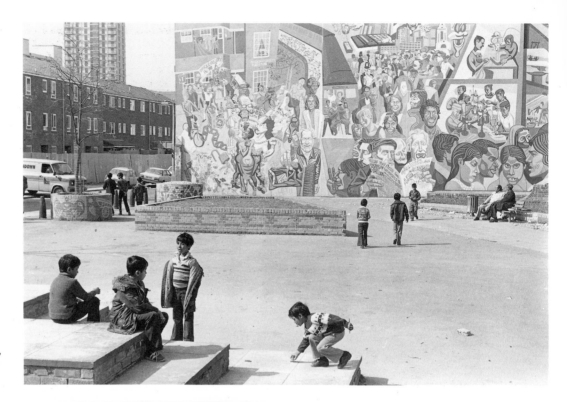

This mural in Chicksand Street in London's East End, illustrates historical and topical events of importance to the neighbourhood communities.

Ray Walker, *The Promised Land,* 1980, mural, 9.75 x 36.6 m, Chicksand Street, London E1. Funded by Tower Hamlets Arts project and ACGB.
Photograph: David Hoffman

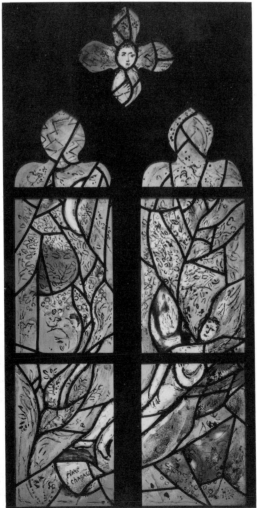

Marc Chagall, Stained glass Windows for All Saints, Tudeley, Kent, 1966/78, 1.32 x 0.35m. Commissioned by Lady d'Avigdor Goldsmid.
Photograph: courtesy of Lady d'Avigdor Goldsmid.

expressed in a vigorous poster campaign. Concern is also expressed if a place has a specific status or symbolic meaning for a local or wider community. A hypothetical example would be to instal a contemporary work by an unknown artist in front of Buckingham Palace, or in Trafalgar Square, which would raise a national and possibly even an international outcry.

Other considerations which will affect people's attitude to change of traditional usage, are political or conservationist. The Yalta memorial committee [See Chapter 22] was refused permission to site the proposed sculpture in any of London's major parks because of the political implications of the memorial. Lady d'Avigdor Goldsmid encountered much resistance from local conservationists before she succeeded in installing the especially commissioned Chagall memorial stained-glass windows in place of existing Victorian windows in All Saints Church, Tudeley, Kent.

How to Consult

Whatever consultative measures or combinations of measures are to be used, the information should be clearly stated in the brief and advertising for the commission, as well as in subsequent public relations for the completed work(s).

■ *Representation from the community* on selection panels or involvement in discussions related to formulating a brief for the commission. The latter could be very helpful with regard to local mores and expectations. [see above]

■ *Exhibition of maquettes and public survey.*
This is the most usual manner of gauging community

2 It could well be that comments that a work of art is sure to be vandalised by 'them' are an unconscious device for people to express a negative response without appearing to be impolite or socially irresponsible. The 'waste of public money' responses might relate to the person's economic status or political beliefs: a middle-class tax-and rates-paying individual might be more conscious of these issues than someone living in council housing who believes in the provision of state and local authority benefits.

response. If the works cannot be exhibited in relation to the actual site or building, useful venues are libraries, community centres, shopping centres, cinema or local theatre foyers. However, the response to the survey, or ballot will be affected by the choice of venue, and library users, for example, might not represent the widest sample of the community.

The way the questionnaire is drafted is of the greatest importance: people respect a serious set of questions. It is also useful to categorise questions in the context of an explanation of the work and the reasons for the commission. A survey at the Brompton Hospital presented in this way, received very useful responses. It was stated for example, that the Graham Crowley *Birds* design was airy and spacious and 'helped people to breathe', which was of importance in a chest hospital. At Northwick Park Hospital, however, a ballot sheet carried the single question: 'Which do you like best?', and most of the returns were spoiled.

An open invitation to written comments, is also not very satisfactory as it limits responses to people who feel confident in expressing themselves in writing. Probably the most effective method is for the artists to be present to talk about their work and answer questions, with a team to fill in the questionnaires.

Telford's Landscape Design Department organised an exhibition of maquettes of sculptures intended for the central square. The works were exhibited in two venues over a period of ten days and received 1221 returns: two people were always present to talk about the commission and a number of voters wrote comments on the voting slips. People were asked to record their first and second choices on the basis of which maquette they preferred and which they thought most appropriate for the square. Officials of the Development Corporation who had initially been

sceptical about the notion of a public vote were impressed by the high level of interest shown, and the fact that out of 1357 voting slips (members of the Development Corporation also voted), only six carried comments that the project was a waste of money; and more than a third of the visitors to the exhibition commented on 'how nice it was to be asked'. A very similar response was noted at the exhibition in the local community centre for four maquettes for a sculpture for Bellingham Green in the London Borough of Lewisham. The exhibition lasted for four days, and 3000 leaflets were distributed. Although attendance was poor, not a single visitor suggested that the commission would be a waste of money. In both Telford and Lewisham, the majority of comments expressed fear that the work would be vandalised[2].

■ *Artists resident in the community*
One of the most satisfactory ways of establishing a *rapport* with the community and ensuring that a commissioned work will relate to people as well as site, is for an artist to work in a residency for a period of time. Not only will the artists be able to get a 'feel' of the place, but in effect they will be writing their own brief, by making detailed enquiries as to the history or associations of the site, and be in a position to gauge the receptivity of the community to the project. The artists will be accessible to the public either within their studios space (at designated times) or by working on site. This is a strategy adopted also by artists in more traditional commissioning situations, and has proved to be useful for helping to 'root' a work in its place and community. The psychology behind this strategy is the very real curiosity that people have about process and making; sometimes a greater curiosity than for the finished art work. It is fashionable jargon to assert that being seen to be creative helps to 'demystify' the creative act; in fact, people admire skill and enjoy watching its secrets.

Graham Crowley *Birds* 1982, Mural in the waiting room of Brompton Hospital, London. Enamelled metal pieces, 12.3 x 4.2m. Commissioned by the King Edward's Hospital Fund for London and supported by GLAA.
Photograph: Heine Schneebeli by courtesy of *Art Monthly*

Richard Harris working on site in front of the Royal Festival Hall during the Arts Council *Sculpture Show* 1983. The environmental sculpture is now a permanent part of the landscaping.
Photograph: Heine Schneebeli, by courtesy of *Art Monthly*

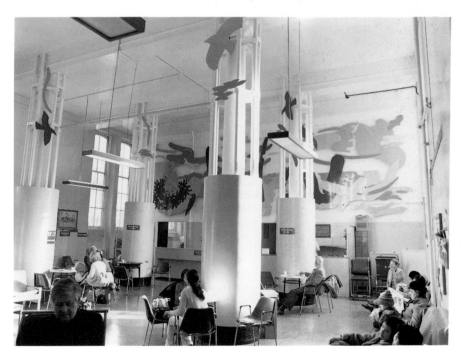

Some of Kevin Atherton's public works employ the device of casting from life in order to involve members of the community in the project.

Kevin Atherton, *Platform Piece*, 1985-6 Commissioned by British Rail Environment Panel with London Borough of Lambeth. Funded by British Rail, British Rail Property Board jointly with Lambeth Inner Area Partnership and GLC.
Photograph: Edward Woodman, by courtesy of Public Art Development Trust

3 *Procedures for Development and Implementation of 1% for Art Projects,* Seattle Arts Commission, 1978 & 1981.
New Jersey Administrative Code, New Jersey State Council on the Arts, 1978. (Guidelines for the 'Arts Inclusion' programme)

The problem with the residency approach (which at present is much favoured by public funding bodies) is that artists are sought as much for their social as their artistic skills; yet by virtue of the particular solitary and obsessive aspects of artistic practice, artists are quite often introverted. The choice has to be made whether the social implications of the role outweigh the aesthetic considerations of the work produced, or vice versa.

■ *Community animation*
Those artists living within the community as *animateurs* or catalysts, who undertake works in association with the local community, such as murals, environmental schemes or community play projects, deploy specific consultation procedures. These involve door-to-door canvassing, leafletting and public meetings. In this sort of activity, as exemplified by Free Form in London, and the Community Arts Workshop in Manchester, commissions come from the community directly, usually from the voluntary sector such as youth clubs or tenants' groups, and local people are involved in all stages of the design process and execution of the works.

■ *Presentation and introduction to the art work*
Whether a commissioned work has come out of a series of consultations or not, it is very important that the completed work be presented to the community, to reinforce the sense that it has not just been 'foisted' on people. The presentation will include the festivities associated with a launch, the 'unveiling', the speeches, the press photographs and VIPS. The presence of the artist or someone qualified to talk clearly about the work and its significance for site, community and client is important. If the artist has held a residency or has worked on site, the structures for setting up the presentation will already exist. In the cases where prior consultation has been minimal it would be very useful for management to arrange an introductory talk in relation to relevant documentation such as preliminary drawings, colour samples, photographs and so on. Equally useful would be the production of a leaflet or commemorative document, with a description of the work and its meaning and origins. An excellent example of this is the book produced by Watmoughs (Holdings) PLC to celebrate the commission of a painting by John Loker for the reception of their new offices in Horsforth. The book contains reproductions of the artist's drawings relating to the commission, which is illustrated on the cover, a statement by the artist and explanatory text by an art critic.

What to do with the public survey

There are different ways of using the information gleaned from public consultation:

■ To incorporate the information within the commission, as would be done by a community artist.
■ To allow a public popularity vote to be the deciding factor in the choice of a work (as was done by Telford Development Corporation in the example mentioned above)
■ To use the consultation procedures as a positive strategy of public relations and consider the public response as one of the many factors to be weighed up by a selection panel.
■ To allow the information to inform and enrich the artistic ideas without totally determining its form or subject matter.

A decision as to any of these approaches has to be taken in advance as it will determine which kind of procedures are used. Furthermore it must be shared by client, artist, back-up team and adviser.

The choice of method depends on the degree of importance that the client places on the artistic merit of an art commission and its value to the site. In the case of the first two options, questions of popularity or social relevance are considered more important. In Telford, the winner of the competition received 41% of the popular vote which was an influential consideration for the selection panel consisting of the Chairman and Assistant General Manager of the Development Corporation, a local councillor, a representative of West Midlands Regional Arts Association and one artist. A survey of responses from other artists (professional and amateur artists, art teachers and craftspeople) was overwhelmingly against the popular choice. In the United States, where procedures for selection panels for percent for art schemes have been codified, the usual procedure is for there to be more than one artist on a panel and the selectors to be experts in the field. Community representatives act as advisers to the jury[3].

In the third case the act of consultation is important in itself. Like an opinion poll, it expresses a point of view but doesn't determine the election. The information can be used by the artist or the clients in an imaginative and unstructured manner.

The response to consultation procedures can be disappointingly low. This was certainly the case with the elaborate procedures organised by the London Borough of Camden for the Maygrove Peace Park commission, and the Borough of Lewisham for the sculpture for Bellingham Green, to cite just two examples. The results of a low turn-out should not determine the commission. In general, the results of consultation are an important factor to be balanced with all the other relevant issues, particularly that of artistic integrity.

Robert Clatworthy *Horse and Rider,* 1984, bronze, ht. 4.57m, 1 Finsbury Avenue, London. Designers: Arup Associates Architects, Engineers and Quantity Surveyors. Commissioned by Rosehaugh Greycoats Estates Ltd.
Photograph: Peter Cook Photography, by courtesy of Arup Associates. ▶

26 Site and context

1 Barrie B. Greenbie, *Spaces: Dimensions of the Human Landscape*, Yale University Press, New Haven & London 1981.
'In the homogeneous proxemic village or neighbourhood, both the social and the physical environment can be extremely complex and yet understandable to its residents because they have learned to know it over a longer period of time, they share its cryptic symbols the more it reflects the special life of its residents, the more interesting it will be to insiders and outsiders alike.' pp.114-115
In the distemic area, 'the environment must be far more predictable and legible at least as regards those details and landmarks that serve for orientation.' p.115

Site Specificity

One of the most significant aspects of commissioning a site-specific work is the realisation that the onus is just as strongly on the architect or designer as it is on the artist to relate the work to its setting.

In most commissions the architect will be required to make some modifications to the building or its landscaping to receive the work. However, a fully integrated work calls for the closest possible collaboration with the artist to achieve the optimum relationship between art work and architecture with both artist and architect being prepared to undertake significant redesigning if necessary.

The implications of site

Considerations for siting art works will depend on whether the work is part of the architectural fabric, or is to be placed in relation to internal or external architectural spaces, or sited independently in either an urban or open landscape context. These considerations will concern not only what works best in relation to the site, but also questions of emphasis and hierarchy of values. A sculptural relief on a building façade, for example, will involve the same guiding design principles as the rest of the building, although it might set up a counterpoint to the system: it may serve to elaborate the light and shade and pattern of the façade, or provide functional emphasis by signalling an entrance. But is unlikely to dominate the whole façade – unless its scale is enormous and there are no other sculptural elements. On the other hand, a mural or sculpture placed in a vestibule, a courtyard or a city square can become the focus of that space, not only in terms of visual drama but also by affecting use-patterns of the space, access routes and other contingent services. The moment when the architect draws a first fond squiggle on the sketch-design representing a notional sculpture, therefore, is the moment for consideration of the aesthetic or strategic value of the art work and its implications for the site.

Urban Spaces

1 Appropriateness of site
Urban spaces can be defined by a whole series of gradations between public and private usage. Outside of the private living space are those areas which can be usefully designated as *proxemic*, that is, spaces used by an identifiable community or neighbourhood, and *distemic* spaces, the 'large and important spaces in all real cities which are used by diverse people of many cultures and subcultures and cannot properly be considered the turf of any group.'[1] These classifications can overlap or change from one generation to another, but they imply important social dynamics: certain areas of the city are the domain of the individual because they can accommodate non-conformity of the sort which would meet great resistance within the

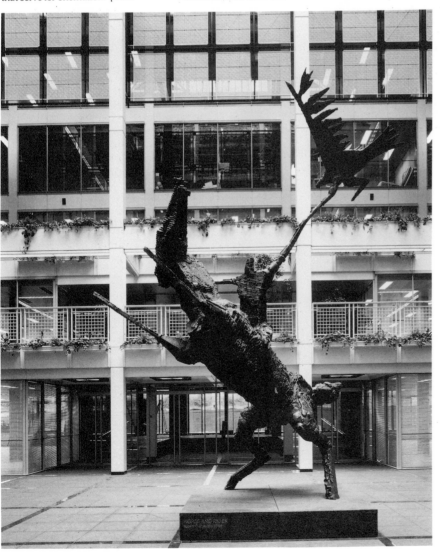

2 Ibid., Greenbie cites in proof of this the fact that 'Martin Luther King, Jr., and his supporters were able to integrate the public places of the U.S. South within a few years, while two generations of school-children have been bused back and forth, north and south, in a largely unsuccessful effort to achieve school integration.' p.117

3 Joseph Rykwert, A Balance-Sheet of the City, Diogenes 121, 1983, p.36.

4 A report by HL Freeman, Mental Health in the Inner City, in Environment and Planning, 1984, Vol.16, pp115-121 which discusses how cities have considerable problems from excess motor traffic, recommends: 'Because of the harmful emotional effects of destroying enormous tracts of the inner cities, there is a need for Psychological Conservation Areas in which familiar landscapes can remain. . . .'

5 Robert Jensen, Dreaming of Urban Plazas in: Urban Open Spaces, Cooper-Hewitt Museum, Academy Editions, London 1981.

6 William H. Whyte, The Social Life of Small Urban Spaces, Conservation Foundation, Washington DC 1980, pp.95-96.

Barry Flanagan, Camdonian 1980, Bronze sprayed steel, ht. 4.57m Lincolns Inn Fields London, Commissioned by London Borough of Camden.
Photograph: Chris Davies by courtesy of London Borough of Camden

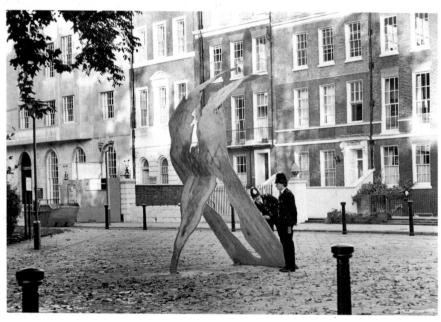

neighbourhood.[2] This can be used as a predictive tool for establishing what sort of art works will be appropriate in different parts of the urban geography. Urban spaces are also different in kind. Those spaces with a symbolic national (or international) significance, signalled by sculptures of a heroic or commemorative nature, such as Trafalgar or Parliament Square, are qualitatively different from revitalised areas like the new Covent Garden or the Place de Beaubourg, where the art activity generated spills over into the surrounding streets. It is no coincidence that the latter sites are adjacent to cultural centres, as is the most recently revitalised area in London, the riverside attached to the South Bank complex, activated by the policies of the GLC. A cultural focus for urban renewal or for generating a lively public space can be signalled by an art commission, such as the Toronto waterfront renewal project which involves a series of commissions, or London's Docklands.

2 Time and Change

■ A basic consideration in siting art works in an urban context is that they, like the surrounding buildings, street furniture and street lay-out, are subject to *time and change*. The perfectly-conceived pedestrianised shopping precinct exists only for a single ideal moment of time on the planner's or architect's drawing board, just as the art work exists only for a brief moment of purity in the ideal conditions of a gallery exhibition. From then on, materials wear and decay or are subject to vandalism, the seasons change, people using the place change diurnally or seasonally, cars are parked or street markets set up, the area 'comes up' or 'goes down' in terms of prestige and social usage, the artist's reputation falls out of or comes back into favour, buildings are pulled down or rebuilt, the designated use of the area changes.

These are basic considerations for patrons and will affect decisions about materials, scale, cost, and which artists to approach for the commission. Unless a commission is expected to have a short life

expectancy, it is very important in a changing public context that the art work is capable of assuming layers of meaning. A single emblematic statement or visual joke – no matter how good its simple configuration may look on the drawing board – may be incapable of outlasting its own simplistic impact. Equally notions of change affect considerations of designing the urban context for the work of art. The more that a work looks arbitrary within a given space, simply a 'plop sculpture' in the words of sculptor Anthony Caro, and not part or focus of a whole concept, the more it will be subject to vandalism.

■ A positive strategy for acknowledging the changing time dimension of public places, is to allow for *festive refurbishments* of areas like adventure playgrounds, underpass murals or other community art projects. This is particularly useful with regard to underpasses, which are seldom well conceived and which very quickly become dirty and vandalised whether decorated with community murals or not. A ritual repainting of an underpass mural can serve many useful purposes.

3 A Sense of Place

A work of art can undeniably impart a 'sense of place', of identity and landmark to an undifferentiated urban space, provided that it is well sited. In an era when planners are trying to reclaim old town and city centres from erosion by traffic and car-parking, and cities are 'more and more seen as a series of pavilions in uninflected public space'[3], the need to re-establish meaningful public space is pre-eminent.[4] This is even more important in new towns and cities where there is a strong psychological need for markers for orientation and pedestrian meeting points within a predominantly vehicle-determined system. The tendency of engineering departments to leave spoil for the purposes of strip landscaping in relation to new road systems, for example at Milton Keynes and Telford, means that recognising landmarks or exit roads is problematical. It is equally difficult to find the way in shopping malls, car-parks, underpass road systems or developments of the scale of the Barbican in the City of London.

The London Borough of Camden's siting of a Barry Flanagan sculpture in Lincoln's Inn Fields is an example of trying to reclaim a public space from cars by the siting of an art work. It is unfortunate that in achieving this objective the sculpture has not been well integrated with the rest of the square and does not appear to be related to seating or pedestrian movements. It is rather incongruously located next to the Victorian lavatories which are an attractive feature in their own right. The success of the sculpture is largely due to the skill of the artist in picking up references to the leafy trees in the original centre of the square.

The importance of an art work in activating the life of a public space has been examined in some depth in the United States, where plaza sculptures have proliferated in front of downtown office buildings in cities as a result of incentive zoning (a planning gain system whereby increased building height is permitted in exchange for a publicly-used street

Jean Dubuffet's *Four Trees,* fibreglass on metal framework, 12.80m Chase Manhattan Corporation Headquarters, New York. Commissioned by Chase Manhattan Corporation.

7 Eduardo Paolozzi's cooling tower commission for Whitfield Partners in Vauxhall, London demonstrates an interesting way of using art to transform a functional element. It unfortunately suffers from its juxtaposition to the adjacent building which is stylistically at variance, and with its relationship to the entrance to Pimlico Underground.
8 The acrimony in relation to David Wynne's sculpture commissions for the west front of Wells Cathedral, from the Society for the Protection of Ancient Buildings highlighted these issues. The cathedral commissioners believed that the church should not be a 'theological museum' whereas SPAB regard the historic fabric as sacrosanct.

Richard Harris' environmental project for Bottle Bank Gateshead picks up echoes of bridges over the Tyne. Work in progress, March 1985.

Richard Harris, *Bottle Bank,* 1984-86, steel and faced sandstone, 6 x 70m. Gateshead. Commissioned by Northern Arts and Gateshead Metropolitan Borough Council. Funded by Gateshead Metropolitan Council reclamation programme through the Department of the Environment with support from Northern Arts and ACGB.
Photograph: by courtesy of Northern Arts.

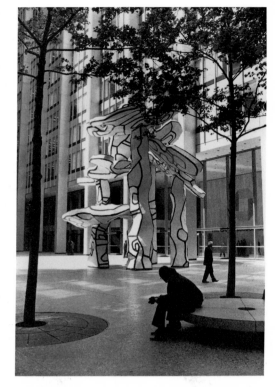

plaza.) Although a number of these plazas with their production-line emblematic sculptures are not successful[5], others are used and enjoyed by city-workers. Major pieces such as the Picasso head and Oldenburg baseball bat in Chicago are tourist-attractions. 'Before and after' studies have revealed that: 'the installation of Dubuffet's *Four Trees* in the Chase Manhatten Plaza has had a beneficial impact on pedestrian activity. People are drawn to the sculpture: they stand under it, beside it; they touch it; they talk about it. At the Federal Plaza in Chicago, Alexander Calder's huge stabile has had similar effects.[6]

■ Relationship to the Urban Context
Generally artists and craftspeople take great care to relate their commissions to the surrounding architecture, as much as anything because this sets up a framework from which it is useful to extrapolate or expand ideas, or make material, colour and formal connections. If the commissioned art work is to be placed within an urban context which does not have a coherent stylistic unity[7], thought should be given to how the relatively small scale of the art work can be best displayed or screened by planting or some other device, or attention focused on the art work away from the fragmentary context. When new developments are proposed adjacent to existing works of art, architects and planners should ensure that a suitable setting is maintained.

■ Axis and Access. The siting of art works in relation to an axial, radial or informal plan seems self-evident, but in fact the syntax of this sort of designing is so unfamiliar to many planners and architects that obvious requirements are often overlooked. The fact that most sculptors persist in not wanting to raise their works up on plinths or built bases exacerbates the problem. However there are other planning devices, such as steps, sunken areas or levels in hard-landscaping which could compensate for, or complement a sculpture placed directly on the

ground. Access to a work does not only imply pedestrian access. Consideration should be given to normal pedestrian sight-lines and view points from surrounding buildings or moving buses, the amount of surrounding space which a work needs to 'breathe' in, and the scale or maintenance of the work in relation to seasonal growth and planting.

■ Commissioning art as a strategy for revitalising or re-zoning a public area becomes more problematic if it is in relation to an area of architectural preservation or in a town or village lacking a tradition of public sculpture. Then there should be consideration of the conservationist and historical dimension[8].
In such a situation, a coherent design which links the work with the surrounding buildings and establishes material, iconographical or formal connections with the 'character' of the place is of great importance and should be specified in the brief.

4 A Sense of Scale
Undoubtedly the main reason for American plaza sculptures is that they provide scale for the immense buildings behind them. Photographers love to photograph the sculptures reflected in curtain-walled glazing because they add a touch of intimacy and human scale. The placing of the art work also serves to guide the visitor to the entrance, sometimes undetectable from the rest of the facade if it lacks a canopy or street number.
No matter how large, an art work acts as intermediary between architectural and human scale. The tactile nature of art work invites intimate exploration and reaffirms the human presence.

5 Urban Furniture
A useful typology of street furniture establishes five categories. The category *'Pleasure and pride'* consists of monuments, bandstands, ornamental fountains

Tess Jaray, Preliminary design for the
central concourse at Victoria Station
1985. Commissioned by British Rail.
Funded by James Sherwood with
support from ACGB.
Photograph: Prudence Cuming Associates Ltd,
by courtesy of Tess Jaray.

Tess Jaray, design for terrazzo floor,
Victoria Station, 1985, Commissioned
by British Rail. Funded by James
Sherwood with support from ACGB.
Photograph: Prudence Cuming Associates Ltd,
by courtesy of Tess Jaray.

and statues which it is feared are 'on the edge of
distinction.'[9] An over-provision of catalogue street
furniture is a common phenomenon in urban
developments; but spaces can be given meaning and
focus by a work of art rather than a profusion of
benches and bins.[10]

■ *Street-furniture* of the functional kind is an area
where artists and craftspeople can be commissioned
for original ideas. Rachel Fenner sculpted varied
bollard designs when she was Portsmouth Sculptor in
Residence and the Jubilee London pavement plaques
were suggested by an artist. Inset pavement
decorations and manhole covers have been made by
artists from Newcastle to Seattle. Just as the most
popular painting in a museum is always the one with
a generous seat in front of it, so the most popular
public squares are those which have seating provided

and a work of art for contemplation.

■ *Floors and pavements* are of psychological and
design importance in large concourses, particularly
railway stations or airports where activity is
spasmodic. A recent very successful commission has
been Tess Jaray's terrazzo floor for Victoria station.

■ *Fountains* Although we have a long history in this
country of water gardens, there is no real tradition of
city fountains as in France or Mediterranean
countries, presumably for climatic and cultural
reasons. Fountains and running water obviously play
a greater role in hot dry climates where there is a
functional (and spiritual aspect) to the provision of
cool running water. Apart from some Italianate
fountains there are few urban water set-pieces across
the country. It is worth noting that the fountains at
Trafalgar Square, which have been so appropriated
into national life that a ritual ducking in the pool at
Trafalgar Square has become institutionalised as part
of New Year celebrations, were designed by Edwin
Lutyens as recently as 1936/7, and the bronze
sculptures by Charles Wheeler and William McMillan
were not completed until 1948. The more ubiquitous
commemorative troughs and drinking fountains
installed in towns and suburbs were a late Victorian
notion, evoking William Morris notions of the utopian
village (with its pump or pond). Perhaps because of
this lack of an indigenous tradition, most water
commissions in recent years such as the always
empty and garbage-filled pool in Birmingham's
Bullring, are desolate monuments to inappropriate
schemes. In specifying running water, account must
be taken of the seasons, of the very real desire of
people to touch, splash and play in it, and how far
spray is likely to carry.

The unsightly empty pool is usually explained away
in terms of 'safety', although this is probably just an
excuse for the failure of proper maintenance
procedures. It is noteworthy that no one has slipped
or been injured in clambering around Lawrence
Halprin's urban water landscapes in Portland
Oregon[11], which allow free access. In a recent
controversy, a fountain planned for an old people's
home was recently refused planning permission
because it was feared that the sound of running
water would cause incontinence[12]!

■ Good *lighting* will enhance the art work as a focus
of the site, or underline its formal elements of
iconography. Illumination can provide a sense of
drama by floodlighting, or establish mood with
concealed lighting and is also a useful deterrent to
vandalism. Artists are used to enhanced lighting in
gallery installations of their work and might provide
original suggestions for out-door or indoor lighting[13].

Buildings

1 *Facade embellishment and 'The Brooch on the Wall'*

Just as it became popular in America in the 1970's to
dismiss plaza sculpture as 'turds in the plaza' it has
been equally fashionable in this country since the
1960's to be sarcastic about 'the brooch on the wall',
cosmetic sculpture. [See Chapter 2] The term is
short-hand for a very real concern that a work of art
commissioned for a finished building with no stylistic
relationship to the architecture looks as replaceable

9 Michael Glickman, Furnishing the Urban Space, in *City Landscape: A contribution to the Council of Europe's European Campaign for Urban Renaissance*, Ed. A B Grove and R W Cresswell, Butterworths, 1983. "The only real survivor is the planter, which, in its many contemporary forms tends to do more harm than good and is a pathetic reminder of better things."

10 The GLC's 1980 manual with its 'approved' list of urban furniture illustrates the ease with which entire tracts of the city can be subjected to a standardization, which takes no account of local colour, historical traditions or even 'specialness' of place. (Differentiation is entirely numerical: depending on the number and lines of bollards and polyangular planters.)

11 Landscape architect Lawrence Halprin and Associates designed stepped concrete waterscapes for the Civil Auditorium Forecourt in Portland, Oregon in 1970, and a similar scheme for Freeway Park, Downtown Seattle, Washington in 1976. These schemes have been widely imitated in the United States and are clearly the model for the conventional 'architectural' water fountains often proposed in this country.

12 This matter was well covered in local (Farnham and Surrey) and national press in December 1984.

13 Guidelines on standard lighting are set out in: *IES Lighting Guide, The Outdoor Environment; and International Lighting Review*, 1978 No 1 & 4.

14 Japanese plum and mid-vernacular green will have a very precise provenance and dating in future archaeological soundings!

and arbitrary as a decorative brooch.

The phenomenon particularly related to bland curtain-wall international-style buildings, where there was no vocabulary for integrating a work into an endlessly repetitive facade. In the 1950's and 60's architects also experimented with sculptural pre-cast concrete or pre-formed plastic elements in an attempt to enliven facades which pre-empted the use of an art work *per se*. Attempts to rethink the use of sculptural relief, except in a revivalist mode, continue to be hesitant, as a result of this historical backlash (although Henry Moore's stone screen for Michael Rosenauer's Time-Life building in Bond Street, 1952-3 has never been bettered). With architects indulging their sculptural fantasies in high-tech, sculptural 'brooches' have been banished to the jewel-case of atrium or vestibule. Nevertheless, the possibility of embellishing a facade with sculptural relief has such a historical dynamic that it cannot continue to be avoided foreover. Most importantly, it provides a rich classical rationale for giving emphasis to entrances, to underlining and differentiating hierarchies of fenestration, to expressing articulation of floors and services and to providing light and shade and liveliness to ubiquitous brickwork.

2 Colour

'The external volume in architecture, the sensations of weight and distance, can be reduced or augmented through the use of colour. A bridge can become invisible and weightless through color-orchestration. Thus the 'exterior block' is open to attack as was the interior wall. Why not undertake a multi-coloured organisation of a street – of a whole city?' Fernand Leger, 1946

Architecture is very fashion conscious (all the more remarkable when one considers the time-delays between the sketch design and the published work in the journals scoured by competitors) and colour is an

element so closely controlled by notions of the modish that future historians will be able to date works very precisely by colour samples[14].

The area of advising on colour – as opposed to making murals – is where an artist can play a very positive role, if allowed the freedom to move away from the limitations of only using colour in woodwork or fascia panels.

With regard to external murals, the designation of particular parts of the facade as suitable for mural painting is very culture-bound. In this country, for example, murals are limited to gable-ends, hoardings and the walls of a specific class of buildings, such as schools, community centres and playgrounds. In parts of Europe such as southern Germany, however, a long folk tradition of discreetly decorated house-fronts and public buildings has survived from the grandiose façade decorations of earlier times. It seems incumbent upon architects and artists to be more imaginative in the siting of external murals, and to break away from the asociation of murals with temporary or derelict sites. Technological improvements in paint means that external colour can be permanent for between 15-25 years.

3 Architectural materials and building skills

A very fruitful way of working with artists is to engage them in giving an inventive dimension to standard building materials. Wendy Taylor stretched the possibilities of using bricks in tension in a commission for Redland Brick at Reigate in 1981 and Rachel Fenner and Tess Jaray have built up visual vocabularies of brick and tile and terazzo designs which explore a rich geometric language. This also opens up the question of skill. Artists working with building teams, in particular David Harding when Town Artist at Glenrothes, have found that difficult and original projects which require particular skill and concentration serve to engender enthusiasm in the team. The sense of pride in perfecting a skill for a

Karl Schlamminger, 1983, flooring and fountain in white Greek Pentelicon marble inset with blue Bahia granite and stainless steel, fountain diam. 2m. Ishmaili Centre, London. Commissioned by the Aga Khan Foundation (United Kingdom). Architects: Casson Conder Partnership.
Photograph: Crispin Boyle Associates

Walter Ritchie, *The Creation,* 1983-86, Ibstock Red Marl Brick 2124mm x 17950mm; front of Bristol Eye Hospital. Architects: Kendall Kingscott Partnership. Commissioned by South West Regional Health Authority.
Photograph: Walter Ritchie

15 Considerations of placing sculpture in landscape and information about sculpture parks are contained in *A Sense of Place: Sculpture in Landscape*, edited by Peter Davies and Tony Knipe, Ceolfrith Press, Sunderland 1984.

challenging job will be sustained if, as is most often the case, the artist is working alongside and not directing from a distance.

Landscape

The scope of this research does not extend to the issues of commissioning or placing art works in landscape or natural environments like forests or rural amenity parks[15]. Nevertheless in relating

commissions to soft landscaping and planting within urban sites there are some important considerations:

1 Simplicity of design

Just as architects show a predilection for over-furnishing their hard-landscaped urban sites, there is a frenetic urge on the part of landscape designers and architects (from both the public and private sector) to over-complicate designing and planting. Edward Relph described these landscapes as '. . . dehumanizing because they are excessively

Brian Yale and Nicholas Wood, 1980, painted cast concrete, 0.25 x 0.467m, Althorpe Grove, London. GLC Housing Scheme. Funded by GLC.
Photograph: by courtesy of the London Residuary Body and the Greater London Records office

102

16 Edward Relph, *Rational Landscapes and Humanistic Geography*, Croom Helm, London 1981, p.104.

Andy Goldsworthy, *Side Winder* 1985, Tree trunks, total length approx. 36m. Grizedale Forest. Commissioned by Northern Arts and the Forestry Commission.
Photograph: by courtesy of Northern Arts

Viv Levy, *Another Breeze,* 1984, welded steel, 1.83 x 1.52 x 1.10m. Commissioned by London Docklands Development Corporation.
Photograph: Edward Woodman, by courtesy of Public Art Development Trust

humanized. There is almost nothing that has not been conceived and planned so that it will service those human needs which can be assessed in terms of efficiency or improved material conditions. But there is almost nothing in them that can happen spontaneously, autonomously, or accidentally, or which expresses human emotions and feelings. If this absence diminishes the quality of our lives it does so sadly, quietly, unobtrusively rather than with some overt and brutal denial.'[16]

In the experience of the Team, practically every sculptor who has had to place a work in a landscaped courtyard or park [See Chapter 11] has been worried about the over-fussiness of the design. Just as the architectural context might need re-assessment in order to successfully site a commissioned art work, a landscaped area will require reconsideration and probably simplification, designed in association with the artist. At a mechanistic level an art work can give a focus to a landscape design, on another level it can lend dignity and rationale.

2. Planting
Trees ameliorate the city climate but they also have a psychological impact, and of course beauty, which might well be part of the contributory mood and context of an art work. An art work can be dwarfed by quick-growing trees and consideration should be given to the kind of maintenance required for keeping the balance correct. A major consideration should also be the extent to which leaves, moss, water or bird-droppings might effect a work. Stains and marks might positively help to mature the patination and add to the poetry of a piece, but equally a work might be marred by these natural effects if they are not kept in check.

3 Landscape management and earthworks
The removal and tipping of building spoil is very expensive, but can be imaginatively deployed on site, or on adjacent sites in the form of earth-work sculptures related to the landscaping. This is an area where a building contractor might be prepared to part-sponsor a sculptural work as a saving on the cost of tipping.

27 Maintenance

It is essential that maintenance matters are discussed early in a commission, however reluctant both sides may be to raise the subject. Contrary to belief, the discussion of these issues is not prejudicial to the granting of a contract, because maintenance costs are usually quite minimal if regular care is taken. Questions of maintenance, however will have a direct bearing on budget, materials, means of fabrication and even the type of work produced.

In fact the inclusion of works of art into the built environment can serve to *reduce* overall maintenance costs, act as a catalyst for positive rather than socially undesirable use of a place, and even be a means of problem-solving.

■ Prints and paintings on walls can serve to reduce redecoration budgets. This was well documented during the Queen's Medical Centre Hospital Conference in 1984 at Nottingham. For example, Ray Walker's snack-bar mural in Newham Hospital, London is in good condition many months after installation, whereas the carpet is marked with cigarette burns and the other walls are defaced.

■ The specific qualities of a work of art can serve to make a space into a place and an empty plot into a garden so that there is far less litter and vandalism.

■ When artists are well briefed, they should be able to come up with imaginative solutions to maintenance problems. Graham Crowley's *Birds* at Brompton Hospital, London, cut out of brightly enamelled sheet metal are set proud of the wall on removable brackets so that the work can be easily dismantled to allow for redecoration or access to wall-mounted conduits.

Early decisions should be taken between artist, architect and client as to:

■ The expected life-span of the art work. As this involves considerations of cost and materials it is very pertinent to the brief.

■ The maintenance Contract. How maintenance will be funded, and who will be responsible for maintaining the work in the long run.

Deterioration

The completed art work will be exposed to the same factors that contribute to the deterioration of a building:

■ Environmental factors such as weathering and natural ageing

■ Corrosion and chemical action

■ Structural and thermal movement

■ Wear and tear associated with people's presence

■ Malicious vandalism

1 *Atmospheric pollution* associated with 'acid rain' causes rapid deterioration in some materials. For example, when siting a stone sculpture near an industrial complex, a hard stone like granite would obviously be preferable to limestone. Similarly, if siting an aluminium or stainless steel sculpture near the sea it would be important to choose the right alloy to withstand the corrosive influence of the sea-breeze.

The whispering figures in front of Sainsbury's Homebase, are safeguarded from vandalism by their situation on a little island in a stretch of water.

André Wallace, *The Whisper*, 1984, coloured polyester resin, ht. 2.44m, Homebase, Bromley Road, South London. Commissioned by J Sainsbury plc.
Photograph: by courtesy of Andre Wallace

104

Plate 13

Adventurous commissioning

The cost of special commissions from artists and craftspeople often compares favourably with commercial products or standard finishes, or the differential is so small that it can be covered by a grant.

The Artists' Collective, entrance to Whitehall Theatre Dundee, 1984. Mosaic on plywood panels. Commissioned by Whitehall Theatre Dundee. Funded by Scottish Arts Council and Scottish Development Agency.
Photograph: by courtesy of The Artists' Collective

Eduardo Paolozzi, *Hunterian Doors,* 1977, cast aluminium, 4 doors each 3.66 x 0.901m, Hunterian Art Gallery, University of Glasgow. Architects: Whitfield Partners. Commissioned by University of Glasgow. Funded by University of Glasgow with support from Scottish Arts Council.
Photograph: Glasgow University by courtesy of Whitfield Partners

Alain Ayers, *The Kissing Gate,* 1984, forged steel, fabricated by Theo Grunewald for Liverpool Garden Festival 1984. Commissioned by Merseyside Development Corporation and Merseyside County Council with support from ACGB
Photograph: John Mills

Plate 14

Graeme Wilson has added a group of painted spectators to Surbition Station so that it always appears colourful and bustling, even on the dullest days. Sue Ridge's discreet ceiling picks up on the authentic period style of the architecture

Graeme Wilson and Sue Ridge, 1984, acrylic on canvas (walls) and emulsion direct on ceiling, booking hall, Surbiton Station, Kingston. Commissioned by British Rail. Funded by British Rail with assistance from GLAA, GLC and Berger Paints. Labour provided by Community Task Force (MSC)
Photograph: Edward Woodman, by courtesy of Public Art Development Trust

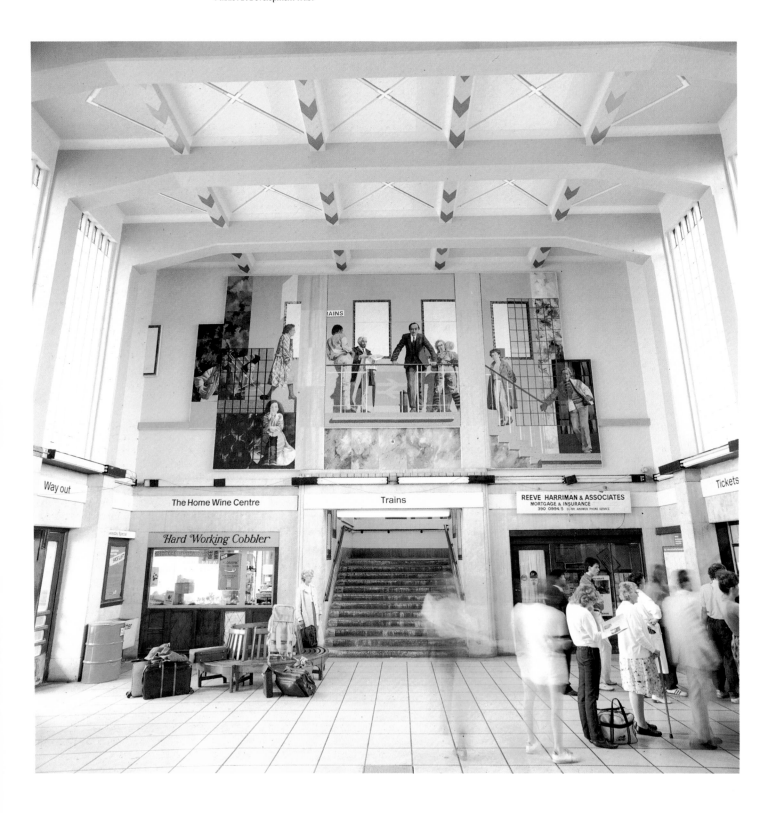

Tim Scott, *Khajuraho 11*, 1978-80, steel, North London Polytechnic. Commissioned by North London Polytechnic with support of ACGB.
Photograph: Heini Scheebeli by courtesy of *Art Monthly*

3 *Finishes*, particularly for outdoor sculpture, do not have an indefinite life and will require regular renewal.

This is an area where if an artist is experimenting with a new technique or type of finish (and most commissions tend to be prototypes) it would be sensible to obtain guarantees from the fabricator. Some artists prefer naturally rusting materials to protective finishes, but the resulting problems need to be carefully considered. For example, the rusting of Tim Scott's iron assemblage sculpture *Khajuraho II* at the Polytechnic of North London has badly stained the surrounding paving stones and adds to the bleak aspect of the site although it is an interesting work. Similarly, David Kemp's *Iron Horse at Four Lanes End Metro* on Tyneside looks neglected because of rusting and staining and, being within an enclosed courtyard, is inaccessible to the cleaning staff. Eduardo Paolozzi solved the problem of staining in his cast-iron sculpture *Camera* 1978-80 outside the European Patent Office in Munich, by placing it on a special gravel which absorbs rust. Even cast bronze, one of the most durable of materials, can cause green staining to plinth or surrounding masonry if the patina is not regularly maintained.

4 *Experimental, temporary and short-life works*. The highest cost implications in terms of maintenance occur when a work is in any way unfixed. In the case of the sculpture garden with medicinal plants at St George's Hospital, Tooting, London the hospital has agreed to pay a retainer of £200 per year for a period of two years to the artist Shelagh Wakeley to maintain the garden until the vulnerable plants are established. Similarly Ken Draper has agreed to maintain his *Oriental Gateway* 1978-80 at Bradford University, which uses a combination of different materials, including areas of solid colour-impregnated resin fixed on a wood and metal framework.

■ *Low budget commissions*, whilst appearing to be a bargain, will also have implications either of heavy maintenance costs or the problems of having to dispose of the work at some stage when it becomes unsightly or a safety hazard.

Raf Fulcher's budget for his commission for Jesmond Station, Tyne & Wear Metro was so small that he could not afford to use durable materials. He has cheerfully predicted that the materials would weather into 'picturesque decrepitude' and foresees a long maintenance involvement. This sort of situation is not practicable without a contract and retainer, because it puts an onus of expenditure and time which the artist will not be able to meet for very long, if at all. It also presupposes that the artist will always be available to tend a work which is no longer his or her property. [see section on Contracts, chapter 30]

■ Some *community art* is low-budget and will have a very short life-span either out of deliberate policy, or because the involvement of unskilled children or community participants implies lack of technical skills. For example, a moulded concrete and rubble giraffe on the Netherfield estate at Milton Keynes, built under the supervision of Liz Leyh the community artist in residence, became a safety hazard as the concrete cracked, loosened and exposed the dangerous metal and rubble core.

Questions of local pollution conditions have a bearing on patination of materials. For example, bronze turns green in a saline atmosphere, and black in industrial areas which have a heavy sulphur element in the atmosphere.

2 Specific *aspects of siting* might have a long-term effect on maintenance. For example, a sculpture on the side of a building, or on an open site will be vulnerable to wind forces. This was the case with the neon sculpture for the side of the Arnolfini, Bristol situated on a quayside, and was an important consideration within the brief and in awarding the commission. Insufficient guttering on the side of Canterbury University's library block has meant that over the years Duncan Newton's large enamel mural has become rusted on the inner face and streaks of rust have stained the brick façade.
Building regulations might also affect choice of materials and therefore maintenance considerations, as for example works in designated 'fire sterile' areas. In St Mary's Hospital, Isle of Wight, paintings in the corridors have to be on specially-treated canvas, and a special fire-resistant conglomerate will be used as the base for some commissioned art works.

1 Richard Cork, *Art Beyond the Gallery in early 20th Century England*, Yale University Press, New Haven and London, 1985, Chapter 1

These mutilated sculptures by Jacob Epstein are still in place on the facade of the former British Medical Association building in the Strand, London, now Zimbabwe House.

Jacob Epstein, 1908, mutilated sculptures, portland stone, ht. 2.15m, Zimbabwe House (formerly British Medical Association) Strand, London. Architect: Charles Holden, Commissioned by Charles Holden for British Medical Association.
Photograph: by courtesy of Conway Library, Courtauld Institute of Art

Philip King's Clarion *in Fulham Broadway has never been seriously vandalised in spite of its proximity to a football ground.*

Phillip King 1981, *Clarion,* 1981, Painted steel 5.17 x 6.08 x 4.56m Fulham Broadway, London, Commissioned by Romulus Construction Co. Ltd.
Photograph: Errol Jackson, by courtesy of Judah Rowan Gallery

■ Encouragement is sometimes given to the painting of *gable murals* because the buildings are due for demolition: this was the case with a group of well-publicised murals done during the late 1970's in Scotland, some of which have survived.

The life-span of a mural will not only depend on the use of the appropriate paints, but also on adequate preparation of the wall surface. In some cases murals have had to be expensively sand-blasted off walls, as was the case with an old mural, done by the Greenwich Mural Workshop, removed to make way for a Women's Peace Mural. It has been suggested by a member of this mural group that workshops should initiate repair funds for mural maintenance. Since a major motive for community murals is the desire to 'animate' a community, the best response to maintenance might be the regular repainting or reconstruction of a project on a seasonal basis.

Maintenance programmes

Regular maintenance usually just means regular cleaning. However it is essential to carry this out, because neglect over a period of time invites malicious vandalism. This was certainly the case with Frank Dobson's *Woman with Fish*, in Cambridge Heath Road, Hackney, London.
■ Failure to *maintain the* art work, including its moving programme (if a kinetic sculpture) or use of water (in the case of a pool or fountain) is not only likely to invite public abuse but is also an infringement of the artist's 'moral rights.' [See Chapter 30] A *cause célèbre* of the post-war period which still ranks as one of the most arrant infringements of an artist's moral rights was the mutilation of the Epstein statues on the facade of Zimbabwe House in the Strand. Having been originally commissioned for the building by the British Medical Association, these controversial figures were declared a hazard thirty years later and heads and limbs were lopped-off by the new owners, with the agreement of the architect Charles Holden, instead of being wholly removed. The mutilated figures have remained in situ[1]. [*See also* Chapter 28].

The Maintenance Manual
The programme for maintenance and relevant technological information should be contained in a clearly-written document handed over to the relevant body at the installation of a commission.

If the commission is part of a new building or refurbishment programme, then this information needs to be incorporated into the general operating and maintenance manuals which will be presented with the Master Plan to the client by the architect or interior designers or landscape architects.

In the case of a commission for a finished building or outdoor site, it is up to the artist to provide the relevant information, including guarantees from fabricators or engineers.

The maintenance manual should contain:
■ Technological information on the type of material and methods of fabrication.

The statue of Eros (the Shaftesbury Monument) in Piccadilly is shown here in its original pristine condition to which it has recently been restored by the GLC.

Photograph: by courtesy of the London Residuary Body and the Greater London Records office

2 In 1984/5 the GLC cleaned and restored the statue of *Eros* (the Shaftesbury Monument) at a cost of £200,000. The legs were filled in, cracks repaired, and the statue sprayed with aluminium oxide. The reduction in sulphur dioxide in London's atmosphere means that the statue will not need repair for many years to come, apart from renewal of the wax finish.

3 The U.S. General Services Administration which is entrusted with the care and preservation of about 101,000 Federal art works has developed a system of permanent files for conservation purposes, including maintenance contracts, examination reports, treatment records and proper photographic documentation. Each artist commissioned by GSA's Art-in-Architecture Programm has been requested to complete a standardized questionnaire. Reported at the ICOM Committee for Conservation, Triennial Meeting, Copenhagen, 1984

4 Henry Lydiate: The legal aspects of commissioning, in *Art Within Reach*, ed. Peter Townsend, Thames & Hudson, London 1984.

■ The specification of the safety check procedures and evaluation of the structural safety of the work. The engineers report should be included, and information about life-expectancy both of work and fixings. (If the fixing of a work has been carried out by a contractor, it might be covered by the contractors guarantee.)

Note: It is important to remember that defects can usually be detected in buildings because of failure of function, but in a non-functional art work, checks have to be carried out.

■ Information on surface protection or finish and its life expectancy.

■ Instruction and timing for cleaning and maintenance. Information on whether repairs can be carried out by a regular maintenance contractor or will require specialist treatment. For example a tapestry can be regularly vacuumed, but at specific intervals would need specialist dry-cleaning, and repairs would probably need to be carried out by a textile conservator if the artist was unavailable or not contracted to provide this service[2]

Maintenance responsibility

With publicly sited works, responsibility for maintenance usually falls to the local authority. Inside London, The Department of the Environment can also agree to take on the care of a public monument or sculpture, by obtaining the consent of the Treasury. This is only forthcoming if an endowment is created to provide a return on investment (estimated at 2½%) that would maintain the statue in perpetuity. [Public Statues (Metropolis) Act of 1856]

The GLC was responsible for an extensive list of public sculptures, but only inspected these works every five years, which was insufficient[2]. In the USA, city governments like Seattle with a very large body of publicly-sited works (commissioned as a result of percentage legislation) pay an arts conservation service a retainer to inspect and maintain the works. The General Service Agency in Washington has instituted a standardised information bank for maintenance, a system which should be adopted in this country[3].

It is also worthwhile examining the possibility of setting up a trust or foundation to maintain and protect a work. According to barrister Henry Lydiate: '. . . . in essence, an independent body accepts the legal responsibility of looking after the work together with the necessary funds and, where appropriate, the ownership and copyright.[4]

With art works sited in relationship to specific buildings, maintenance usually devolves to tenants associations or property managers, with costs being met out of property revenue. In Milton Keynes, where new works are commissioned by the development corporation out of a special features budget, matters of management and maintenance are discussed from the initial stages.

Where there are several commissioned art works on site, or a large corporate collection such as that at the National Westminster Bank Headquarters in London or the Granada Television collection in Manchester, maintenance responsibility will also involve curatorial duties in documenting the works, keeping maintenance records, arranging loans to outside exhibitions, or issuing photographs for publication.

Contracts [See Chapter 30]

There are so many variables in a maintenance contract that it is not possible to propose a model contract. As a general rule a contract should contain the following clauses:

■ Care of work. The contract should state the owner's undertaking to maintain the work of art and not to intentionally alter, damage or destroy it.

■ Protection of the moral rights and integrity of the work. There should be a clause to the effect that if any alteration occurs to a work after installation whether intentional or accidental, then it will no longer be represented as being the work of the artist without his/her written consent.

■ All repairs and restorations made during the lifetime of the artist to be made with the artist's approval.

■ If the artist is to be consulted, and agrees to inspect the work or to execute maintenance works, then a retainer or appropriate fee and costs should be specified.

■ Artist and buyer to notify each other about changes of address.

Note:

■ A maintenance agreement can also contain clauses concerning copyright considerations, or agreement on resale rights.

■ Conservation or appropriate maintenance can be an issue on the demise of the artist. In Seattle, the 'whirligig' sculptures at Viewland-Hoffman Electricity substation needed replacement after the death of the commissioned artists. [See Chapter 13]. A decision was taken to commission new designs from young artists in order for the concept to 'continue to live'. It was decided that faithful reproductions of the originals would not be in the spirit of the total work.

28 Dealing with vandalism

The artist claims that this work was vandalised because it was not lit as specified.

Liliane Lijn *Circle of Light,* 1979/80 Copper-wired tubing rotating at variable speed. 6m diameter. Shown here installed in Midsummer Arcade, Central Milton Keynes. Commissioned by Milton Keynes Development Corporation.
Photograph: by courtesy of Milton Keynes Development Corporation

Issues of vandalism and maintenance are closely related, because a work will be more prone to vandalism if it is not regularly maintained, especially if rusted, scratched, covered with garbage or not properly functioning. Moreover, if responses to acts of vandalism are not immediate there is encouragement to further attacks.

Appropriation or Protest?

Vandalism is an emotive concept, and our understanding of it as anti-social behaviour is ambiguous. Graffiti in the New York subway which were once considered as acts of vandalism are now considered art, and the spray-painters now show and sell their works in art galleries. Doubtless, the act of making graffiti is an expression of either appropriation or protest: the work of art is claimed by marking it with a person's signature, or the mark is a protest against the work, a desire to cancel out its message in some way. Even protest does not have entirely negative connotations: persistent vandalism might not just mean a bloody-minded community, it could also be an expression of a very real disaffection which calls for a response.

■ *Ritual vandalism*, like that carried out every year by students during rag week or in relation to specific events in the university calendar, arises out of the need of the student-body to identify with historical precedent and reaffirm beliefs about autonomy or status, but can be no less wantonly destructive for being 'traditional'.

■ Simple *carelessness* can cause damage. Graham Crowley's corrugated mural for Pitt & Scott near King's Cross Station was badly marked by runnels of tar from the nearby roof repair some years after completion. Leaving work uncleaned in these circumstances is condoning vandalism.

■ *Abuse* as vandalism. Verbal or written abuse can have disastrous consequences in stirring up acts of vandalism. The most horrifying recent example was the case of the David Mach *Submarine* sculpture outside the Hayward Gallery during the Art Council's *Sculpture Show* of 1983. An arsonist died from burns received during his attempts to destroy the piece, following exaggerated media vilification of the work.

■ *Moral responsibility*
The maintenance authority, public or private, not only has a responsibility to the *community* to take appropriate action, but also has responsibility towards the *artist*. According to the Berne Convention '. . . the author (or artist) shall have the right to . . . object to any distortion, mutilation or other modifcation of, or other derogatory action in relation to the said work, which would be prejudicial to his honour or reputation.' [See Chapter 31]. Acts of

This fine work was vandalised during the inaugural exhibition of the Welsh Sculpture Trust at Margam park, Wales.

Jake Kempsell, Squaring the Circle (Almost), 1983, Scots pine, approx. 5.7 x 6.7 x 3.3 m.
Photograph: Deanna Petherbridge

David Gentleman, Designs for Northern Line platforms at Charing Cross Station, commissioned by London Transport.
Photograph: by courtesy of London Regional Transport

malicious vandalism can be extremely distressing for artists who still retain pride of authorship after a work has passed out of their possession. An aspect of disregarding moral rights, which might have a decided effect on inviting vandalism, is when the owners default on presenting the art work as the artist has intended it. In Edinburgh a neon sculpture erected in Leith Walk as part of an abandoned redevelopment programme, was hardly ever switched on by the local authority. A neon sculpture does not have any life or *raison d'etre* if it is not functioning, and consequently the local community was highly critical of the work. Eight years later the work was dismantled, having never been seen in the way it had been conceived by the artist.

Suitable Response

When vandalism occurs, remedial measures should be responsive to public opinion. For example to seal off a damaged work by a fence could be challenge to further acts of vandalism. Equally if a work is persistently vandalised over a long period of time, this may imply that it is in some way offensive to the community. The appropriate response might be to remove the work.

Strategies for dealing with vandalism

■ Appropriate commissioning. Commissioners should take careful consideration of what will be socially appropriate for a specific community and site. [See Chapters 27 & 28].
■ Proper maintenance
■ Prompt repairs or cleaning when work has been vandalised.
■ Graffiti containing inflammatory statements of racism, sexism or political hatred should be removed *immediately*.
■ Imaginative ways of containing graffiti.
One of the best-known examples of this is Stan Bell's gable-end decoration *Hex* in St. Georges Road, Glasgow which was signed by a local gang leader in order to deter other graffiti. At Hockley Canal port [See Chapter 6] one of the low retaining walls carried out by The Mural Company is heavily varnished to allow successive play groups to paint in outlined figures in powder paint or react to the work.
■ Robust art works. Robust materials are important for withstanding vandalism, but the argument is more complex than simply insisting that works should be indestructible. For example, white backgrounds in murals for some reason remain relatively untouched. The David Gentleman graphics at Charing Cross station on London Underground maintain an air of pristine cleanliness.
However paper advertisements are easily scrawled over and appear to attract graffiti.
Art which works on a variety of levels and serves to keep people intrigued is less prone to vandalism than simplistic images, irrespective of materials. Works which appear materially robust, such as large-scale metal sculptures, if not also intellectually robust will be quickly covered in graffiti, whereas something small and fragile can be free of vandalism if the community feels protective towards the work.

In other words, a commissioner will not prevent vandalism by commissioning unadventurous work in predictably tough materials: experience proves that art works, well rooted in the community and with a breadth of appeal and meaning, have the best chance of survival, whatever the medium.

29 Planning permission for works of art

No short summary can provide answers to the questions which can arise in deciding whether planning permission is needed for works of art associated with land and buildings. The basic legislation on which the question depends is contained in the Town and Country Planning Act 1971 and the Town and Country Planning General Development Order 1977 (the GDO)[1]. In cases of doubt about the application of these provisions those responsible for commissioning works of art are advised to consult the local planning authority.

There are essentially two issues at stake. The first is whether the proposed work of art would be "development" for the purposes of the Act: if it would be, planning permission is required either under the GDO or upon specific application to the local planning authority. The second question is therefore whether a general permission for that type of development is provided by the GDO – in which case a specific planning application is not needed.

In cases of real doubt, formal application may be made to the local authority under Section 53 of the 1971 Act for a determination as to whether an application for planning permission is needed. The applicant has a right of appeal to the Secretary of State for the Environment if it is determined that an application for planning permission is required.

Planning permission is needed for any "building engineering or other operation" or any " material change in the use of land". In these expressions, "operation" includes anything which permanently changes the character of land, and "land" includes buildings on the land. *Permission is not, however, needed for any works to a building which affect only the interior, or do not materially affect its external appearance.*

The General Development Order 1977[1] as amended grants a general permission for certain kinds of development so that no planning application is needed[2]. These "permitted development" rights are contained in the various classes of Schedule I. The most relevant will be Classes I and II. Class I provides permission for alterations *to dwellinghouses* subject to certain restrictions: in the case of works of art the most relevant are those preventing projections beyond any wall of a dwellinghouse which fronts on a highway, and alterations more than 4 metres high within 2 metres of the boundary of the curtilage. This general permission would cover sculptural reliefs which do not project too far, sculptures integral to a building, stained glass windows, mosaics, and artist designed doors.

Class II gives a general permission for the erection of gates, fences or walls, subject to certain height restrictions. It also gives permission for the painting of the exterior of *any building or work* (other than for the purpose of advertisement, announcement or direction), and would be likely to permit most murals. However, art work other than a mural, which materially affects the appearance of a building which is not a dwellinghouse will normally require an application for planning permission.

External sculptures are likely to be classed as "operational development" (see para 4). Generally, however, they will not require an application for planning permission when they are sited *within the curtilage of a dwellinghouse behind* any wall which fronts on the highway.

Some works of art may require *other* consents apart from planning permission. Any alterations to a listed building will require listed building consent; anything amounting to an advertisement may require consent under the Control of Advertisement Regulations (there is 'deemed consent' in respect of certain types of advertisement); anything affecting a schedule ancient monument will require scheduled monument consent. Advice on these consent procedures will normally be available from the local authority.

Planning Applications

Once it is established that planning permission is required, a planning application must be made to the local planning authority (normally the district council where the proposal is located). A fee is payable in respect of each application. Applications are made on forms supplied by the local planning authority, often with 'notes for applicants', which set out the requirements for information and plans to be submitted. As a general rule plans should show the location of the site, the position of the building or work of art on the site, and plans and elevations of the proposed development.

An application must specify the type of permission sought. There are several possibilities:

(i) *Outline planning permission*, giving approval in principle for development on a specific site. This can only apply to buildings as such, but could obviously

1 Consultations for the revision of the GDO are in progress at the time of going to press. It is therefore necessary to check whether any relevant revisions have been made to the 1977 GDO.
2 Permitted development rights may be withdrawn by a direction by the local planning authority (known as an "Article 4 direction"). On occasion, a condition attached to the original planning permission for the building have the effect of withdrawing permitted development rights in respect of that building.

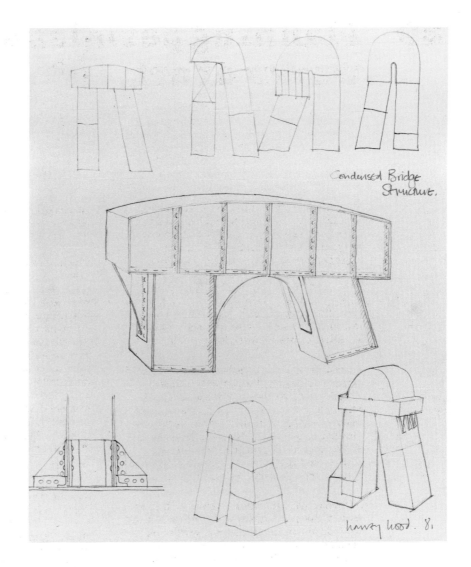

Condensed Bridge
Structure.

harvey hood. 81.

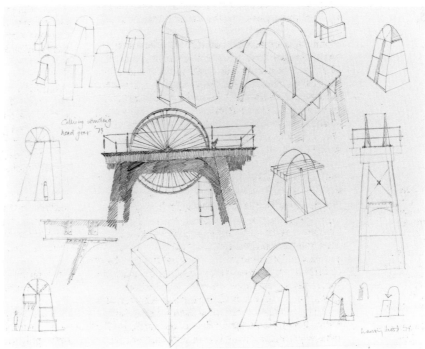

Colliery winding
head gear '79

harvey hood 79.

Drawings for *Archform* 1981 by
Harvey Hood for Newport Station,
Gwent, which was the subject of a
successful Planning Appeal by British
Rail.
Photograph: by courtesy of Harvey Hood

be relevant where a work of art is to be incorporated. Outline permission may be appropriate where the broad location and purpose of a building are known, but where details of siting and design remain to be determined. Where outline permission is granted, conditions are normally imposed requiring "reserved matters" (comprising full details of the scheme) to be submitted for approval within three years, and for development to commence within a further two years from the date when the last of the reserved matters is approved. Advice on planning conditions is given in DOE Circular 1/85. In considering an outline application the planning authority is empowered to seek any additional information necessary to reach a decision – for example the details of a building's position on a site where the relationship with adjoining development is crucial.

(ii) *Full planning permission* gives approval not only to matters of principle but also details of design, siting, materials and so forth. It is appropriate to all forms of development, which must usually be commenced within five years.

(iii) *Temporary planning permission* gives approval for a limited period, after which the development must cease or be removed unless a further permission is granted. Temporary permission may be appropriate where final siting is uncertain, or for a long-running exhibition. Where long term intentions are for permanent development, full planning permission should be sought at the outset: whilst temporary permissions may have short term attraction (for example in the case of controversial development, or where a 'trial run' is desirable) the permission will not necessarily be renewed.

Again, where Listed Buildings, Ancient Monuments and Advertisements are concerned, the requirements of paragraph 8 above must be borne in mind.

The local planning authority must reach a decision on a planning application within the statutory period of eight weeks, but may seek the agreement of the applicant to an extension of time. This may be required where the authority is obliged to seek amendments or additional information. It is however open to an applicant to appeal to the Secretary of State for the Environment if the local planning authority fails to reach a decision within eight weeks, or an extended period agreed in writing.

Getting Planning Approval
New works of art in public places may raise local controversy and objections which the planning committee will need to consider. But it is not the primary purpose of planning legislation to control artistic content. The planning committee is likely to be concerned about the merits of the work in relation to its site and surroundings, in the light of local policies or relevant goverment advice, as for example in DOE circulars 22/80 (paras 18-21 on aesthetic control) and 14/85 on development control.

Where an application has to be made, applicants would be well advised to present the case well and, in particular,

(i) before formal submission, to obtain from the planning office details of policies for the area, which may be contained in local plans and design guides;

(ii) to ensure that client and artist are agreed about the design, thus avoiding subsequent amendments to the application;

(iii) to ensure maximum time for consideration of the planning applications; both to allow time for negotiations and to avoid the main development being unduly delayed;

(iv) to submit the fullest possible description of the proposal in respect of materials, siting, size and so forth;

(v) to provide (or have available) details of artists' or craftworkers' backgrounds, previous commissions, finance and ability to execute the work. This information may encourage a local planning authority to reach a favourable decision;

(vi) to provide background as to theme, meaning and setting of the work of art. Identification with local tradition may influence the local planning authority;

(vii) to ensure a single (well informed) contact to whom the authority may refer for additional information.

Planning Decisions
Planning permission may be granted with or without conditions or refused. In either case, reasons for conditions or for the refusal to grant planning permission must be given. An applicant who is 'aggrieved' by a refusal or an unacceptable condition has a right of appeal to the Secretary of State for the Environment within six months of the decision. The Secretary of State will then appoint a Planning Inspector to consider the cases of both applicant and the local authority, either in the form of "written representations" or sometimes at a Public Local Inquiry. The Secretary of State's decision is final, and may be challenged in the courts only on a point of law or procedure.

30 Legal considerations

Satisfactory commissioning procedures should include proper legal agreements between the artist, or maker, and the commissioner, together with all the other parties involved in a project.

Such arrangements may take the form of an exchange of letters, or a series of letters, signed by both sides, or preferably a contract drawn up after detailed discussions and negotiations and signed by both sides. It is advisable to consult a solicitor who should draw up the final draft.

Standard building contracts, even if modified, are not really suitable as art-commissioning contracts. In any event the contract needs to set out as clearly as possible the rights and obligations of everyone involved.

Set out below is a CHECKLIST of items to be considered in the course of negotiations leading to the drawing up of a contract. The check list is intended to be as comprehensive as possible and to cover all eventualities; it may therefore include items which are inappropriate for certain projects. A sample contract as used by PADT is reproduced in Appendix V. However this is not a model and is only intended to be illustrative. It must be stressed that each agreement must be drawn up in the light of individual circumstances, and bearing in mind the points made in this chapter, preferably with the benefit of legal advice. The principal stages of commissioning which should be protected by contractual agreement are:
- The idea or design stage
- The implementation stage (fabrication, delivery and installation)
- Completion arrangements
- Maintenance and copyright agreements and 'moral rights' [see Chapters 27 and 28].

Comprehensive check list of items to be included

Idea or Design stage agreement
A separate contract (or formal letter and acceptance) covering the initial ideas stage is usual both in a direct commission or when more than one artist is taking part in a competition.

The main issues to be established in such a contract are:
- Timetable for the submission of the artist's proposal
- Delivery point for the completed submission
- Type of presentation required including any limitations of size or material
- Artist's fee and method of payment and arrangements if the design is unacceptable.
- Ownership and copyright of the models or designs after the commission has been awarded
- Provision for an extension of the design stage (if, for example client is not satisfied or variations are introduced) with additional fees as appropriate
- Timetable for the final selection by jury or client and deadline for the acceptance of the commission by the artist, subject to a mutually agreed contract.

Main agreement
The principal areas to be considered are:
1. *Identities of the Parties:* These should include:-
- The artist: name, address
Tax status of the artist, whether self-employed and/or VAT registered.
- The Commissioner: name, address
In cases of direct commissioning by a single client identity should not present a problem, since the client and the source of finance are the same. A more complex situation arises where several parties are contributing to the cost of the commission, but may not be the eventual owners of the work of art. Where for example funding for a commission comes from several sources (such as a Regional Arts Association, an independent trust and a business sponsor) and a local authority is contributing the site, it will be necessary to establish whether the local authority is prepared to accept the rights and obligations attaching to a commission, or whether a special trust or other organisation will be required in this role.
- Agent: name address
If an agent is involved in commissioning it must be made clear for whom and in what capacity, the agent is acting. It may be:
- The artist (usually the case where the agent is a dealer or Gallery representative)
- The commissioner (an architect might be the agent for client-commissioning)
- Independently of both artist and commissioner (for example an arts administrator)
It is also useful to establish:
- Who is paying for the agent's services although the agent's fee and method of payment are discretionary.

2. *Description of the commissioned art or craft work:* This should include:
- Title
- Type of work (eg wall hanging, sculpture)
- Materials, with precise descriptions if precious or

exotic materials are used
- Method of fabrication
- Dimensions
- Location (any relevant information on siting; plinth, base, etc)
- Subject matter (if relevant)

Where applicable, this section might include clauses on:
- Originality, where the client may require the artist to confirm that the commission is an original work and that a replica will not be reproduced or placed elsewhere.
- Edition, where if the work is one of an edition the artist may covenant that the size of the edition will not be increased after the date of the execution of the commission
- The fidelity of the finished art/craft work to the idea/design submission accepted by the commissioner.
- Mutual consent to any changes.

3. *Financial aspects:*
There should be clear statements on:
- The total value of the commission specifying whether this amount is exclusive or inclusive of VAT, and whether it covers the cost of delivery and ancillary works connected with installation of the work,
- The amount payable to the artist as fee if this has been agreed as a separate item in the tender.
- The method and timetable of payments to the artist specifying what is to be achieved at each stage
- Any agreed payments in respect of other specified expenses (such as travel, site visits, administrative costs, etc)
If these are not specified a clause will be required to the effect that the fees are 'inclusive of any expense incurred by the artist'.
- A clause to the effect that the artist will retain title to the work and all rights until the final instalment of fees.
- Arrangements for increased cost consequent upon variations introduced by the commissioner.
Where appropriate this section should include a clause dealing with:
- Financial arrangements for ordering materials. For example where a commissioner can deal more effectively with purchasing of materials than the artist, or is providing some or all the materials as a part of the contract, or where an artist is not VAT registered and it would be more advantageous for materials to be ordered through the commissioning agent.

4. *Insurance:*
It will be necessary to establish the responsibilities of the parties for arranging appropriate insurance cover in respect of the various stages of the commission, including the period of cover required, who is paying, and who is responsible for arranging cover at any stage:
- All risks insurance while the art work is being fabricated would normally be the artist's responsibility but where the artist is working on site or in another workshop rather than in his or her own studio, insurance may be arranged by another party. Equally the artist might need to take out extra cover

during the making of the art work.
- Accident insurance for artist while working, subject to the same considerations above.
- Public liability insurance during fabrication and installation at an appropriate level of indemnity. (This is a matter for discussion between client, architect and contractor).

5. *Timing and Indemnities:*
This section of a contract should include a timetable indicating:
- The date on which the artist is expected to start working on the commission in the studio or on site.
- The date by which the commission should be completed and ready for inspection by the commissioner (if the work is being fabricated in the studio or engineering workshop)
The commissioner might require the artist to give, say, four weeks notice of completion of the work.
- The date of delivery and installation.
This could be affected by delays arising from technical difficulties such as the refusal of planning permission or because the site is not ready for installation. The artist therefore might wish to include a clause providing indemnity against the cost of storing the completed work, or loss of earnings (to cover inflation during the period of delay.)

 The artist might fail to deliver and install the work on time thus holding up construction. The commissioner may therefore wish to include a penalty clause to operate in such circumstances.
- The date by which the completion should be finalised. This date is very important since it will affect the transfer of insurance and maintenance responsiblities to the commissioner, and could be the subject of a separate contract of sale.

6. *Termination of the Agreement:*
This section should provide a framework for the possible termination of the contract by:
- The Commissioner. This would set out the last stage at which the commissioner is entitled to terminate the agreement, the notice to be given to the artist, and who will retain title to the work and rights in this eventuality.
- The Artist: this would cover non-completion of the work due to illness, or other causes beyond the control of the artist, and establish the payment(s) due in such an eventuality.
- A separate clause might state that in the event of non-completion of the commission for other reasons, the commissioner reserves the right to take possession of all preparatory work as might exist, without payment (other than sums determined above).

7. *Guarantees and areas of responsibilities of the parties involved*
These might include:
- Guarantee by the artist to exercise diligence and skill in execution and installation where required of the commission.
- Guarantee of workmanship and durability of materials: the artist will need to obtain these from fabricator or material supplier.
- Indemnity clause covering the commissioner for

any loss or damage resulting from the negligence of the artist and wilful acts of omission.
■ Guarantee on behalf of the client to pay the fees according to the agreed timetable.
■ Guaranteed access to the site for the artist between specified dates.
■ A clause establishing who will be responsible for seeking planning permission.
■ A clause establishing who will be responsible for the preparing of the site for installation of the work. (This may be dependent upon the client's contractual arrangements with the main building contractor for the site.)
■ Guarantee that the artist will be present and make his/her expertise available to the commissioner during the installation of the work.
■ Description of agent's administrative responsibilities towards the commission.
■ Ancillary building work: who is responsible for organising and paying for foundations or other structural and/or other ancillary building work, such as plumbing or electrical supply as specified in the original artist's submission.
■ Increased costs or costs beyond control: responsibility for any increased costs caused by unforeseen site changes and consequent alterations to the art work (these could be circumstances beyond the control of artist or client such as subsidence of the foundations, which could also require redesign of the base of the work.)
■ Arrangements for additional fees or reimbursement of the artist or craftsperson in the event of variations introduced by the commissioner.

Completion arrangements

These can be included as a section of the main Commission Contract, or could be the subject of a separate agreement, the equivalent of a *Contract of Sale Agreetment*. In this case full descriptive details should be appended with information about originality and editioning. The agreement should cover:
■ Formal acceptance of the commission by the commissioner provided that the work is made in accordance with the description as set out, or arrangements for payment if not accepted.
■ The effective transfer from the artist to commissioner of the responsibility for all risks insurance cover for the commission on the completion date, subject to formal acceptance of the commission. (Alternatively this could be included as a Sale clause).
■ Agreement of the commissioner/owner to display the work as intended by the artist.
■ Acknowledgement clause specifying the wording of the plaque and ensuring that the commissioner will at all times acknowledge the artist as the creator of the work.
■ Specification of the period for which the artist is responsible for any hidden defects stemming from faulty workmanship. The maker has an obligation to supply goods of 'merchantable quality' under the Sale of Goods Act; a reasonable period should be specified during which defects should be reported and repaired at the maker's expense. (This applies mainly to craftspeople but would also be the case in a work of art depending on a programme of movement,

like a kinetic sculpture or a changing neon series.)
■ Ownership of copyright and rights to reproduction of the work. This will either be retained by the artist, or assigned to the commissioner. Fuller details on copyright and copyright infringements are contained in the next section.
■ 'Moral right' clauses preventing removal, relocation or demolition of the commission without the artist's consent. If the work is altered in any way whether intentionally or accidentally then the work will no longer be represented as the work of the artist without the written consent of the artist.
■ A *maintenance contract*, which could be the subject of a separate agreement.
A maintenance clause should make clear:
1. Responsibility for maintenance. There might be agreement that a special body or trust set up for this purpose; that the commissioner intends to hand over maintenance to a receiving body in the future, as may be specified; or that the artist contracts to maintain the work for a specific period.
2. How any funds available for maintenance in the future are to be administered, and the undertaking on the part of the commissioner/owner to maintain the work properly according to the timetable and procedures laid out in the maintenance manual which the artist has provided; and to pass on the liability to any future owner.
3. Any agreement by the commissioner/owner to keep a permanent file on record as to the location, condition and disposition of the work.
■ Arrangements for restoration ensuring that if the art work is damaged the commissioner shall notify the artist and give the artist a reasonable opportunity to conduct or supervise the restoration of the art work or alternatively for the commissioner to have recourse to a conservator of repute to advise on these matters.
■ The commissioner's undertaking to notify the artist (or the artist's estate) that if the work (or the building of which the work is an integral part is disposed of, or a mobile work of art is sold, then the artist will be apprised of the identity of the new owner or address where the work is housed or, alternatively be given the right to purchase the work back under certain conditions.
■ That if the commissioner sells the work with the agreement of the artist, it will be subject to any resale royalty rights which must be due to the artist.
■ That the artist should notify the commissioner of any change of address.

The concluding clauses of a contractual agreement
All contracts need the following clauses:
■ Proper law: the commission contract is governed by the law of England and Wales (or Scotland) and may only be amended by further written agreement signed by all the involved parties.
■ Arbitration: Any disputes arising over the interpretation of the commissioning contract should be settled by an independent nominated arbiter, or according to the provisions of the Arbitration Act 1950 (or any statutory modifications. This should not apply to issues of artistic merit).
■ Dated signatures of parties concerned.

In general, where a contract for commissioning a work of art is part of a larger building contract care

should be taken to ensure that the rights and duties (in respect of the matters mentioned in this section) of all the parties involved are carefully and clearly drawn up.

Copyright

Copyright is the right of artists to prevent other people copying their original work. Copyright Law is set out in the Copyright Act 1956 and gives protection to creators of certain specific material or 'works' of which 'Artistic Works' is a category.

Copyright protection in the United Kingdom is automatic, and there is no copyright registration system. Nor is any endorsement of a work required under the 1956 Copyright Act, although marking a work with the international symbol ©, the originator's name, and year of creation is often done to give notice that copyright is claimed.

It should be noted that the Government is currently engaged in a comprehensive review of copyright law. Following the report in 1977 of the Whitford Committee on Copyright and Designs Law, proposals for reform were published in a 1981 Green Paper *Reform of the Law relating to Copyright, Designs and Performer's Protection* (Cmnd 8302) and a 1985 Green Paper *The Recording and Rental of Audio and Video Copyright Material* (Cmnd 9445). A White Paper entitled *'Intellectual Property and Innovation'* was published in April 1986 (Cmnd 9712), and the Government proposes to introduce new legislation when the Parliamentary timetable permits. In this event it will become necessary to check this chapter for accuracy against the contents of new legislation.

Protection

Under current law art works are protected if they pass three tests. For full details of descriptions and definitions, sections 3 and 48 of the 1956 Copyright Act should be consulted.

Test 1: 'Artistic Works'
Art works must fall into one of three groupings but are in practice likely to fall into group 1 or 3.

Group 1: Traditional Media
(a) Paintings (not defined by the Act)
(b) Sculptures: includes any casts or models made for the purpose of sculpture. (Each cast from a single master work forming an edition is separately protected for copyright purposes).
(c) Drawings: includes diagrams, maps, charts or plans
(d) Engravings: includes etchings, lithographs, wood-cuts, prints or similar works which are not photographs
(e) Photographs: means any product of photography or of any process akin to it (other than part of a cinematograph film).
Any work in the above media, irrespective of artistic quality, falls into this grouping of 'artistic works'.

Group 2: Works of Architecture
being either buildings or models of buildings

Group 3: Works of Artistic Craftmanship
Any work which does not fall within the above two groups, may fall into this grouping, providing that it possesses 'artistic merit', which exists (in law) when the creator applied skill and taste to its production with the intention of creating an article which would have appeal to the aesthetic taste of those who see it.

Test 2: Originality
The work must be the product of original skill and labour. In brief, it must not be copied or substantially derived from the work of another artist.

Test 3: Qualified Person
A work is given protection in the UK if it is made by a national, resident, or domicile of the UK or a country which has signed either of the international copyright conventions. A work of art also gains protection in the United Kingdom if it is first published in the United Kingdom, or a 'convention member' country. This latter applies even if the author is not a national of the United Kingdom or a 'convention member' country or domiciled or resident such a country. A 'convention member' country is one which has signed either of the Berne or Universal Copyright Conventions. This includes the United Kingdom, and most other countries. United Kingdom works of art are themselves protected in other member countries under the terms of local copyright law.[1]

Length of Protection and Infringement
Under current law, the general rule for 'artistic works' is that copyright lasts for the artist's lifetime and for fifty years after the artist's death. Exceptions relating to photographs and engravings are set out in section 3(4) of the 1956 Act.
If an author suspects infringement, it is strongly recommended to seek legal advice, since the burden of proof required will depend on the nature of the infringement. However Section 9 of the 1956 Copyright Act sets out the circumstances which do not constitute infringement, including for example the provision that sculpture and works of artistic craftsmanship may be painted, drawn, engraved, photographed, filmed or broadcast on TV – so long as those works are permanently situated in a place open to the public. A copy or replica of the original work may not be made.

Copyright ownership

Under current law, the creator or artist is the first owner of copyright in the work; but there are exceptions set out in Section 4(1)-(6) of the Act, which include:
1. *Photographs*
The copyright owner is the person who owns the material on which the photograph is taken – not necessarily the taker of the photograph.

2. *Commission*
The commissioner is the first copyright owner of a commissioned photograph, commissioned portrait painting or portrait drawing, and a commissioned engraving – unless there is a prior agreement to the contrary, and provided that he pays for, or agrees to pay for the work.

1 DACS, The Design and Artists Copyright Society Ltd, was established in 1983 for the protection of copyright and collection of British artists' dues throughout the world. It is part of the international network of copyright-collecting societies for artists. DACS, St. Mary's Clergy House, 2 Whitechurch Lane, London E1 7QR

Mutilated statues by Jacob Epstein on the facade of Zimbabwe House, formerly the British Medical Association Headquarters in the Strand, London
Photograph: by courtesy of the Conway Library, Courtauld Institute of Art

2 See discussion on moral rights in Tomorrow is a Long Time Henry Lydiate. *Art Monthly* February 1985 No 83, pp35-36.
3 Following the 1981 Green Paper on Copyright, a White Paper entitled 'Intellectual Property and Innovation' was published in April 1986 (Cmnd 9712), which includes proposals on moral rights. See also *The Artist and Copyright,* Arts Council, 1986
4 The information for this section has been drawn from articles by Henry Lydiate in Art Monthly, from his The Visual Artist Copyright Handbook, Artlaw Guide Number One, and further supplemented by Henry Lydiate.

3. Employees
Employers own the copyright of the works of employees made during the course of their employment – unless there is a prior agreement to the contrary.

4. The Crown and the Government
The Crown or the Government own copyright in the works of their employees or commissioned artists contracted to make art works for them, unless agreement to the contrary is reached.

Movement of copyright ownership

Under current law, first ownership of copyright can only be changed if the copyright owner puts the change in writing and signs the document – unless the copyright owner becomes bankrupt or dies without making a will, when copyright passes to the trustee in bankruptcy or next of kin by operation of the law.

Contracts

In agreeing contracts it is advisable to specify in whom copyright vests, especially in cases where works are commissioned or created in the course of employment [see Chapter 30].

Moral rights [2]

Whereas copyright law exists to determine the ownership of copyrighted works and to regulate who benefits financially from the legitimate use and exploitation of such works, and also to provide protection against wrongful exploitation, 'moral rights', (enshrined in the Berne Convention on Copyright to which the UK is a signatory, though they do not as yet exist in UK law) [3] are concerned with the artist's artistic integrity and reputation as expressed through his work.

Two main aspects of 'moral rights' are the following:-

(a) the 'right of paternity' – namely, the right of artists to publicly claim authorship of their work (eg by having their name on it) and to be protected against denial of authorship;

(b) the 'right of integrity' – namely, the right to object to any distortion, mutilation, modification of or other derogatory action towards their work which would prejudice the artist's honour, reputation or integrity.

The artist would continue to enjoy these 'moral rights' even when the works are owned by someone else, the justification for this being that his reputation rests on them regardless of whose ownership they are in. 'Moral rights' would thus co-exist with copyright law.

ACKNOWLEDGEMENT. The authors wish to acknowledge the advice and assistance of Henry Lydiate, a barrister specialising in branches of the law appropriate to the preparation of this section. [4]

31 Inauguration and public relations

1 *The Wellington Monument*, John Physick, V & A Museum, HMSO 1970
2 A register of members is published by the Institute of Public Relations, 1 Great James Street, London WC1N 3DA
3 Of the 1984 Association for Business Sponsorship of the Arts (ABSA) ABSA/Daily Telegraph Awards for arts sponsorship, Radio City (Sound of Merseyside) Limited and Cadbury Limited both received awards for sponsoring exhibitions.

'As the clock of Paddington Church struck noon, the procession set off on its journey to the playing of 'See the Conquering Hero Comes' by one of the military bands. Leading were a detachment of the Life Guards and their regimental band. After them came two troops of Life Guards, pioneers of the Fusilier Guards, and then the statue, on either side of which were twenty Life Guards. Behind the carriage marched another hundred Fusilier Guards . . . Bringing up the rear of the cortege were the band and a hundred Fusilier Guards, the band and two hundred Grenadier Guards, the band and one hundred Coldstream Guards, and right at the end, a troop of the 2nd Life Guards. It took the procession an hour and a half to reach Apsley House . . . A great crowd lined the whole route, but it was at its thickest at Hyde Park Corner hoping to see the statue raised . . . Early the next morning . . . riggers . . . began to raise the statue. This took all day, during which time Queen Adelaide returned to the balcony of Apsley House and even the Prime Minister felt sufficiently curious to pay Wyatt a visit on the site.'[1]

Not many public monuments nowadays could hope to be installed with the aid of a great military parade, as was accorded to Wyatt's statue of the Iron Duke.

But most works of art in public places are inaugurated with some ceremonial or festivities, and there is usually publicity in the press. The public relations aspect is not irrelevant, and can furnish very positive benefits for the associated community, the client, the artist and the architect. It might be considered important to employ a professional public relations consultant,[2] but in cases where artist, architect or client are handling this aspect, the following guidelines may be useful.

Guidelines on public relations

Useful publicity can be gained at different stages of the commission:
■ *The competition.* In the case of an open or international competition, widely-based advertising will help to attract a better standard of entries, and raise the prestige of the commission. The organisation and publicity associated with a competition is an occasion when the services of a professional publicity firm might be useful, and is an event with a good potential for gaining sponsorship.[3]
■ *Making the art work.* This will be of interest to the local press if the artist is in residence or working on site (because of the 'human interest' aspect), and is of particular value for community relations.

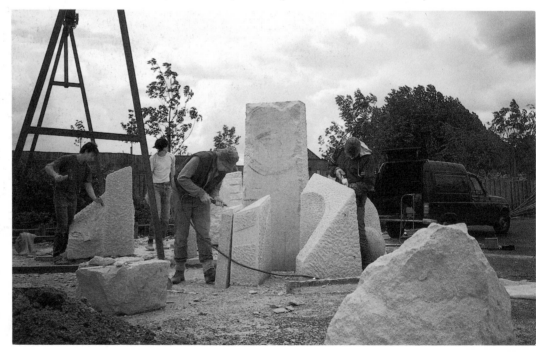

Hamish Horsley worked on site building his environmental sculpture at Bellingham Green, London during 1985.

Hamish Horsley, *Sunstone*, 1985, portland stone, Bellingham Green, Commissioned by London Borough of Lewisham. Funded by London Borough of Lewisham with support from ACGB, GLAA.
Photograph: Edward Woodman by courtesy of Public Art Development Trust

4 A dubious post-commission publicity benefit was awarded to the engineering group Powell Duffryn in The Guardian, 30 January 1985. A pottery piece commissioned from ceramicist Hans Coper in order 'to demonstrate controlled or concerted energy and the relationship between Powell Duffryn and its subsidiaries' was left behind as part of the fixtures and fittings when the firm moved. The new owners recognised its value and auctioned it at Christies for £30,000.

■ *The inauguration.* This will be the main target for a publicity campaign. The unveiling ceremony could attract sponsorship, and is the time for acknowledging funding, sponsorship, or contributions in materials and assistance received during the making of the art work.

■ *Long-term benefits* can accrue beyond the inauguration of the work, in the use of the image as a logo for the firm, or for advertising or publication.[4] For example, the statue of *Jeeves* by Kate McGill, 1971, in Pont Street, London is publicly sited on the pavement outside the shop of the same name, and acts as landmark and trademark.

Benefits for All
The Client in the public sector

An art commission is a potent event around which to structure a campaign or statement of policy or ideological commitment. The Liverpool Garden Festival with its commissioned gardens and sculptures was an expression of government policy with regard to inner city regeneration following the disturbances of 1981. Birmingham's *Peace Park* with sculpture by William Pye, the London Borough of Camden's *Maygrove Peace Park* with a sculpture by Anthony Gormley and the various Peace Murals commissioned by the Greater London Council have been expressions of ideological commitment.

Patrick Caulfield, 1983, Oil on canvas, 6 x 6m. London Life Assurance Headquarters, Bristol. Commissioned by London Life Assurance Ltd with support from ACGB.
Photograph: Heini Schneebeli by courtesy of *Art Monthly*

5 PIMS Media Directory publish subscription directories from 4 St John's Place, St John's Square, London EC1. The General Press directory comes out monthly, and there is also a Towns list quarterly dealing with regional press. This can be consulted in a library.

6 The Arts Council of Great Britain publishes two lists, for sale at £10.00: a General List, dealing with contact addresses under different arts headings, and a Press List of media contacts. These are revised yearly and are available from The Publications Department, Attention Tania Butler, The Arts Council of Great Britain, 105 Piccadilly, London W1V OAU.

Useful information on gaining access to the press and broadcasting media is included in A Basic PR Guide for Charities by Dorothy and Alastair McIntosh, 1985 published by the Directory of Social Change, 9 Mansfield Place, London NW3 1HS. This supplies detailed advice on building a PR campaign, writing press releases, tips on publicity stunts and dealing with journalists or confronting a hostile press.

Milton Keynes Development Corporation for some years used Wendy Taylor's sculpture *Octo* on the cover of its commercial opportunities brochure, and more recently has produced a brochure of the commissioned art works and 'special features' in and around the city as an amenity guide.

The Art in the Metro projects associated with metro systems in Brussels, Amsterdam, Stockholm, Toronto have all become tourist attractions and draw in users to the systems. Even London Transport, which professed a strategy for using artists in its refurbishment programme which has not been realised, is using the mosaics by Eduardo Paolozzi for Tottenham Court Road Station in the advertising associated with this programme. 'The Underground is well on the way to becoming not only a nicer place to travel in, but also an attraction in its own right.' Tyne and Wear Transport have a special brochure and set of postcards associated with Art in the Metro, to attract users to the 'clean, fast and efficient' system which provides 'ideal sites for the public to experience artworks.'

Corporate commissioners

Traditionally business firms have taken advantage of the celebratory nature of art to commission works for special events in their corporate history or to commemorate new premises. The board-room portrait commissioned on retirement of the chairman, or the presentation gift designed by a craftsperson has been a long-standing tradition, but more inspired examples of patronage are now believed to contribute towards a company's reputation for being forward-thinking or responsive to the community, as well as reflecting their wealth and prestige. For example, London Life and Sun Life Insurance companies in Bristol and IBM, UK in Portsmouth celebrated the building of new headquarters with painting and sculpture commissions which have won them favourable publicity. London Life produced a small booklet commemorating the move to Bristol containing a reproduction of Patrick Caulfield's design for the foyer mural. The Peter Stuyvesant Foundation was for many years associated with a major collection of British Art, toured abroad by the British Council. Mobil, De Beers, National Westminster and Unilever have put together art collections for their new or refurbished headquarters. The De Beers collection has been the subject of a Sunday coloured supplement and catalogue and the Unilever refurbishment has been widely published. The Granada Foundation collection was the subject of an exhibition at the University of Manchester's Whitworth Gallery, and paintings from corporate collections in the City of London were exhibited in the *Capital Painting* exhibition at the Barbican Art Gallery in 1984.

The Artist

Although artists complain that they do not receive enough critical attention from the specialist art press for their architectural or public commissions, nevertheless, there is usually a great deal of attention from the local press. This is not always of a serious

nature [See below] but the climate is changing as the community-related aspects of commissioning assume renewed importance. Bridget Riley received acclaim both from the national and the art and architecture press for her colour project for the Royal Liverpool Hospital, and an exhibition of the designs was staged both at the Walker Art Gallery in Liverpool and the Royal Institute of British Architects in London.

Dealing with the Press

■ It is necessary to decide at whom a publicity campaign will be aimed. This will determine whether local or national journals might be interested. (That is, the journals concerned with news items, or those which publish full-scale criticism.)

Information about the press is contained in PIMS Media Directory 5, and the Arts Council can supply a general mailing list and a list of media contacts.[6]. Regional Arts Associations and local museums will also have information about the arts press.

The campaign will consist of sending out press releases and photographs, making telephone calls and inviting the press to a special press launch or unveiling ceremony.

Of course, the press might make the decision in advance by responding to a controversy about planning permission or the standard 'angry ratepayers' story, (which is stereotyped from Landsend to John O'Groats). Continuation of such coverage will depend as much on the dearth of other news at the time as whether public figures involved indulge in sensationally vituperative arguments.

■ A Press Release should be sent out as widely as possible, but contrary to common belief a standard release does not interest radically different elements of the press. It is sensible to prepare a newsy press release for the general press containing information about the artist, patron and architects and how the commission has come about. A more specific release about the art work and its relation to the architectural context would be more appropriate for the specialist art or architectural press. Press releases will be sent out at the various stages of the project, as listed above. It should be borne in mind that editors and journalists receive quantities of standardised press releases so it is useful to follow up mailed information with a personal telephone call. However, some critics are nervous of being importuned, so the right balance needs to be struck.

A release for the general press should contain:

■ A clear description of the work, its dimensions, materials, how it has been made and where it is sited. The language should be precise and untechnical, as it will be an important aid to those journalists who might be unfamiliar with describing art works, or it might be published in full.

■ Information about the artist, if agreeable to the artist. Some artists are reluctant to dwell on personal issues which they believe are irrelevant to consideration of the art work.

■ Details of public consultation. This is very important for making a commission news-worthy and its publication helps to defuse the post-unveiling stories of the 'waste of rate-payers money' variety.

Plate 15

Art for the Community

Free Form, *The Pit,* 1984, 600 sq. m.
Hackney Grove Gardens, London E8.
Commissioned by the local
community. Funded by London
Borough of Hackney Planning
Department. Garden maintained by
Hackney Grove Garden Group.
Photograph: Jo Reid & John Peck by courtesy of
Free Form

Free Form, *Thamesworld,* 1985 cast
relief mosaics and tiles, 2 x 9m,
Provost Estate Murray Grove, London
N1. Commissioned by Provost Tenants
Association as part of a wider scheme
of improvements. Funded by GLC
Community Areas.
Photograph: Jo Reid & John Peck, by courtesy of
Free Form

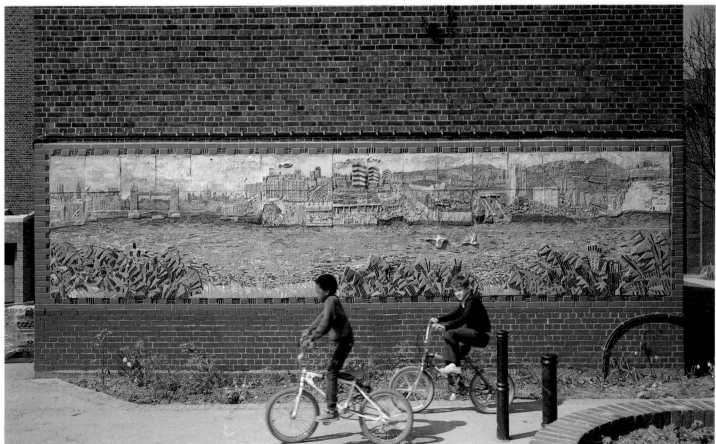

Plate 16

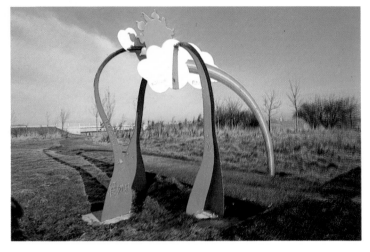

Art in the New Towns

Liz Leyh, *Herd of Cows,* 1979, painted concrete life size, Stacey Bushes, Milton Keynes. Commissioned by Milton Keynes Development Corporation
Photograph: by courtesy of Milton Keynes Development Corporation

Anthony Pratt, *Rainbow,* 1983, painted steel, ht. 4.57m, Riverside Walk, Broomlands, Irvine. Commissioned by Irvine Development Corporation
Photograph: by courtesy of Irvine Development Corporation

Susan Bradbury, *Maze,* 1981, stained glass window, 1.52m diam., Irvine Shopping Centre. Project initiated by artist while artist in residence. Commissioned by Irvine Development Corporation, local shopkeepers and banks.
Photograph: by courtesy of Irvine Development Corporation

Nigel Lloyd, *Wooden Archway,* 1985, wood, 2.44 x 2.44m. Whitehurst Park Community Centre, Kilwinning. Project initiated by artist whilst artist in residence. Funded by Irvine Development Corporation
Photograph: by courtesy of Irvine Development Corporation

Candice Girling, *Seven Flying Fishes,* 1983, painted steel, ht. 4.57m, park, Braehead, Girdle Toll, Irvine. Commissioned by Irvine Development Corporation
Photograph: by courtesy of Irvine Development Corporation

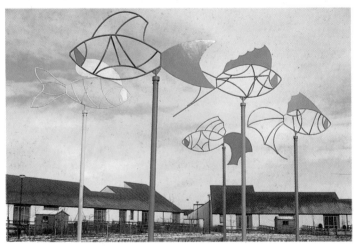

- The reasons for the commission. This is also important because there may be a feeling that if something doesn't have a perceivable purpose it is somehow socially irresponsible.
- Sponsorship credits. The publicity is the return which a sponsor requires for the investment and must be dealt with fully and fairly. As this is such an important issue, sponsors might well be interested in issuing a separate press release, or providing the services of their own PR departments. Details should also include acknowledgements of public funding, and list those people who have provided materials, services and other assistance in a more modest way. If there has been a reasonable level of sponsorship, care must be taken that press releases are sent to the financial sections of the daily press and financial journals, and to The Association for Business Sponsorship of the Arts. At the appropriate time of year nomination forms may be requested from ABSA so that projects may be considered for a scheme run in association with the Daily Telegraph in which awards are made to business sponsors for outstanding sponsorship. ABSA should be contacted for details of requirements.
- Other relevant facts, about the competition, number of entries, the public response to an exhibition of maquettes, details of the inauguration of the work, and so on.
- Photographs. Good quality photographs are *essential* for obtaining short and long-term publicity, and justify expenditure. For the general press, 8″ x 10″ glossy black and white photographs will be needed and for the architectural press or other periodicals good quality transparencies, not 35mm slides, or large coloured prints. Photographs must be checked for colour accuracy against the original work. Large transparencies are expensive, and need only be commissioned if publication has been agreed. (Few art journals in this country have facilities for good colour reproduction) But if the opportunity comes up, photographs must be supplied immediately: the press functions on deadlines, and if they are not met, opportunities will be completely missed. Artists are often very remiss about the quality of photographs, but they are an essential tool of publicity.

The photographs should not just concentrate on the work, as if it were a gallery piece, but provide the context of the surrounding architecture or urban landscape, and if possible include people to give a sense of scale and vitality.
- VIPs. If the commission is of a grand-enough scale to warrant unveiling by a VIP, this might mean the issue of a separate press release. There should be liaison with the relevant department or press office about press releases or presentation speeches.
- Interviews. It is probably only at the 'important' or 'well-known' end of client, architect and artist scale, that it will warrant trying to set up interviews. Interviews will only be arranged through telephone calls and personal contact.
- Disclosure of information about sums of money. Most large-scale commissions are funded from a mixture of sources, public and private. Disclosure of the details of the funding are psychologically important, as they help to dispel myths that the art

An energetic inauguration, Hull 1984
Peter Fink, *Red Wave,* 1984, welded painted aluminium, ht. 10.5m, Hull River Walkway. Commissioned by Hull City Council. Funded by Lincoln and Humberside Arts, Angle Ring Company, British Alcan Aluminium and International Paints.
Photograph: by courtesy of Hull City Museum and Arts Galleries

works are funded solely from the rates and give publicity to acts of sponsorship or private or business generosity. Where possible, reluctant funders should be persuaded to let their generosity be known. It is also useful to place the cost in the context of spending on related matters: for example, it is significant if an art work costs £15,000 in relation to a new civic centre, to point out that the building cost £850,000!

■ Special press launches. The press have 'seen it all', but will be more likely to respond positively if an imaginative idea is used for the press 'junket'. For the press view of the Graham Crowley mural for Pitt & Scott, a special train was hired to take the press from Kings Cross Station up the line to where the mural could be clearly seen. The press was in full and enthusiastic attendance and the work was very well reported.

Inauguration of the Commission

■ An unveiling ceremony is necessary for all the parties concerned in a commission, as a form of *rites-de-passage*. It marks the end of a period of hard work, it signals the handing over of the work to the new owner, and therefore its change of status, and it's an effective deadline to work towards. (Sometimes a local authority deadline is geared to spending money before the end of the financial year)

■ Even the artists who profess to be embarrassed by such ceremonies may feel dissatisfied if they don't take place. The unveiling of a commission is the equivalent of an exhibition to an artist, and it allows all concerned to get some feedback and have a chance to assess the work.

■ It is important that the inauguration is marked by a plaque or permanent record of the artist's name, date, title of the commission and so on.

■ Unveilings don't have to be desperately solemn and conventional even though there might be a flurry of VIPs, company directors, local officials and press. The artist could be encouraged to design a ceremonial or come up with something more original than the little velvet curtains drawn back to reveal the new brass plaque.

■ It is useful to accompany an inauguration by an exhibition of the relevant architectural drawings and the artist's sketches and working drawings and written information or other documentation which helps people to find a way in to the art work.

■ Where possible, the exhibition and opening should be the occasion for arranging lectures by the artist and architect in local venues, such as schools, community centres, local authority architect's departments and so on. Associated educational activities and publications can usefully extend beyond the inauguration. The commission by Liliane Lijn for Warrington Science Park, for example, has become the subject of a documented slide presentation which is used by the local education authority. The video documentation of Kevin Atherton's placement with Langdon Park School, in Poplar, London out of which came *A Body of Work* has implications for other projects far beyond its immediate application.

■ An inauguration will be even more of an event if it can be tied in with a local festival, or associated cultural events.

The inauguration of the international sculpture project for Hagi Yamaguchi Prefecture, Japan in 1981 was an elaborate ceremony involving religious and civic dignitaries in a Shinto ritual.

John Maine, triangular sculpture for the Hagi Project, 1981, granite, ht. 4.50m. Commissioned by City of Hagi, with the support of Yamaguchi Prefecture, Cultural Office of the Japanese Government and Kurokami Granite Corporation.
Photograph: John Maine

SECTION 4
Appendices

Appendix I
Recommendations of the Art and Architecture Research Team

In the course of their studies the Art and Architecture Research Team identified a number of issues to which they wish to draw attention. These are set out below together with the comments of the relevant government departments.

Encouragement through the planning system

1.1 The Department of the Environment should advise local planning authorities, preferably through a circular, to consider art and craft commissions as potential benefits in the enrichment of the built environment when deciding planning applications for new development or the refurbishment of existing buildings.

1.2 The Department of the Environment should clarify the need for planning permission in respect of art and craft works (taking into account that what constitutes such works has been considerably extended in contemporary practice) and consider reducing control in this respect.

1.3 The Department of the Environment should emphasise that it is not the primary purpose of planning controls to regulate the aesthetic or artistic content of art and craft works.

Department of the Environment response

As a general principle, where a work of art would enrich the built environment, it is expected that this would be to the advantage of the planning application concerned.

The Chapter *Planning Permission for Works of Art* in the handbook makes the clear statement that it is not the primary purpose of planning legislation to control artistic content. In particular this aspect is dealt with in paras 18-21 of Circular 22/80 on aesthetic control, which by implication applies also to art and craft work for buildings.

However, as with all forms of development, decisions on works of art which require planning permission must depend on the circumstances and facts of the individual case. In deciding individual applications, local authorities must have regard to all considerations which are material to the application. The Department has recently reiterated that there is always a presumption in favour of allowing applications for development, having regard to all material considerations, unless that development would cause demonstrable harm to interests of acknowledged importance. This is as true of proposals for works of art as it is for proposals for other developments.

Existing guidance in Regulations and Circulars, about what constitutes development subject to planning control is as comprehensive as possible, though it is regularly updated as appropriate. This is described fully in the Chapter *Planning Permission for Works of Art* but ultimately art and craft works have to be judged in the context of the statutory definition of development.

Public Sector Initiatives

2.1 Guidance on development, for example in design guide notes prepared by government departments as sponsors of building programmes, should include positive encouragement for art and craft works and guidance on commissioning for the purpose.

2.2 In view of their special position in the development scene, PSA should consider instituting a mandatory scheme.

2.3 Local authorities and development corporations should institute mandatory or voluntary percent for art schemes for programmes and projects whereby a percentage of costs on new build or refurbishment is allocated to art and craft works.

2.4 Alternatively, local authorities and development corporations should set up Art in Public Places schemes on the lines of that administered by the Arts Councils, the Regional Arts Associations, and the Crafts Council, whereby seed funding attracts private sector patronage for publicity sited commissions.

2.5 Funding for art and craft commissions should not be subject to restrictions relating to the financial year, but should be allowed to accumulate as part of a coherent programme, so that investment can take place over the longer periods normally associated with commissioning art and craft work.

Departmental responses

Department of Education and Science
2.1 Decisions with regard to the provision of works of art in educational buildings are a matter for local education authorities to determine in the light of resources available. However, a number of authorities make a practice of incorporating works of art from time to time in educational building projects both in the form of free standing works, and works forming an integral part of the building fabric.

In a number of instances works of art have been incorporated in development projects undertaken jointly by LEAs and the Architects and Building Branch of the Department of Education and Science. In addition to the provision of specific works of art, LEAs have from time to time engaged the services of practising artists in support of educational activities and to work closely with pupils and students.

Department of Health and Social Security
2.1 The Department of Health and Social Security recognises the value of the arts in making a positive contribution to the environment of hospitals and other health buildings. Positive encouragement to the NHS on this subject has taken the form of a conference held at the King's Fund in June 1983, followed by two publications giving guidance to health authorities called *Art in the NHS* and *The*

Arts in a Health District. Decisions to incorporate works of art into hospitals and other health buildings are of course a matter for the individual regional and district health authority.

Property Services Agency
2.2 While a mandatory scheme would not be appropriate, it is PSA policy to take a positive approach to the provision of works of art inside and outside its projects and to ensure that all suitable opportunities for their inclusion are fully considered. The methods to be applied in achieving this aim are set out in a PSA works instruction to project design teams, *Accommodation and Works Circular 29/84, Provision of Works of Art for PSA Projects – Selection of Artists*, available from Mr J D Albion, Room A515, Whitgift Centre, Croydon.

Department of the Environment
2.3 Local authorities are at liberty to institute percent for art schemes for programmes and projects and to devote resources as they see fit, subject to the current constraints on public expenditure, and taking into account other schemes or proposals for sponsorship.

2.4 Again art in public places schemes would be a matter for local authorities and development corporations, subject to powers available to them and budgetary constraints, but such schemes should not duplicate existing public funding.

2.5 Where art and craft works are to be incorporated in a building contract, the financial arrangements should obviously include provision for the art works involved. It is not uncommon for building projects, especially the larger ones, to require funding which spans several years. Where provision is required for expenditure in more than one year, such expenditure must be allowed for in successive annual budgets, and this would include the commissioned art and craft work.

Incentives for the Private Sector
3.1 The scope of tax allowances for business in relation to art and craft commissions should be clarified. An extension of the tax incentives for commissioning and purchasing works of art and craft would be welcomed.

3.2 Incentive schemes on the lines of ABSA's Business Sponsorship Incentive Scheme should be set up to encourage commissioning by private investors and developers.

Response from Inland Revenue
3.1 The chapter on Fund Raising and Financial matters sets out information on current provisions and measures. However, it is always advisable for donors or sponsors to seek independent professional advice on the tax implications of any particular project given the widely varying circumstances which may arise.

Tax incentives for art and craft works have to be considered in the context of general policy considerations and other priorities.

Response from DOE
3.2 There may be scope for further schemes. There have been encouraging examples recently of sponsorship by both individuals and institutions. It is hoped that, if scope for other schemes can be clearly identified, further sponsors and patrons will come forward.

Moral rights
4.1 The government should make provision for moral rights as proposed in its Green Paper *Reform of the Law Relating to Copyright, Designs and Performers' Protection*, July 1981.

Response from Department of Trade and Industry
In preparation for legislation a White Paper entitled *Intellectual Property and Innovation* was published in April 1986 (Command 9712) on overall Copyright law reform, and this includes proposals on Moral Rights issues.

Education
5.1 Courses in schools of architecture should include a study of the history and practice of commissioning arts and crafts.

5.2 Special courses should be made available at post graduate level in art colleges and university fine art departments dealing with the skills, use of materials and historical background for working to commission.

5.3 Art school courses should include curriculum courses or professional practice relating to working to commission.

5.4 Students from art and architecture, planning and design departments should collaborate on special projects.

Response from DES
5.1 There is general agreement with this recommendation and it is felt that architects should be trained to develop a sensitive understanding of the different and various roles played by the visual arts in relation to architecture. Training needs to include consideration of specific examples of different kinds of visual arts for different purposes and in various media, and also in social and historical contexts. Study visits should also be undertaken which would provide opportunities for professional contact between architects and artists. However, it is understood that many schools of Architecture already provide the training mentioned above.

5.2 and 5.3 Rather than providing specific courses in art colleges dealing with the skills, use of appropriate materials and historical background for working to commission, it is suggested that this should form a part of all fine art training and we would agree that the curriculum of general art courses should include provision on professional practice.

5.4 We agree that where possible, students from art and architecture departments should collaborate on special projects and this certainly takes place already, for example at Preston Polytechnic and at Canterbury College of Art where the School of Architecture is located within the College of Art.

Appendix II
Architects commissioning works of art

Results of a survey commissioned by the Art & Architecture Research Team

The aim of the survey was to collect factual information on recent commissioning trends. Following the advice of the RIBA statistical unit, a detailed questionnaire was sent to 75 British architectural practices of all types, sizes and localities. Of the 62 entries which were completed and returned, 36 were from private firms and 21 from local government practices (a wide designation for purposes of the survey) and 3 from development corporations. The return was analysed by Public Attitudes Survey Research Ltd in December 1984.

Q.1. Have you ever commissioned any art/crafts work?

A. Base (all replying)	Total	Private Practice	Local Govt.
	62	36	21
YES	51 (82%)	34 (94%)	14 (67%)
NO	11 (11%)	2 (6%)	7 (33%)

Q.3. How often have you commissioned a work of art/craft?

	Total	Private Practice	Local Govt.
Once only	7 (13%)	5 (15%)	2 (14%)
2-3 times	10 (20%)	6 (18%)	4 (29%)
3-5 times	20 (20%)	6 (18%)	3 (21%)
More than 5 times	24 (47%)	17 (50%)	5 (36%)

Q.4. When was the last time you commissioned a work of art/craft?

	Total	Private Practice	Local Govt.
Within last year	23 (45%)	14 (41%)	6 (43%)
1-5 years ago	16 (31%)	10 (29%)	6 (43%)
6-10 years ago	10 (20%)	8 (24%)	2 (14%)

Q.6. Did the idea originate with:

	Total	Private Practice	Local Govt.
Yourself	31 (61%)	22 (65%)	7 (50%)
The Client:			
Public Sector	6 (12%)	4 (12%)	1 (7%)
Private sector	4 (8%)	4 (12%)	–
Mixed	1 (2%)	–	1 (7%)
Both you and client	12 (24%)	7 (21%)	4 (29%)

Q.57. What was the value of the commission?

	Total	Private Practice	Local Govt.
£0–999	8 (16%)	5 (15%)	3 (21%)
£1,000–4,999	19 (37%)	13 (38%)	5 (36%)
£5,000–9,999	8 (16%)	4 (12%)	2 (14%)
£10,000–14,000	7 (14%)	4 (12%)	2 (14%)
Over £15,000	8 (16%)	6 (18%)	2 (14%)

Q.8. Who paid for the commission?

	Total	Private Practice	Local Govt.
The Client:			
Private sector	24 (47%)	21 (62%)	–
Public sector	16 (31%)	7 (21%)	9 (64%)
Mixed	6 (12%)	4 (12%)	2 (14%)
The Arts Council	12 (24%)	2 (6%)	8 (57%)
Local Authority	8 (16%)	3 (9%)	4 (29%)

Q.9. How was the artist/craftsperson selected?

	Total	Private Practice	Local Govt.
By open competition	3 (6%)	2 (6%)	–
By limited competition	7 (14%)	3 (9%)	3 (21%)
By invitation	35 (69%)	27 (79%)	7 (50%)

Q.10. Did the commissioned work:

	Total	Private Practice	Local Govt.
Fulfill the brief	38 (75%)	24 (71%)	12 (86%)
Improve the brief	9 (18%)	7 (21%)	1 (7%)
Fail the brief	1 (2%)	–	1 (7%)

Q.11. Did the art/craftsperson deliver the commissioned work on time?

	Total	Private Practice	Local Govt.
YES	40 (78%)	28 (82%)	10 (71%)
NO	3 (2%)	1 (3%)	2 (14%)

Q.12. Did he/she complete the commission within the agreed sum?

	Total	Private Practice	Local Govt.
YES	43 (84%)	30 (88%)	10 (71%)
NO	1 (2%)	–	1 (7%)

Q.13. Did the collaboration with artist/craftsperson:

	Total	Private Practice	Local Govt.
Take the amount of time that you expected?	29 (57%)	17 (50%)	10 (71%)
Take more of your time than expected	18 (35%)	14 (41%)	3 (21%)
Take less of your time than expected	1 (2%)	–	1 (7%)

Q.14. Was the artist/craftsperson able to work with the constraints of your architectural practice?

	Total	Private Practice	Local Govt.
YES	47 (92%)	31 (91%)	13 (93%)
NO	–	–	–

Q.15. Was the client satisfied with the result of the commission?

	Total	Private Practice	Local Govt.
YES	41 (80%)	30 (88%)	8 (57%)
NO	4 (8%)	1 (3%)	3 (21%)

Q.14. Would you like to be involved in commissioning further works of art/craft?

	Total	Private Practice	Local Govt.
YES	49 (96%)	33 (97%)	13 (7%)
NO	1 (2%)	–	1 (7%)

Other questions invited comments or suggestions, and are précised here:

Q.2. 80% of the work commissioned was sculpture (total percentage), 63% were murals, 49% craft work and 45% paintings. Other types of commissions, such as carvings, stained glass or typography were in the region of 2%.

Q.16. Do you have any evidence of user(s) reaction to the Commissioned work? 61% had such evidence, most of it in the form of 'Generally liked'.

Q.20. Suggested ways to improve the opportunities for artists/craftspersons to work with architects. All replied to this question, and the major tenor of the returns was that there should be better systems of indexes and availability of information on artists. A number of firms called for information on methods of commissioning and costings, others felt the need for work to be integrated from the outset of the project. There were suggestions that both local authority and private clients should allocate a percentage of costs to works of art.

The full survey is available from the Public Arts Development Trust.

Appendix III
Useful names and addresses

Arts Councils

Arts Council of Great Britain tel: 01-629 9495
105 Piccadilly
London W1V 0AU

Contact: Art Officers

Crafts Council tel: 01-930 4811
8 Waterloo Place
London SW1Y 4AY

Contact: Officer, Crafts Commission Scheme Loan slide library of craftspeople

Scottish Arts Council tel: 031-226 6051
19 Charlotte Square
Edinburgh EH2 4DF

Contact: Art Officer
Slide register of visual artists and craftspeople – by appointment

Welsh Arts Council tel: 0222-394 711
Museum Place
Cardiff CF1 3NX

Contact: Officer, Artists & Commissions Slide and information library on artists and craftspeople

Arts Council of Northern Ireland tel: 0232 663 591
181a Stranmillis Road
Belfast BT9 5DU

Contact: Arts Council Gallery, Bedford House, Bedford
Street, Belfast BT2 7FX tel: 0232-221 402
Slide Index of visual artists

The Arts Council tel: 0001-764 685
70 Merrion Square
Dublin 2
Eire

Contact: Art Officer Slide index of artists

Regional Arts Associations

Eastern Arts tel: 0223 215 355
Cherry Hinton Hall
Cherry Hinton Road,
Cambridge CB1 4DW

Contact: Visual Arts Development Worker.
Illustrated register of artists and craftspeople.
Area covered: Bedfordshire, Cambridgeshire,
Essex, Hertfordshire, Norfolk, Suffolk

East Midland Arts tel: 0509 218 292
Mountfields House
Forest Road
Loughborough
Leicestershire LE11 3HU

Contact: Visual Arts Officer Crafts Officer
Art Index and Slide Library of artists and craftspeople
Area covered: Derbyshire (excluding High Peak District),
Leicestershire, Northamptonshire, Nottinghamshire

Buckinghamshire Arts association tel: 0296 434 704
55 High Street
Aylesbury
Bucks HP20 1SA

Contact: Arts Officer

Greater London Arts tel: 01-837 8808
9 White Lion Street
London N1 9PD

Contact: Visual Arts Officer
 The Public Art Development Trust 01-837 6070
Area covered: The 32 London Boroughs and the
City of London

Lincolnshire and Humberside Arts tel: 0522 335 55
St Hugh's
Newport
Lincoln LN1 3DN

Contact: Principal Officer, Visual Arts
List of local artists and craftspeople
Area covered: Lincolnshire, Humberside

Merseyside Arts tel: 051-709 0671
Bluecoat Chambers
School Lane
Liverpool L1 3BX

Contact: Arts Officer
'Artdex' illustrated directory of artists, photographs &
design-makers tel: 051 708 7620
Area covered: Districts of Knowsley, Liverpool, St.
Helens, Sefton, West Lancashire and Wirral,
Ellesmere Port & Halton districts of Cheshire

Northern Arts tel: 091 281 6334
9-10 Osborne Terrace
Newcastle upon Tyne NE2 1NZ

Contact: Commissions Agent
Artists index
Area covered: Cleveland, Cumbria, Durham,
Northumberland, Districts of Newcastle, Gateshead,
Sunderland, North Tyneside and South Tyneside

South West Arts tel: 0392 218 188
Bradninch Place
Gandy Street
Exeter EX4 3LS

Contact: Visual Arts & Crafts Officers
Slide index of artists and craftspeople
Area covered: Avon, Cornwall, Devon, Dorset (except
Districts of Bournemouth, Christchurch and Poole),
Gloucestershire, Somerset

West Midlands Arts tel: 021 631 3121
82 Granville Street
Birmingham B1 2LH

Contact: Public Art Development Agent
'Artfile' slide index of artists, craftspeople and
photographers
Area covered: County of Hereford & Worcester,
Shropshire, Staffordshire, Warwickshire, Districts of
Birmingham, Coventry, Dudley, Sandwell, Solihull,
Walsall and Wolverhampton

Yorkshire Arts Association tel: 0274 723 051
Glyde House
Glydegate
Bradford BD5 0BQ

Contact: Visual Arts Officer
Slide index of artists, craftspeople and photographers

North West Arts tel: 061-228 3062
12 Harter Street
Manchester M1 6HY

Contact: Visual Arts Officer 'Showcase' slide library

Contact: Terry Eaton, Partnership, Orient House,
65 Granby Row,
Manchester M1 7AA tel: 061 228 6874

Area covered: High Peak District of Derbyshire,
Lancashire (except District of West Lancashire),
Cheshire (except Ellesmere Port & Halton Districts),
Districts of Bolton, Bury, Manchester, Oldham,
Rochdale, Salford, Stockport, Tameside, Trafford
and Wigan

Southern Arts tel: 0962 55099
19 Southgate Street
Winchester
Hampshire SO23 9DQ

Contact: Visual Arts Officer
Crafts Officer
Artists index being assembled
Area covered: Berkshire, Hampshire, Isle of Wight,
Oxfordshire, West Sussex, Wiltshire, Districts of
Bournemouth, Christchurch & Poole

South East Arts tel: 0892 41666
10 Mount Ephraim
Tunbridge Wells
Kent TN4 8AS

Contact: Visual Arts & Crafts Officer
Slide register of artists and craftspeople
Area covered: Kent, Surrey, East Sussex

Commissioning Bodies & Agents

Art & Design Consultants tel: 0206 577 067
C/o The Minories
74 High Street
Colchester
Essex C01 1UE

Art for Offices tel: 01-481 1337
The Galleries
15 Dock Street
London E1 8JL

Art in Partnership (Scotland) tel: 031-225 2042
25a South West Thistle Street Lane
Edinburgh EH2 1EW

Artscape tel: 021 704 4772
78 Beauchamp Road
Solihull
West Midlands B91 2BU

Artists' Agency tel: 0783-41214
17 Grange Terrace
Stockton Road
Sunderland SR2 7DF

Artworks Contemporary Art – Jeremy Hunt
11-12 Dover Street tel: 01-629 7137
London W1X 3PH

City Gallery Arts Trust tel: 0908 606 791
The Great Barn
Parklands
Great Linford
Milton Keynes MK14 5DZ

Janita Elton, Art & Design Consultant tel: 0522 28739
30 Rasen Lane
Lincoln LN1 3EY

New Milestones Project (Common Ground)
 tel: 01-379 3109
The London Ecology Centre
45 Shelton Street
London WC2H 9HJ

Partnership, Environmental Art Organisation
 tel: 061 228 6874
Orient House
65/67 Granby Row
Manchester M1 7AA

Public Arts tel: 0924 367 111 ext 4791
Room 210
County Hall
Wakefield
West Yorkshire WF1 2QW

Public Art Development Trust tel: 01-837 6070
6 & 8 Rosebery Avenue
London EC1R 4TD

The Artangel Trust tel: 01-434 2887
133 Oxford Street
London W1R 1TD

Other useful addresses

Association of Business Sponsorship for the Arts (ABSA)
 tel: 01-235 9781
2 Chester Road
London SW1X 7BB

ABSA Scotland tel: 031-228 4262
Room 613
West Port House
102 West Port
Edinburgh EH3 9HS

Aspects Gallery tel: 01-580 7563
3-5 Whitfield Street
London W1P 5RA

Index of craftspeople

British Crafts Centre tel: 01-836 6693
43 Earlham Street
London WC2

Business Art Galleries tel: 01-734 1448
Royal Academy of Arts
Burlington House
Piccadilly
London W1V 0DS

Calouste Gulbenkian Foundation tel: 01-636 5313
98 Portland Place
London W1N 4ET

Council for the Care of Churches tel: 01-638 0971
83 London Wall
London EC2M 5NA

Crafts Council's resource centre tel: 01-930 4811
12 Waterloo Place
London SW1Y 4AU

The Craft Council publishes a Crafts Map of selected craft shops & galleries throughout the country and a list of Trade Fairs and Exhibitions

Department of Health & Social Security tel: 01-388 1188
Euston Tower
286 Euston Road
London NW1 3DN

Contact: Architectural Services

King Edward's Hospital Fund for London
 tel: 01-727 0581
14 Palace Court
London W2 4HT

Contact: Public Art Development Trust tel: 01-837 6070

Merseyside Exhibitions (MEX) tel: 051-708 7620
Unit B61
New Enterprise Workshops
SW Brunswick Dock
Liverpool L3 4AR

'Artdex', illustrated directory of artists, photographers & design-makers

Office of Arts & Libraries tel: 01-233 5033
Information Services
Room G57
Government Offices
Great George Street
London SW1P 3AL

Paintings in Hospitals tel: 01-722 8871
Nuffield Lodge
Regents Park
London NW1 4RS

Portland Sculpture Trust tel: 0305 823 489
36 High Street
Fortuneswell
Portland
Dorset

Royal Academy of Arts tel: 01-734 9052
Trust Funds: Edwin Abbey Memorial Fund for Murals
Vincent Harris Mural Fund
Leighton Fund
Piccadilly
London W1V 0DS

Royal Institute of British Architects tel: 01-580 5533
66 Portland Place
London W1
(Also regional branches)

Scottish Sculpture Trust tel: 0383 412 811
2 Bank Street
Inverkeithing
Fife KY11 1LR

SHAPE tel: 01-960 9245
1 Thorpe Close
London W10 5XL
(Also regional branches

The Contemporary Arts Society tel: 01-821 5323
The Tate Gallery
20 John Islip Street
London SW1P 4LL

Contact: The Organising Secretary

Theatre in the Forest
Grizedale
Hawkshead
Ambleside
Cumbria LA22 0QJ

Welsh Sculpture Trust tel: 0222 374 102
6 Cathedral Road
Cardiff CF1 9XW

Yorkshire Sculpture Park tel: 0924 85579
Bretton Hall College
West Bretton
Wakefield WF4 4LG

Artists' Organizations

Association of Artists & Designers in Wales
tel: 0222 487 607
Gaskell Buildings
Collingdon Road
Cardiff CF1 5ES

Artist Placement Group tel: 01-639 3597
210 Bellenden Road
London SE15

Art & Architecture

Contact: The Secretary
14 Percy Circus
London WC1X 9ES

Contact: The Hon Treasurer tel: 0342 82 2704/2748
Dunsdale
Forest Row
East Sussex RH18 5BD
(Also regional branches)

AIR & SPACE tel: 01-278 7795
6 & 8 Rosebery Avenue
London EC1R 4TD

The Design & Artists Copyright Society tel: 01-247 1650
St Mary's Clergy House
2 Whitechurch Lane
London E1 7QR

The Federation of British Artists tel: 01-930 6844
17 Carlton House Terrace
London SW1Y 5BD

Contact for a large number of art societies including the
Royal Institute of Oil Painters, Society of Portrait
Sculptors, etc.

International Association of Art tel: 01-250 1927
Clerkenwell Workshops
31 Clerkenwell Close
London EC1

National Artists Association tel: 0783 673 589
17 Shakespeare Terrace
Sunderland SR4 6DG
(Also regional branches)

Printmakers Council tel: 01-250 1927
31 Clerkenwell Close
London EC1

Royal Scottish Academy of Painting, Sculpture &
Architecture tel: 031-225 6671
The Mound
Edinburgh EH2 2EL

Royal Society of British Sculptors tel: 01-373 5554
108 Old Brompton Road
London SW7 3RA

Photographic index

The Women Artists Slide Library
Fulham Palace
Bishops Avenue
London SW6 6EA

Yorkshire Contemporary Art Group tel: 0532 456 421
Stowe House
5 Bishopsgate Street
Leeds LS1 5DY

Slide index of artists and craftspeople.

Educational Courses

Some colleges offer courses in mural painting and
environmental sculpture at undergraduate and post
graduate level.

Chelsea School of Art tel: 01-749 3236
40 Lime Grove
Shepherds Bush
London W12 8EA
Mural Design Course –

Dartington College of Arts tel: 0803-862224
Totnes
Devon TO9 6EJ
Art & Design in Social Contexts –

Glasgow School of Art tel: 041-332 9797
167 Renfrew Street
Glasgow G3 6RQ
A Murals and Stained Glass course is one of the main
second year subjects in a three year BA and BA
Honours Degree in Art

Duncan of Jordanstone College of Art tel: 0382-23261
Perth Road
Dundee DD1 4HT
Contact: Ronald Forbes, MA Course Leader
MA Course in Public Art & Design

Royal College of Art tel: 01-584 5020
Kensington Gore
London SW7 2EU
Landscape and Environmental Sculpture – a two year
MA Degree course

Appendix IV
Selected bibliography

Note: References to books and articles dealing with specific matters such as tax,
copyright, sponsorship are included in the notes to the relevant chapters.

Books & Pamphlets

Adams, E. and Ward, C., **Art and the built
environment,** Longman for the Schools Council, 1982
Angus, Mark, **Modern Stained Glass in British
Churches,** A.R. Mowbray & Co Ltd., Oxford, 1984
Barthelmeh, Volker, **Street Murals,** Penguin Books,
Harmondsworth, 1982
Beardsley, John, **Art in Public Places,** ed. A.L. Harney,
Partners for Livable Places, National Endowment for the
Arts, Washington DC, 1981
Beardsley, John, **Earthwork and Beyond:
Contemporary Art in the Landscape** Abbeville Press,
New York, 1984
Butler, David, ed. *Making Ways,* Artic Producers,
Sunderland, 1987
Clarke, Brian, ed, **Architectural Stained Glass,**
John Murray, London, 1979
Coles, Peter, **Manchester Hospitals Art Project,**
Calouste Gulbenkian Foundation, London, 1981
Coles, Peter, **Art in the National Health Service, a
report by the DHSS,** Cleveland, 1983
Coles, Peter, **The Arts in a Health District,** Guidelines
based on a case-study, DHSS
Cooper, Graham and Doug Sargent, **Painting the Town,**
Phaidon Press, Oxford, 1979
Cooper, Graham, **The Murals Book: A Guide to
Wallpainting,** available from Hammersmith and Fulham
Amenity Trust, Bishop Crighton House,
378 Lillie Road, London SW6
Cork, Richard, **Art Beyond the Gallery in early 20th
century England,** Yale University Press, New Haven and
London, 1985
Crosby, Theo, **How to Play the Environment Game,**
Penguin Special, Harmondsworth, 1973
Damaz, Paul, **Art in European Architecture,** Reinhold,
New York, 1968
Davies, P. and Knipe, T., Eds. **A Sense of Place:
Sculpture in Landscape,** Ceolfrith Press, Sunderland,
1984

Diamondstein, B, ed, **Collaboration Artists and
Architects,** The Architectural League, New York, 1981
Fleming, Ronald Lee and Renata von Tscharner, **Place
Makers: Public Art that tells you where you are** The
Architectural Book Publishing Company, New York,
1981
Green, Kevin W., ed, **The City as Stage: Strategies for
the Arts in Urban Economics Partners for Livable
Places,** Washington DC, 1983
Green, Dennis, **% for Art: New Legislation can Integrate
Art and Architecture** Western States Arts Foundation,
Denver, 1976
Harding, David, **Artists and Buildings,** Scottish Arts
Council, 1977
ICOM Committee for Conservation, **Triennial Meeting,**
Copenhagen 1984.
Lydiate, Henry, **Collected Artlaw articles**
Lydiate, Henry, **The Visual Artists Copyright
Handbook,** Artlaw Guide Number One, London, 1983
McCullough, Jamie, **Meanwhile Gardens,** Calouste
Gulbenkian Foundation, 1978
Parkin, Jeanne & William J.S. Boyle ed, **Art in
Architecture: art for the built environment in the
province of Ontario,** Visual Arts, Ontario, 1982
Robinette, Margaret, A, **Outdoor Sculpture: Object and
Environment,** Whitney Library of Design, New York,
1976
Safdie, Moshe, **Form & Purpose: Is the Emperor
Naked?** International Design Education Foundation,
Aspen, 1980
Strachan, W.J., **Open Air Sculpture in Britain,**
A. Zwemmer Ltd, London, 1984
Sculpture in Harlow, The Harlow Development Trust,
1973
Thalaker, Donald, W., **The Place of Art in the World of
Architecture,** Chelsea House, New York, 1980
Thorpe, David, **Town Artist Report,** Scottish Arts
Council, 1980
Townsend, Peter, ed, **Art Within Reach,** Thames and
Hudson, 1984
Willet, John, **Art in a City,** Methuen, London, 1967

Catalogues

Art & Architecture, catalogue of a series of exhibitions at the Institute of Contemporary Art, London, Jan-May 1983

Art into the Landscape I, II & III, catalogues of the exhibitions at the Serpentine Gallery, London, Sept-Oct 1974, July-Aug 1977, Mar-Apr 1980

Arts on the Line: Art for Public Transit Spaces. Cambridge Arts Council, Cambridge USA 1980

L'Art dans Le Metro, Bruxelles, 1981

British Sculpture in the Twentieth Century, catalogue of the exhibition at the Whitechapel Art Gallery, London, Sept 1981-Jan 1982

Growing up with Art, The Leicestershire Collection for Schools and Colleges, catalogue organised by the Arts Council and the Whitechapel Art Gallery, 1980

Private Vision-Public Art, catalogue of the Eduardo Paolozzi exhibition at the Architectural Association, London, 1984

Probing the Earth: contemporary land projects, catalogue of the exhibition at the Hirshhorn Museum and Sculpture Garden, Washington, Oct 1977-Jan 1978

Prophesy and Vision, ed, Peter Burman & Frank Kenneth Nugent SJ, catalogue of the exhibition at the Arnolfini, 1982

Sculpture in a Country Park, catalogue of the outdoor exhibition of the Welsh Sculpture Trust at Margam, Wales, 1983.

Sculpture in the City, catalogue of the Arts Council of Great Britain, London, May-June 1968

The Sculpture Show, catalogue of the exhibition at the Hayward and Serpentine Galleries, London, Aug-Oct 1983

Towards a New Iron Age, catalogue of the exhibition at the Victoria & Albert Museum, London, May-June 1982

Van Metro Tot Beeldbuis, (Art in the Amsterdam Subway), Werkgroep Kunstzaken Metro Amsterdam (Metro Art Work Group), Stadsrukkerij van Amsterdam

Articles

A Cautionary Tale, Editorial **Art Monthly, No 94,** March 1986

Alloway, Lawrence, Public Sculpture for the Post-Heroic Age, **Art in America,** Oct 1979, pp9-11

Alloway, Lawrence, The Public Sculpture Problem, **Studio International, Vol 184,** No 948, Oct 1972, pp145-8

Artist Placements, **Artists Newsletter,** July 1983

Crosby, Theo, A kind of Urban Furniture, **Studio International Vol 184,** No 946, July/August 1972

Crosby, Theo, Patron of the Arts, **Architects' Journal, Vol 179,** No 3, January 18, 1984, pp24-27

Davies, Peter, Commissions: after Gateshead, **Art Monthly, No 69,** Sept 1983, pp31-32

Fink, Peter, Inspiration versus Administration **Artists' Newsletter,** March 1985

Forgey, Benjamin. It takes more than an outdoor site to make a public sculpture, **Art News,** Sept, 1980, pp84-89

Gibberd, Patricia, Harlow Art Trust, **Landscape Design, No 138,** May 1982, pp20-22

Harney, Andy, L, The proliferating 1% program for the use of art in public buildings, **AIA Journal,** Oct 1976, pp35-39

Hawthorne, Don, Does the public want public sculpture?, **Art News,** May 1982, pp56-63

Hefting, Paul, The Everyday Work of Art, **The Architectural Review, Vol. CLXXVII No 1055,** January 1985, pp72-74

Hill, Peter, The great outdoors, **Design, No 421,** Jan 1984, pp53-54

Hooper, Les, Aspects of commissioning & commissioned art, **Artists Newsletter,** July 1983, pp9-12

Jones, Gareth, Collaboration; a dirty word, **Art Monthly, No 53,** Feb 1982, pp8-9

Jones, Gareth, and Will Alsop, Drawings for Riverside, Extracts from Diaries, **Art Monthly,** Feb 110981 pp33-5

Jones, Gareth, The Riverside: The Artist's Story, **Cue Magazine,** Nov/Dec 1981 pp10-11

Kindersley, David, My Apprenticeship to Eric Gill (2 parts), **Crafts Magazine,** Crafts Council, London July/Aug and Sept/Oct 1980

Linker, Kate, Public Sculpture: the pursuit of the pleasurable and profitable paradise, **Artforum,** March 1981, pp64-73

Linker, Kate, Public Sculpture II: provision for the paradise, **Artforum,** Summer 1981, pp37-42

Lippard, Lucy, R., Art indoors, in and out of the public domain, **Studio International, Vol 193, No 986,** Mar 1977, pp83-90

Lippard, Lucy, R., Gardens: some metaphors for a public art, **Art in America, Vol 69,** pt 9 Nov 1981, pp136-50

Lydiate, Henry, Artlaw, **Art Monthly, No 10,** 1977

Lydiate, Henry, Commissions and the responsibilities they bring (part I), **Art Monthly, No 43,** 1981

Lydiate, Henry, Commissions and the responsibilities they bring (part II), **Art Monthly, No 44,** 1981

Lydiate, Henry, Percentage for art: UK – OK?, **Art Monthly, No 55** 1983, pp35-36

Lydiate, Henry, Artlaw, **Art Monthly, No 57,** 1982

Lydiate, Henry, Tomorrow is a Long Time, **Art Monthly, No 83** Feb, 1985, pp35-36

Ostler, Timothy and Steve Field, Working with artists, Possibilities, **Architects' Journal, Vol 179 No 3,** Jan 1984, pp55-66

Ostler, Timothy and Steve Field, Practicalities, **Architects' Journal, Vol 179 No 4,** Jan 1984, pp63-67

Ostler, Timothy and Steve Field, Case studies, **Architects' Journal, Vol 179, No 5** Feb 1984, pp59-66

Ostler, Timothy and Steve Field, Working with Architects Part 1, **Artists' Newsletter,** October 1984

Petherbridge, Deanna, Architects and the Arts, **Architectural Design, Vol 49 No 11** 1979

Petherbridge, Deanna, Composite orders, **Architects' Journal, Vol 175, No 6** Feb 10, 1982, pp40-42

Petherbridge, Deanna, The town artist experiment, **Architectural Review, Vol 166,** No 990 Aug 1979, pp125-9

Petherbridge, Deanna, A sculpture for all seasons, **Architectural Review, Vol 169,** No 1008, Feb 1981, pp98-103

Petherbridge, Deanna, Sculpture up front, **Art Monthly, No 43** Feb 1981, pp7-15

Petherbridge, Deanna, Commissions: the one percent, **Art Monthly, No 52,** Dec 1981/Jan 1982, pp29/31

Petherbridge, Deanna, Joint games of chance, change and interchange, **Art Monthly, No 53,** Feb 1982 pp6-8

Petherbridge, Deanna, Art and Architecture, A special supplement, **Art Monthly, No 56,** 1982, ppi-viii

Petherbridge, Deanna, The Writing on the Wall, **Interior Designers Handbook,** Grosvenor Press, London, 1985

Rees, J. & T. Stokes, **Public Sculpture?,** Studio International, Vol 185, No 952 Feb 1973, pp46-7

Rees, Jeremy, **Public Sculpture,** Studio International, Vol 184, No 946, July/Aug 1972

Reynolds, Patrick, The threat to outdoor art: the growing menace of acid rain, **Historic Preservation** Vol 36, No 3, June 1984, pp34-39

Scott, Alison, **Publicly Sited and Commissioned Art,** Artists Newsletter, July 1983

Some art in urban sites in Tyne and Wear, Aspects, No 19, 1982, pp68

Stephen, Douglas, **Hospital Treatment,** Building Design, No 705, Sept 7 1984, pp2

Trombley, Stephen, **Art in business: three firms in the art rental business,** RIBA Journal, Vol 91, No 10 supplement, Oct 1984, pp25

Appendix V
Example of Commission and sale agreement as used by Public Art Development Trust

This Agreement is made on day of (date) between 'The Artist' MARY SMITH

...

...

...

and 'The Commissioner' SEAGROVE INVESTMENTS

1. Commission

(a) The Artist agrees to complete by October 1985 the following work of art ('The Work'): two tapestries each 8' x 3'6"

(b) The work will be sited in the Foyer of Seagrove House, London SW1 and space will be made available by Seagrove Investments ('The Recipient')

(c) The site will be repainted in preparation for the work, in accordance with Clause 8 of this agreement.

2. Sale

The Artist agrees to sell the work to the Commissioner when completed: and the Commissioner agrees to transfer the title in the work to the Recipient.

3. Fees and materials

(a) In consideration for the creation and the sale of the work, under the terms of this agreement, the Commissioner agrees to pay the Artist the sum of £8,000 (the 'agreed sum').

The Artist will be paid the agreed sums in the following installments:

Design Fee	£1,000 (paid October 1984)
Stage 1 (materials)	£2,000 (paid January 1985)
Stage 2	£1,000 April 1985
Stage 3	£1,000 July 1985
Stage 4	£1,500 September 1985
Stage 5	£1,500 the balance remaining on the completed work beind accepted by the Commissioner

(b) The Artist will both complete the Work and sell it to the Commissioner for the agreed sum, which is inclusive of any expenses borne, or to be borne by the Artist.

(c) The Artist will retain title to the preparatory drawings and proposals, but agrees to lend these, on agreement with the Recipient, to an exhibition either accompanying or separate from the Work.

4. Termination of agreement

(a) *By the Commissioner*
At any time until (Stage 3) the Commissioner may terminate this Agreement upon giving written notice to the Artist, who will be entitled to receive or retain payment for all work done in pursuance of this Agreement up to the date of receiving such a notice (and any further sums which may be reasonable in the circumstances).

(b) *By the Artist*
(i) If the Artist should die before completing the Work, her successors in title will be entitled to receive or retain payment for all work done in pursuance of this Agreement (and any further sums which may be reasonable in the circumstances).

(ii) If, in the event of the Artist's illness, damage by fire, flood, or other hazard to the Artist's house or studio, or to any other place where the Work may be housed, or any other cause outside the control of the Artist, the Work cannot be completed by *October 1985* or other date as may be agreed between the parties, the Artist will be entitled to receive or retain payment for all work done at the stage reached in pursuance of this Agreement, up to the date of the commencement of the illness or other cause, and further sums which may be reasonable in the circumstances.

(iii) If the Work cannot be completed for any of the reasons set out in (i) and (ii) above, the Commissioner reserves the right, without any further payment (other than such sums as may be payable under (i) and (ii) above) to acquire and take possession of all preparatory work as might exist.

5. Copyright and reproduction

(a) Except as herein otherwise provided, copyright in all designs for the Work and in the Work is retained by the Artist (unless assigned by the Commissioner or Recipient under a separate agreement).

(b) The Artist warrants that she will not make nor authorise any copies of the Work, without prior consent of the Commissioner.

(c) The Commissioner and the Recipient shall be entitled, without consulting the Artist, and without any payment to her, to make or authorise any photograph of the Work, and to include or authorise the inclusion of the Work or any such photograph in any record, publication, film or television broadcast.

6. Originality

The Artist warrants that the Work will be original.

7. Acceptance

The Artist will use her aesthetic skill and judgement to create the Work, and the Commissioner and Recipient agree to accept the completed Work in accordance with the terms of this Agreement, unless either of them can show that the Work was executed not in accordance with the description and design agreed by them in Clause 1 of this Agreement.

8. Transport

The Artist will arrange at her cost for all the necessary transport of the Work, both during the making, and for delivery to the site.

9. Site preparation and installation

(a) The Recipient will be responsible at his cost and in consultation with the Artist for the preparation of the site.

(b) The Artist will give four weeks notice to the Commissioner re the completion of the Work.

(c) The Artist will be present and make her expertise available to the Commissioner (Recipient) during the installation of the Work.

10. Damage/maintenance

(a) If the Work is damaged, and if after consultation with the Artist, the Recipient decides that restoration is feasible at reasonable cost, the Recipient will give the Artist the option to conduct or supervise the restoration of the Work, on terms and to a schedule agreed.

(b) The Recipient will be responsible for insurance and maintenance of the Work.

(c) The Artist will advise in writing on the necessary maintenance required, on handover of the Work.

11. Acknowledgement

(a) The Recipient will place near the Work a suitable plaque, with wording to be agreed with the Commissioner, describing the Work and its subject, naming the Artist and acknowledging the Commissioner and all funding agencies.

(b) The Commissioner and Recipient will at all times acknowledge the Artist as creator of the Work.

12. Addresses

(a) The Artist will notify the Commissioner and Recipient in writing of any change of her address, including the address of her studio, within seven days of any such change occurring.

(b) The Recipient will notify the Artist and the Commissioner if he sells, lends, or otherwise parts with possession of the Work, and such notice will include the name and address of the person/institution which has acquired possession of the Work or where the Work of Art is housed.

13. Duration

This Agreement will be binding upon the parties, their assigns and all other successors in title.

14. Proper law

This Agreement is governed by the law of England and Wales and may only be amended by further written agreement signed by all parties.

15. Arbitration

Any dispute under or arising from this Agreement will be referred to an arbiter appointed by the Public Art Development Trust independent of Artist or Recipient.

signed:

... Artist...........Date

... Commissioner
 Date
(for or on behalf of)

... RecipientDate
(for or on behalf of)

133

HMSO publications are available from:

HMSO Publications Centre
(Mail and telephone orders only)
PO Box 276, London SW8 5DT
Telephone orders (01) 622 3316
General enquiries (01) 211 5656
(Queuing system in operation for both numbers)

HMSO Bookshops
49 High Holborn, London, WC1V 6HB
(01) 211 5656 (Counter service only)
258 Broad Street, Birmingham, B1 2HE
(021) 643 3740
Southey House, 33 Wine Street, Bristol, BS1 2BQ
(0272) 264306
9-21 Princess Street, Manchester, M60 8AS
(061) 834 7201
80 Chichester Street, Belfast, BT1 4JY
(0232) 238451
71 Lothian Road, Edinburgh, EH3 9AZ
(031) 228 4181

HMSO's Accredited Agents
(see Yellow Pages)

and through good booksellers